DAVID INGALL & KARIN RISKO

Published by The History Press Charleston, SC 29403 www.historypress.net

Copyright © 2015 by David Ingall and Karin Risko All rights reserved

Unless otherwise noted, images appear courtesy of the authors.

Front cover, top: Michigan Soldiers and Sailors Monument at Campus Martius, Detroit.

Courtesy Rod Arroyo, Portraits by Rod.

Front cover, bottom, left to right: Ford's Theatre Lincoln assassination chair. From the collections of The Henry Ford, Dearborn; Fort Wayne barracks, Detroit; Civil War Muster at Cascade Falls Park, Jackson.

Back cover, top, left to right: Battle Creek Underground Railroad monument; General Ulysses S. Grant. Library of Congress.

Back cover, center: Custer equestrian statue, Monroe.

Back cover, bottom, left to right: Governor and Mrs. Austin Blair reenactors at Fort Wayne,
Detroit. Courtesy Kristina Austin Scarcelli; 1914 GAR National Encampment Parade, Campus
Martius, Detroit. Library of Congress.

First published 2015

Manufactured in the United States

ISBN 978.1.62619.940.8

Library of Congress Control Number: 2015930458

Notice: The information in this book is true and complete to the best of our knowledge. It is offered without guarantee on the part of the authors or The History Press. The authors and The History Press disclaim all liability in connection with the use of this book.

All rights reserved. No part of this book may be reproduced or transmitted in any form whatsoever without prior written permission from the publisher except in the case of brief quotations embodied in critical articles and reviews.

To Mom, Kathy, Liz and Stefan with love
—Karin

To my wife, Elizabeth; son, Austin; and daughter, Ava, for embracing my fascination with the Civil War
—David

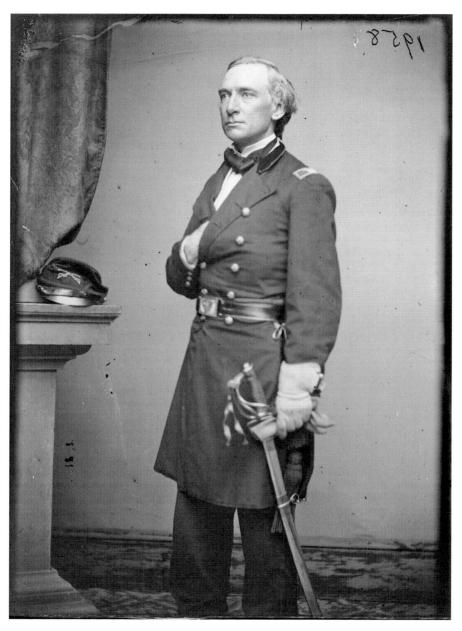

Colonel Thornton Fleming Brodhead, First Michigan Cavalry, was shot point-blank by the Confederate adjutant of the Twelfth Virginia Infantry after he refused to surrender. *Library of Congress*.

Two bullets have gone through my Chest, and directly through the lung. I suffer little now, but at first pain was acute. I have won the Soldier's fate. I hope that from heaven I may see the glorious old Flag waive [sic] again over the individual Union I have loved so well. Farewell wife and Babes and Friends. We shall meet again.

Your loving Thornton

This book is dedicated in memory of Colonel Thornton Fleming Brodhead, who was mortally wounded at the Second Battle of Bull Run and is the inspiration behind this publication. From his deathbed, Brodhead penned this poignant farewell letter to his wife and six children. His words illustrate the unwavering resolve possessed by those willing to fight to keep the Union intact and remind us of the sacrifices they made.

Contents

Foreword, by Jack Dempsey	9
Acknowledgements	11
Introduction	13
1. Southeast Michigan	17
2. Southwest Michigan	117
3. Mid-Northern Michigan	153
4. Upper Peninsula	175
5. Extending Your Tour: Michigan Civil War Monuments	
and Markers in Other States	187
Appendix I. Michigan's Regiment Training Sites	193
Appendix II. Prominent Civil War Monuments and Statues	
in Michigan (176)	197
Appendix III. Civil War Medal of Honor Recipients Buried	
in Michigan (53)	205
Appendix IV. Civil War Generals Buried in Michigan (73)	209
Sources/Suggested Reading	213
Index	217
About the Authors	224

FOREWORD

B ruce Catton, the nation's foremost Civil War historian and Michigan's own, wrote how the soldiers and sailors who served during the Civil War contended desperately with a fate that was almost more than they could cope with. Abraham Lincoln predicted that the world could not, would not, forget what they did.

Michigan sent some ninety thousand troops off to war, defending the American Union and ending the great evil of slavery in America. One of every six never came home alive. Many who returned had suffered wounds, illness and imprisonment. Their sacrifice was a great and bloody one.

The Michiganders who stepped up during our country's greatest crisis came from all over Michigan, from city and farm and far-flung posts where they were already serving. They were as young as teenagers and as old as the late stages of life. They were Native American, African American, Irish American and just about every other kind of American. Some in uniform were female. Those women who did not wear Union blue kept up their families, farms or stores; went close to the front to provide necessary support; and helped in overcrowded hospital wards.

The sacrifice of the soldiers and their supporters was made possible by a Michigan electorate that kept raising up leaders who would not tolerate two American nations existing on the same continent.

In many respects, the issues that confronted Michigan a century and a half ago still challenge us—chief among them whether we are a society of equal opportunity. The Civil War remains relevant.

FOREWORD

It is for us to remember what they did, how they contended with a desperate fate and how they overcame. It is for us to comprehend the rebirth of American freedom that should resonate today and ever through the corridors of time.

This book is an invaluable resource for discovering Civil War heritage. It documents history that should never be forgotten. Whether one is a career historian or casual tourist, there is nothing comparable to seeing such monuments and locations up close and personal.

JACK DEMPSEY

Jack Dempsey is an attorney, president of the Michigan Historical Commission and author of Michigan and the Civil War: A Great and Bloody Sacrifice.

ACKNOWLEDGEMENTS

A special thank-you to former and current members of the U.S. military. We appreciate your service and sacrifice on behalf of our nation.

Thank you to Krista Slavicek, our wonderful editor, for taking interest in this book and helping us bring the project to fruition and our project editor, Darcy Mahan, for making us look and sound good.

An additional thank-you to the following people:

"The General" Steve Alexander

Jack Dempsey, Michigan Historical Commission president, author

David Finney, Civil War historian, author

Shawna Mazur, National Park Service ranger

Marty Bertera, Fourth Michigan Infantry historian, author

John McGarry, Lakeshore Museum Center executive director

Thomas Dietz, Kalamazoo Valley Historical Museum curator of research

Heidi Butler, Capital Area District Libraries

Scott Kuykendall, Allegan County Historical Society

Thomas Berlucci, Fort Wayne Coalition chairman

Dave Jamroz, Fort Wayne historian, author

James Conway, Fort Wayne project manager, author

Matt VanAcker, Michigan Capitol tour and information service director

Butch Miller, Nash-Hodges Post No. 43, Sons of Union Veterans

Chris Cox, Jackson Civil War Society Board

Bruce Butgereit, Department of Michigan Sons of Union Veterans past commander

ACKNOWLEDGEMENTS

Lou Komorowski, Monroe County Library System, Ellis Reference and Information Center manager

Charmaine Wawrzyniec, Monroe County Library System, Ellis Reference and Information Center reference technician

Regina Manning, Monroe County Library System, Ellis Reference and Information Center reference librarian

Joan Croy, Little Big Horn Associates past president

Don Schwarck, Little Big Horn Associates

Gary Wlosinski, Ann Arbor Civil War Roundtable past vice-president

Brian Egen, Michigan Sesquicentennial Committee chairman; The Henry Ford, executive producer

Jim Orr, The Henry Ford, image services specialist

Bobbie Fowkes-Davis, Underground Railroad Reading Station Bookstore proprietor, Second Baptist Church

Mark McPherson, historical interpreter, author

Elizabeth Ingall

Charley Bohland

Chad Bianco

Introduction

Thank God for Michigan!" It's believed President Abraham Lincoln uttered those words when the First Michigan Infantry arrived in Washington, D.C., shortly after his declaration of war. The First Michigan was the first western unit to answer his call for troops.

More than ninety thousand Michigan residents, nearly 23 percent of the state's male population in 1860, served the Union during the American Civil War. Nearly fifteen thousand made the ultimate sacrifice by giving their lives for the Union cause. They fought hard and sacrificed much. Their actions resulted in the outcome we enjoy today: a united nation, the United States of America. The people of Michigan and the United States should know this and be proud.

Michigan Civil War Landmarks brings the war home by identifying the local people behind these memorials, the people whose efforts helped preserve the Union, thereby shaping our nation's history.

We hope this book serves as a catalyst that ignites reader interest in further exploring the huge role Michigan played during the Civil War and encourages them to visit the forts, museums, monuments, cemeteries and other sites found within these pages in their own hometowns and throughout the state.

An extensive reading list at the back of the book is a great place to start for those wishing to delve further into Michigan's role in the Civil War. Other resources worth exploring include the Herbert D. Doan Midland County History Center in Midland, Sloan Museum in Flint, Heritage

Introduction

Museum and Cultural Center in St. Joseph, Michigan State University Museum in East Lansing and Washtenaw County Historical Museum in Ann Arbor. All have substantial Civil War collections but do not display them on a continual basis. Michigan State University, Central Michigan University and Western Michigan University archives contain Civil War letters, diaries and photographs, as do the archives at many state colleges, county museums and local libraries.

Every attempt has been made to publish the most current information. Please contact sites in advance to verify hours of operation and fee schedule.

AUTHORS' TOP TEN MICHIGAN CEMETERIES FOR CIVIL WAR—ERA GRAVE SITES

Elmwood, Detroit
Mount Evergreen, Jackson
Woodland, Monroe
Woodmere, Detroit
Fulton Street, Grand Rapids
Oak Hill, Pontiac
Oak Grove, Coldwater
Forest Hill, Ann Arbor
Silverbrook, Niles
Oak Hill, Battle Creek

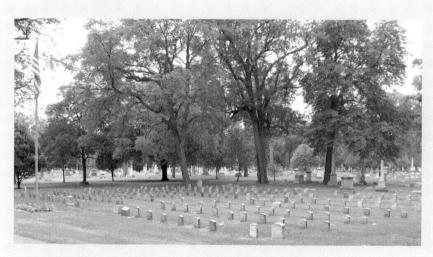

Civil War soldiers plot at Elmwood Cemetery, Detroit.

Chapter 1

Southeast Michigan

When it comes to unearthing Civil War history, southeast Michigan doesn't usually come to mind. Far removed from the major battlefields and action, people underestimate the role its citizens played in this conflict.

Detroit, a thriving Northern city, was instrumental in recruiting and organizing troops, including the First Michigan Infantry, the first western regiment to answer Lincoln's call for troops, eliciting his famous response: "Thank God for Michigan!"

Numerous celebrated regiments originated from this region, while many individuals earned accolades for bravery and meritorious service. Off the battlefield, outspoken activists influenced public opinion, while lawmakers brandished pens and authored major legislation that shaped national policy.

One of America's most coveted artifacts of this era can be found in Dearborn. The original black walnut rocking chair where our nation's sixteenth president, Abraham Lincoln, was seated when assassinated is on display at The Henry Ford.

On April 14, 1865, five days after Confederate general Robert E. Lee surrendered, Confederate sympathizer John Wilkes Booth assassinated President Lincoln while he and First Lady Mary Todd Lincoln attended the play *Our American Cousin* at Ford's Theatre in Washington, D.C.

Ranked among the greatest presidents in United States history, Lincoln successfully led the nation through the American Civil War, our country's

FIFTH MICHIGAN A VALUE TO THE MICHIGAN TO THE MICHIGAN

Able Bodied Recruits!

Will be received during the month of January to serve in this

GALLANT RECIMENT

Under the DASHING ALGER.

This Regiment is in the "MICHIGAN BRIGADE," commanded

DY THE BRAVE AND DARING CUSTER,

The boy General with the Golden locks," All recrnits for this Regiment will receive the

HIGHEST BOUNTIES,

And will be enrolled in any Township or Ward they desire, thus enabling them to seeme

ALL THE LOGAL BOUNTIES!

R. BAYLIS, Adjutant, Recruiting Officer.

Teenmseh, Mich., Jan, 1st, 1864.

Recruiting poster for the Fifth Michigan Cavalry. Monroe County Historical Museum Archives.

greatest internal crisis. He preserved the Union and abolished forever the repugnant institution of slavery. In 1929, the theater chair came up for auction. Agents representing automobile magnate Henry Ford purchased for \$2,400 this remnant from our nation's darkest hour.

While many argue the Civil War was about states' rights rather than slavery and President Lincoln never intended to free slaves, slavery was

SOUTHEAST MICHIGAN

the issue that divided the nation and caused Confederate states to secede. With its proximity to Canada, southeast Michigan played an important role in the secretive network known as the Underground Railroad. Fervent abolitionists risked their own lives to help thousands of freedom seekers make this long and treacherous journey through the lower portion of our state and on to freedom.

A Civil War tour of southeast Michigan wouldn't be complete without a visit to Monroe County, the gateway to Michigan's Civil War history. Here, you'll find the adopted hometown of General George Armstrong

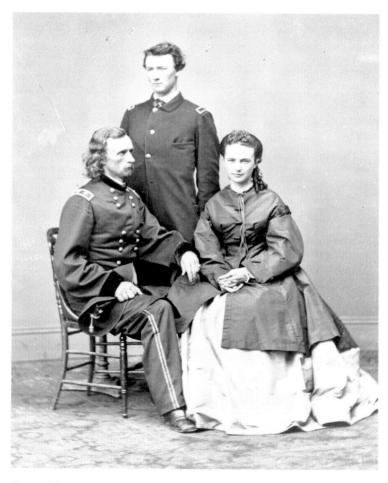

General George Custer with his wife, Elizabeth, one of the few women allowed to accompany her spouse near the battlefield, and his brother Tom, the first double Medal of Honor recipient. Library of Congress.

Custer, one of the youngest Union generals to serve in the Civil War. The commander of the acclaimed Michigan Cavalry Brigade rallied his men with the famous battle cry: "C'mon you Wolverines!" as they thwarted numerous Confederate advances and participated in critical campaigns that helped secure Union victory. While Custer's men captured numerous Confederate battle flags, they never lost a color.

At Gettysburg, the Michigan Cavalry Brigade, with Custer in the lead, forced the retreat of the once invincible General James Ewell Brown "Jeb" Stuart and his Confederate cavalry in what's often called "the cavalry battle that saved the Union."

Private John A. Huff, a member of Custer's brigade, delivered a huge blow to the Confederacy when he shot and mortally wounded General Stuart during the Battle of Yellow Tavern. Near the end of the war, Custer's Third Cavalry Division blocked the retreat of Confederate general Robert E. Lee's forces, resulting in Lee's subsequent surrender.

Southeast Michigan offers numerous opportunities for history buffs to learn firsthand about the Civil War and the local participants who rose to meet this threat to our national security. Fort Wayne, an eighty-three-acre, star-shaped fort where thousands trained before heading to battle; exquisite monuments immortalizing yesterday's heroes; library and museum collections featuring firsthand accounts of the war recorded in letters, diaries and other period documents; and many cemeteries recount the stories of those who served and sacrificed on behalf of our nation and created the America we celebrate today.

Adrian

Laura Smith Haviland Statue Church and South Main Streets

A monument dedicated to Civil War nurse Laura Smith Haviland stands next to the Lenawee County Historical Museum. Affectionately called Aunt Laura, this abolitionist, suffragette and reformer devoted her life to the principle of equality for all.

Born in Canada, Haviland and her husband, Charles, followed her parents to Lenawee County, where her father served as minister in the Society of Friends. Early on, Laura Haviland became aware of the societal disparities that existed based on gender, skin color and

SOUTHEAST MICHIGAN

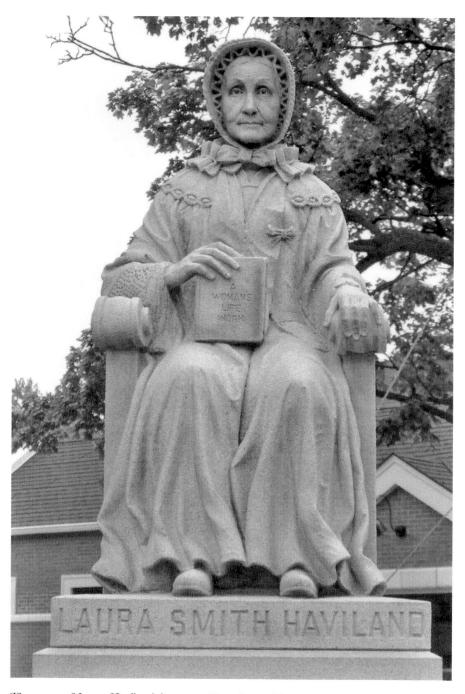

The statue of Laura Haviland, known as "Aunt Laura," in Adrian commemorates the life of the abolitionist, suffragette and social reformer.

economic standing. Believing education was crucial to surmounting many of these obstacles, the Havilands founded the Raisin Institute of Learning, one of the first integrated schools in the United States. Later, Laura helped found the State Public School for Dependent Children in Coldwater to provide educational opportunities for orphans and disadvantaged children.

Both the Raisin Institute and Haviland farm served as stops on the Underground Railroad. As Laura Haviland became more involved in the antislavery movement, she traveled to different junctures on the Underground Railroad and escorted freedom seekers to Canada. In her autobiography, Haviland claims to not have lost anyone. So successful were Haviland's efforts that one Southern slave owner posted a \$3,000 bounty to anyone willing to kidnap or murder her on his behalf.

When the Civil War ended, Haviland toured abandoned plantations and collected the chains, irons, restraints and other implements that had been used to perpetuate fear in slaves. She transported these items north and exhibited them during her lectures to help whites understand the conditions freed blacks had been subjected to as slaves.

Raisin Valley Friends Meeting House / Raisin Valley Cemetery 3552 North Adrian Highway/M-52 and West Valley Road / (517) 265-5050

The Raisin Valley Cemetery is the site of the Haviland family burial plot. Adjacent to the cemetery is the Raisin Valley Friends Meeting House, where Laura Smith Haviland's father once served as pastor.

Raisin Institute Wilmouth Highway

A plaque mounted on a boulder marks the site of the first integrated school in Michigan, founded in 1837 by Charles and Laura Haviland.

Southeast Michigan

Chandler Family Cemetery / Hazelbank Breckel Highway near East Valley Road / Raisin Township / private property

Elizabeth Margaret Chandler, a noted Quaker poet and abolitionist, is buried here. In 1830, Chandler, her brother Thomas and aunt Ruth Evans moved from Philadelphia, Pennsylvania, to a farm located on the outskirts of Tecumseh that they called Hazelbank.

Thomas, a follower of noted abolitionist William Lloyd Garrison, established the Garrisonian Michigan Anti-Slavery Society and served as its first president. Garrison and other abolitionists would stay at Hazelbank when on lecture tours in the area.

Already a nationally published author when she moved to Hazelbank, Elizabeth continued to publish poems and writings that depicted the injustice of slavery, rallied for emancipation, demanded better treatment for Native Americans and encouraged women to be agents of change.

She and Laura Smith Haviland became friends, and together the two women established the Logan Female Anti-Slavery Society in 1832.

Camp Williams / Fourth Michigan Infantry Marker 110 South Madison Street

A state historical marker at Adrian College's North Hall denotes Camp Williams, the site of the Fourth Michigan Infantry training camp, in use from late May through June 25, 1861. The camp was named after General Alpheus Williams. See Detroit, Belle Isle entry for more on General Williams.

Oakwood Cemetery

Colonel Dwight A. Woodbury, of the Fourth Michigan Infantry, and Brigadier General William Humphrey are buried here. Colonel Woodbury was killed at the Battle of Malvern Hill on July 1, 1862.

General William Humphrey, twice wounded at the Battle of Spotsylvania, served in several major battles. At Cold Harbor, he was charged with maintaining the picket line in front of the enemy as General Grant's army withdrew to the south side of the James River. After the war, General Humphrey held positions in the newspaper and manufacturing industries

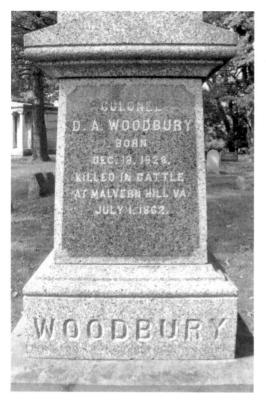

The grave of Colonel Dwight Woodbury, Fourth Michigan Infantry, at Oakwood Cemetery in Adrian.

and the public sector, serving as auditor general of Michigan, Jackson State Prison warden and Adrian postmaster.

Lieutenant Colonel Richard A. Watts, who played a unique role during the execution of the Lincoln conspirators, is buried here. As a member of Major General John F. Hartranft's staff, Watts was part of the special assigned to team supervise the imprisonment of accused Lincoln assassination conspirators and execute the four found guilty. After the convicted were executed, Watts's duties included writing the names of Mary Surratt, Lewis Powell, George Atzerodt and David Herold on individual slips of paper; inserting their names in bottles; and then placing the bottles in the appropriate coffins before sealing them shut.

Although not directly related

to the Civil War, another soldier memorialized here is tied to a significant event in American history. Private George Post of Company I, Seventh U.S. Cavalry, died on June 25, 1876, alongside General George Armstrong Custer, on "Last Stand Hill" at the Battle of Little Big Horn in Montana. His memorial stone is inscribed with the words: "Killed in Custer massacre." His remains lie at the battlefield.

Lenawee County Historical Society Museum 110 East Church Street / (517) 265-6071

The museum features a Civil War exhibit and artifacts of interest.

SOUTHEAST MICHIGAN

Monument Park

Center Street between Maumee and Church Streets

Adrian's Civil War monument was dedicated in 1870. The marble column used in the monument dates back further in American history to 1799, when it stood in front of the Bank of Pennsylvania in Philadelphia.

ANN ARBOR

University of Michigan Campus Alumni Memorial Hall / 525 South Street / (734) 764-0395

Approximately 1,500 students from the University of Michigan fought in the Civil War. Over 100 died. A plaque honoring the Twentieth Michigan Infantry hangs in Alumni Memorial Hall, now the university's Museum of Art. The alumni association dedicated Alumni Memorial Hall in memory of university students who died in both the Civil and Spanish American Wars.

Bentley Historical Library / 1150 Beal Avenue / (734) 764-3482

The Bentley Historical Library covers all periods of Michigan history. The library has an extensive collection of items relating to Michigan and the Civil War, including primary sources, books, newspapers, documents, photographs, etc.

William L. Clements Library / 909 South University Avenue / (734) 764-2347

This library has an impressive Civil War collection, mainly oriented toward non-Michigan material.

Signal of Liberty
1000 block of Broadway / building no longer exists

In April 1841, abolitionists Theodore Foster and Reverend Guy Beckley launched the Signal of Liberty, the state's most prominent antislavery

newspaper, above the mercantile shop belonging to Reverend Beckley's brother Josiah. The weekly publication featured stories designed to arouse sympathy and gain support for the abolitionist agenda, which was to end slavery in America. The *Signal of Liberty* has been digitized and can now be accessed online.

Reverend Guy Beckley House 1425 Pontiac Trail / private residence

Reverend Guy Beckley, publisher of the *Signal of Liberty*, resided here with his family. It's believed Reverend Beckley's home may have served as a station on the Underground Railroad.

African American Cultural and Historical Museum 3261 Lohr Road / (734) 761-1717

Established in 1993, the African American Cultural and Historical Museum maintains a collection of artifacts, art, papers, books, photographs and other materials pertaining to the history and culture of African Americans in Washtenaw County. Programming includes bus tours to sites in Ypsilanti and Ann Arbor that were part of the Underground Railroad and the antislavery movement.

The administrative building is currently located in the David R. Byrd Center. The 1830s farmhouse was restored by the late David R. Byrd, a prominent African American architect who also built the beautiful chapel adjacent to the museum. A legacy campaign is underway by the organization to occupy another historic home located at 1528 Pontiac Trail.

Fairview Cemetery 1401 Wright Street

A Civil War monument, featuring an eagle on top, graces the grounds of this cemetery.

Southeast Michigan

Forest Hill Cemetery 415 South Observatory Street

Two Medal of Honor recipients are buried here. Sergeant Conrad Noll, of the Twentieth Michigan Infantry, Company D, received his medal for exemplifying courage when he saved the regiment's colors at Spotsylvania Court House on May 12, 1864.

Sergeant Joseph B. Kemp, of the Fifth Michigan Infantry, Company D, earned his medal for capturing the flag of the Thirty-first North Carolina Infantry at the Battle of the Wilderness on May 6, 1864.

Also buried here is Colonel Norval W. Welch, of the Sixteenth Michigan Infantry. Welch was killed at the Battle of Peeble's Farm, Virginia, on September 30, 1864.

A Civil War monument depicting a soldier at parade rest honors soldiers and sailors from Washtenaw County.

Top: The grave of Sergeant Conrad Noll, Twentieth Michigan Infantry, at Forest Hill Cemetery in Ann Arbor.

Right: A Washtenaw County Civil War soldier statue in Ann Arbor's Forest Hill Cemetery.

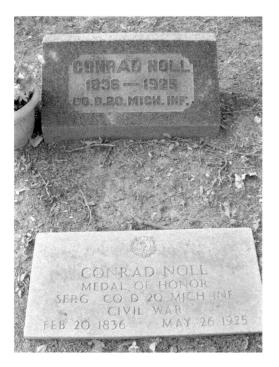

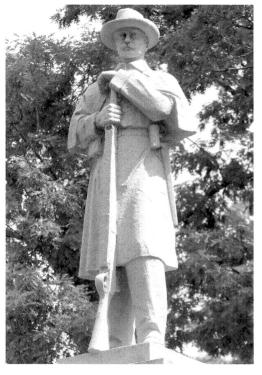

St. Thomas Cemetery 300 Sunset Road

Sergeant Patrick Irwin, of the Fourteenth Michigan Infantry, Company H, is interred here. Sergeant Irwin was awarded the Medal of Honor for capturing a Confederate general and his command at Greensboro, Georgia, on September 1, 1864.

ARMADA

Willow Grove Cemetery Armada Ridge Road

Willow Grove Cemetery is the final resting place of Private John A. Huff, who mortally wounded Confederate major general Jeb Stuart on May 11, 1864, during the Battle of Yellow Tavern, Virginia. Huff, a member of Company E, Fifth Michigan Cavalry, managed to shoot Stuart with a .44-caliber colt revolver when the general and his staff rode within close range of portions of the Fifth Michigan.

General Stuart's death was a monumental loss to the Confederacy. Unfortunately, Huff would also die on June 23, 1864, due to complications from a head wound received during the Battle of Hawes Shop, Virginia, on May 28, 1864.

John Huff Home 23644 East Main Street / private residence

This home once belonged to John Huff, who mortally wounded Confederate major general Jeb Stuart. See previous entry.

BLISSFIELD

Pleasant View Cemetery U.S. 223 and High Street

A Columbiad cannon, placed by the local GAR Scott Post No. 43, is located here.

Southeast Michigan

Ogden Zion Cemetery Crockett Highway and East Horton Road

Here rests Corporal Addison J. Hodges of Company B, Forty-seventh Ohio Infantry. He was awarded the Medal of Honor for his actions at Vicksburg, Mississippi. On May 3, 1863, Hodges and a group of volunteers attempted to run the enemy's batteries with a steam tug and two barges loaded with explosives. A GAR monument is located in the cemetery.

BLOOMFIELD HILLS

Christ Church Cranbrook 470 Church Street / (248) 644-5210

A statue of a beardless Abraham Lincoln stands on the north side of the church, which was built in 1928.

BROOKLYN

Walker Tavern Historic Site 13320 M-50 / (517) 467-4401

Built in 1832, the Walker Tavern is a pre—Civil War building that provided respite to early visitors and settlers traveling to and from Michigan via stagecoach and pioneer wagon. Conveniently located at Cambridge Junction, where the Monroe Pike and Chicago Road met, the tavern thrived until the 1860s, when railroads replaced stagecoaches and wagons as the main mode of transportation.

Massachusetts lawyer, senator and three-time presidential candidate Daniel Webster once stayed here. Early in his political career, Webster viewed slavery as a moral evil. Decades later, he wasn't as resolute in his stance. Webster advocated for preserving the Union but not at the expense of civil war. On March 7, 1850, this great orator delivered a speech in support of the Compromise of 1850. A hotly contested component of this compromise was the Fugitive Slave Law of 1850, which required the federal government to recapture and return runaway slaves. In his speech, Webster deemed abolitionists extremists and accused them of threatening the Union by agitating Southerners. Webster's "Seventh of March" speech enraged abolitionists, who likened him to Lucifer.

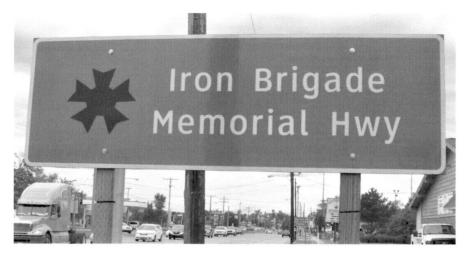

U.S. 12/Michigan Avenue extending from Detroit to New Buffalo is named in honor of the famous Union army's Iron Brigade.

Webster's popularity plummeted after delivering this speech. He never regained the political clout he once held

The Chicago Road, now called U.S. 12, stretches across the lower portion of Michigan between New Buffalo and Detroit. It's also designated as Iron Brigade Memorial Highway.

DEARBORN

The Henry Ford / Lincoln Chair 20900 Oakwood Boulevard / (313) 982-6001

President Lincoln tried desperately to hold the country together during the Civil War. Ultimately, he concluded that ending slavery was the only means to do so. How did Abraham Lincoln come to grips with issues that split the nation? The artifacts, images and interactive panels on display in the With Liberty and Justice for All exhibit at The Henry Ford allows visitors the opportunity to explore Lincoln's background, assess his leadership qualities and understand the evolution of his political views, starting with the highly publicized debates with Stephen Douglas.

One section of the exhibit features reformers, including radical abolitionists, protesting the nation's failure to live up to its foundational principles set forth in the Declaration of Independence with its continued

Southeast Michigan

acceptance of slavery. A rare collection of slavery artifacts featuring a whip, shackles and a neck collar paints a graphic picture of this once acceptable institution.

In another setting, exhibit goers "meet" the people of Pennsylvania involved in the 1851 Christiana Revolt. Here, a slave owner pursuing four runaways was stymied by sympathetic whites and blacks and lost his life in the resulting confrontation. An audio program draws on the writings of Frederick Douglass, illustrating the impact of this influential communicator in shaping the public opinion at the time.

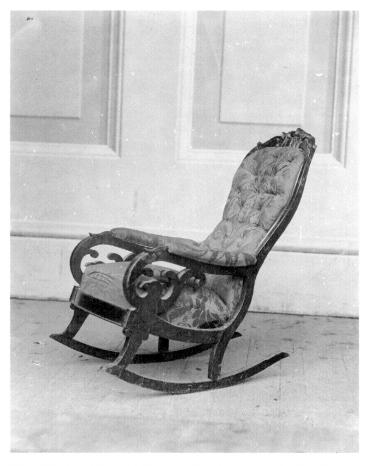

The original chair in which President Lincoln was seated at Ford's Theatre when assassinated by Confederate sympathizer John Wilkes Booth. *Library of Congress*.

President Lincoln's key speech, the Gettysburg Address, is dramatized in a short audio program. Photographs, engravings and lithographs illustrating key battles of the Civil War accompany this exhibit. An original copy of the Thirteenth Amendment, which abolished slavery, bearing Lincoln's signature as well as those of 148 members of Congress, is displayed.

At the center of this exhibit is the actual chair from the Ford's Theatre in which Lincoln was seated when he was assassinated. The chair sits in a special case, along with a theater handbill from the evening's performance. Period mourning items complete the vignette.

With Liberty and Justice for All explores the defining moments of American freedom from the Revolution through the civil rights movement.

Greenfield Village / Logan County Courthouse 20900 Oakwood Boulevard / (313) 982-6001

The Logan County Courthouse at Greenfield Village is the original Pottsville, Illinois building where a young lawyer and rising Whig politician named Abraham Lincoln argued cases before a judge on behalf of his clients.

Other Civil War-era buildings can be found inside the village, including the Susquehanna Plantation, once located in the Tidewater region of Maryland.

Dearborn Historical Museum / Commandant's Quarters 21950 Michigan Avenue / (313) 565-0844

The two main buildings of the Dearborn Historical Museum were part of the United States Detroit Arsenal, an eleven-building, 360-foot-square walled compound. Built in 1833, the Detroit Arsenal was located in what was then called Dearbornville and served as an occasional training and recruiting center during the Civil War.

Today, the museum displays a few artifacts from this era, including the battle flag of the First Michigan Cavalry, Company E, displayed in the basement of the Commandment's Quarters. The First Michigan Cavalry mustered in at Camp Lyon, Hamtramck, under Colonel Thornton Fleming Brodhead and later served with distinction under General George Armstrong Custer.

Color Bearer Sergeant Thomas Henry Sheppard led the First Michigan through several major battles while proudly carrying and protecting its battle

SOUTHEAST MICHIGAN

flag. In total, the flag survived thirteen major battles, over one hundred skirmishes, seventy-two bullet holes and eventual capture.

A front-page article published in the June 12, 1889 edition of the *Detroit Free Press* recounted how the women of Charleston, then located in Virginia, unleashed their fury upon the flag:

It was fresh in color and sound of texture when, by order of Colonel Brodhead it was hung from the window of the Court House at Charleston near Harpers Ferry, but the women of the town made it a target and when, with the movement of the regiment it was taken in, there were five bullet holes to show the feeling of the irreconcilables in petticoats!

At Gettysburg, a member of Confederate general Jeb Stuart's cavalry slashed Sheppard with a saber, causing him to fall from his horse. With injuries to his shoulder and ankle, Sheppard couldn't flee. Knowing he'd be captured, Sheppard ripped the flag from its staff and hid it under his clothes. Miraculously, Sheppard and the flag survived 505 days of imprisonment under the most wretched conditions at Libby Prison, Belle Isle and the infamous Andersonville Prison.

Detroit

Woodmere Cemetery 9400 West Fort Street / (313) 841-0188

Woodmere Cemetery is the final resting place of many Civil War soldiers, notable public figures, business leaders and politicians. Several members of the Fourth Michigan Infantry are buried here. This regiment fought in many major battles as part of the Army of the Potomac and is one of the few to have lost more men in battle than to disease.

Michael Vreeland served in the Fourth Michigan Infantry and was seriously wounded at Gettysburg. He's buried in Lot 370. Vreeland enlisted in 1861 and earned the rank of brigadier general. The Vreeland family played a prominent role in settling an area of southeast Michigan called Downriver, specifically the city of Flat Rock. A major road is named Vreeland after the family.

After noticing Vreeland's grave had endured years of neglect, a group of Fourth Michigan Infantry reenactors restored his monument in 1991

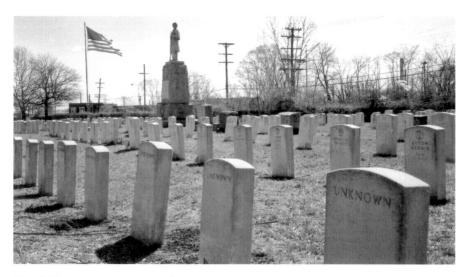

The GAR plot and veterans' section at Woodmere Cemetery in Detroit. Soldiers and their families buried at Fort Wayne were reinterred here.

and added a commemorative plaque that reads: "Gravely wounded in the 'Wheatfield' Gettysburg, Pa. July 2, 1863."

Several members of the Fourth Michigan Cavalry are buried here, too. This regiment is probably best known for being part of the famous Minty's Sabre Brigade and for capturing Jefferson Davis, president of the Confederacy, as he attempted to flee after General Lee surrendered.

Detroit pharmacist James Vernor, creator of Vernors Ginger Ale, belonged to this acclaimed regiment. Vernor enlisted at age nineteen and began his service as a hospital steward. Vernor lost his right eye during one battle and was captured by enemy troops in another. Eventually he was rescued by Union troops.

Jacob Siegel, a successful Detroit merchant and founder of the American Lady Corset Company, is buried in the family mausoleum along with his cousin Benjamin, another prominent Detroit clothier. Jacob Siegel attended the performance of *Our American Cousin* at Ford's Theatre on the same evening President Lincoln was assassinated.

Innkeeper and abolitionist Seymour Finney is buried at Woodmere. See Finney Barn entry for more information.

In 1896, the Woodmere Cemetery board of trustees agreed to provide burial space for soldiers and sold the U.S. government ten thousand square feet of property. From November to December of that year, 156 bodies were

Southeast Michigan

reinterred from Fort Wayne's decaying cemetery to Woodmere. Fort Wayne's cemetery records were in such disarray that 34 of the 156 bodies moved were unknown. A flagpole divides the GAR section on the left from the U.S. Army section on the right. The cemetery offers an eight-page publication entitled Michigan Notables and Civil War Soldiers Buried at Woodmere Cemetery in addition to the book by author Gail D. Herschenzon entitled Detroit's Woodmere Cemetery.

Mount Elliot Cemetery 1701 Mount Elliot Street

Buried here is Medal of Honor recipient Patrick Colbert, a sailor aboard the USS *Commodore* during the capture of Plymouth, North Carolina, on October 31, 1864. As captain of the forward pivot gun, Private Colbert remained at his post, even though he sustained severe injuries, and battled heavy enemy fire until the action subsided.

Historic Fort Wayne 6325 West Jefferson Avenue / (313) 224-6385

Detroit's Historic Fort Wayne is the only American fort still standing with its original star configuration intact. Fort Wayne was built in the

America's First Soft Drink Created by Civil War Veteran

Hires Root Beer and Vernors Ginger Ale both claim to be America's oldest soft drink. Many argue Hires was just another root beer while Vernors was distinctly different from other ginger beers or ginger ales produced at the time. That discrepancy is what gives Vernors the edge as the oldest surviving American soft drink still produced today.

According to local lore, James Vernor began experimenting with a formula for ginger ale while working as a clerk at Detroit's Higby & Sterns Drug Store prior to enlisting in the army. When Vernor joined the Fourth Michigan Cavalry, he left his experimental concoction behind, stored in an barrel. After being discharged from service in July 1865, Vernor returned to Detroit and discovered that the secret ingredients he left behind had aged into a delicious beverage he proudly dubbed Vernors Ginger Ale.

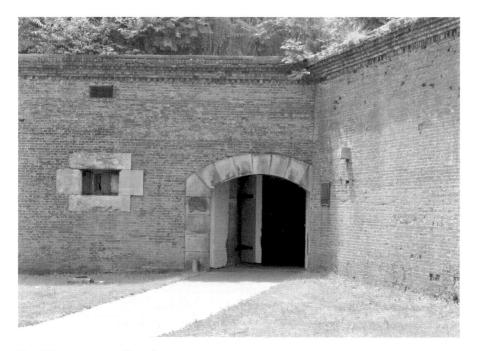

Fort Wayne entrance, Detroit.

Fort Wayne limestone barracks, Detroit.

SOUTHEAST MICHIGAN

1840s as a means to protect the northern border of the United States from British attack. By 1849, the British threat diminished and the fort's importance subsided.

When the Civil War broke out, Fort Wayne became a major recruiting and training station for Michigan troops. Thousands of soldiers passed through as they headed off to battle. The fort underwent massive construction changes during this time. For national security purposes, the original earthen fortifications were replaced by brick and concrete walls.

While the fort was utilized through the Vietnam era and expanded numerous times to meet military needs of the time, Civil War enthusiasts can walk through a portion of the fort that hasn't changed. Built between 1842 and 1849, the Federal-style limestone barracks that housed soldiers during the Civil War still stands. A room has been re-created to depict the cramped conditions enlistees endured. A long list of rules billeting soldiers had to follow back then is posted on the wall.

Montgomery Miegs, who designed Fort Wayne and supervised its construction, later laid the foundation for what is now known as Arlington National Cemetery. As U.S. quartermaster general during the Civil War, Miegs, who was a former West Point classmate of Confederate general Robert E. Lee, proposed the confiscation of two hundred acres from the Lee estate to be used to bury Union casualties of war.

Fort Wayne may have been one of the final stops on the Underground Railroad prior to the Civil War. The fort's location at one of the narrowest parts of the Detroit River would have made it an excellent crossing point, and for many years, the fort was abandoned except for a lone security guard who resided on the property. References have been made in a few escaped slave narratives of departures from a wharf in Springwells Township. The only wharf in the vicinity at the time belonged to Fort Wayne. Sandwich Township, a Canadian community, lies directly across the Detroit River from Fort Wayne. A hotbed of abolitionist activity, Sandwich Township was heavily populated with escaped slaves.

Fort Wayne now belongs to the City of Detroit. The Historic Fort Wayne Coalition was formed by preservation-minded people to help restore the fort and offer quality programming. Visit www.historicfortwaynecoalition. com to learn more about this organization.

Belle Isle / Statue of General Alpheus Starkey Williams Central and Inselruhe Avenues

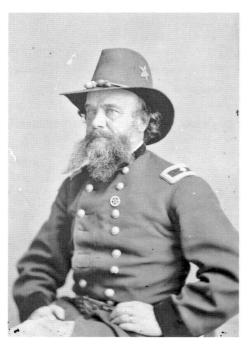

General Alpheus Williams. Library of Congress.

Dubbed Michigan's "citizen general," Alpheus Starkey Williams is considered by many to be the Union's unsung hero due to the lack of recognition of his military accomplishments during and after the war. Little attention was paid to this deserving general who fought bravely for over three years to preserve our nation and end slavery—until 1959, when his memoirs where published in the book From the Canon's Mouth: The Civil War Letters of General Alpheus S. Williams by Wayne State University Press and the Detroit Historical Society. The important chronicling his many contributions was finally told.

Williams served as commander during numerous important battles and was responsible for several

successful assaults and defensive campaigns. Considered one of the best generals to come from our state, many claim the general's lack of political connections and absence of a West Point pedigree to tout are the reasons he never received the accolades he so deserved.

Born in Connecticut, Williams moved to Detroit at the age of twenty-six and served the community as a lawyer, judge, postmaster, alderman, bank president and newspaper publisher and editor. In 1844, he made an unsuccessful bid for mayor of Detroit.

When the Civil War broke out, Williams trained the state's first volunteers. Soon after the South Carolina militia attacked Fort Sumter in the spring of 1861, Governor Austin Blair appointed Williams brigadier general of volunteers in the Union army. In October 1861, he was called into service to lead Michigan troops with the Army of the Potomac.

SOUTHEAST MICHIGAN

Williams and his men saw battle at Cedar Mountain, Antietam, Chancellorsville, Second Winchester and Gettysburg. Williams had served the Army of the Potomac as brigade commander, division commander and corps commander. In 1863, he was transferred to the Army of the Cumberland and served as commander of the First Division of the Twentieth Corps. During the Atlanta Campaign, Williams fought in the battles at Resaca, New Hope Church, Kolb's Farm and Peach Tree Creek and in the siege and capture of Atlanta. Williams was made commander of the Twentieth Corps, the first troops to enter Savannah, in November of 1864. The following January, Williams was brevetted the rank of major general. During the Carolina Campaign, Williams saw battle at Averasboro and Bentonville.

Most statues of generals display triumphant leadership. This statue of General Williams, completed in 1921, portrays him as sad. Perhaps sculptor Henry Merwin Shrady—who designed the Ulysses S. Grant memorial in Washington, D.C.—wanted to convey the difficulties Union leaders and soldiers faced during the early years of the war. Or perhaps he wanted to represent Williams's disappointment for never receiving the public recognition he deserved.

Williams sits astride Plug Ugly, one of two horses he used during the Civil War and his preferred choice for more grueling duty. Williams survived the brutal war uninjured in large part due to Plug Ugly, who was wounded numerous times. At the Battle of Chancellorsville, a Confederate shell landed under Plug Ugly and exploded, sending both Williams and the horse into the air. Miraculously, Williams was uninjured, and Plug Ugly sustained only minor injuries. Plug Ugly accompanied Williams to Gettysburg. He was retired the following year and died shortly thereafter.

General Williams is buried in Elmwood Cemetery.

Belle Isle / Civil War Soldier Monument and Orlando Poe Marker

Central Avenue and Muse Road

A Civil War soldier monument, dedicated to the Grand Army of the Republic, can be found here. Nearby, on Picnic Way, is a marker dedicated to General Orlando M. Poe GAR Post No. 433.

Detroit's First Memorial Day Celebration

History books state Memorial Day, originally designated as Decoration Day, was first celebrated in Detroit in 1869. Detroit's first observance of the holiday actually occurred one year earlier on May 30 at Elmwood Cemetery.

Quickly organized on three days' notice, the ceremony took place opposite the cemetery entrance with national flags and a stuffed eagle forming the background to the speakers and the Fort Wayne Band.

Elmwood Cemetery 1200 Elmwood Avenue / (313) 567-3453

Over six hundred men who served the Union during the Civil War are buried at Elmwood Cemetery, including twenty-eight generals, three Congressional Medal of Honor recipients, seventeen members of the 102nd U.S. Colored Infantry and Colonel Thornton Fleming Brodhead, to whom this book is dedicated.

The city's oldest cemetery is also the final resting place for many antislavery activists such as George DeBaptiste, William Lambert and Dr. Joseph Ferguson, as well as prominent politicians such as U.S. Senators Jacob Merritt Howard and Zachariah Chandler. Some historians claim Senator Chandler's

infamous "blood letter," which was sent to Governor Austin Blair and released nationally, was the real start of the Civil War.

One of the founders of the Republican Party, Jacob Merritt Howard, served Detroit and Michigan as city attorney, state representative and attorney general. A United States senator representing Michigan from 1862 to 1871, Howard fervently voiced his opposition toward the South and believed the Union needed to win the war and reunite the nation.

Howard pressed for the war's conclusion and was active in reconstruction efforts. Howard played a major role drafting the Thirteenth, Fourteenth and Fifteenth Amendments to the U.S. Constitution. The Thirteenth Amendment officially abolishing slavery is inscribed on Howard's obelisk, which reads, "Neither slavery nor involuntary servitude, except as punishment for crime whereof the party shall have been duly convicted, shall exist within the United States, or any place subject to their jurisdiction."

A biography of Howard distributed by Elmwood Cemetery states, "Howard left permanent imprints of his work in the Laws of the United States. Few men,

other than the founding fathers of our country, have had the opportunity to make their beliefs felt on important Amendments to the Federal Constitution."

Another founder of the Republican Party, Zachariah Chandler, was a dry goods merchant whose shrewd investments made him one of the wealthiest men in the state. Chandler served a one-year term as mayor of Detroit, four terms as a United States senator from Michigan and as secretary of interior under President Ulysses S. Grant.

A lifelong opponent to human bondage, Chandler generously provided not only financial support to abolitionist activities but muscle as well. Chandler, once a member of the Whig party, and other well-built local men who shared the same political philosophy often appeared en masse on election days to discourage voter intimidation by

Top: U.S. senator Jacob Howard, principle author of the Thirteenth, Fourteenth and Fifteenth Amendments. The Thirteenth Amendment, outlawing slavery, is inscribed on his obelisk.

Right: U.S. senator Zachariah Chandler's fiery "blood letter" sent to Governor Blair is considered by many to be the real start of the Civil War. Library of Congress.

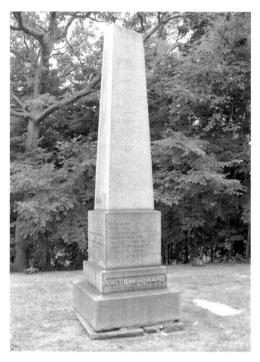

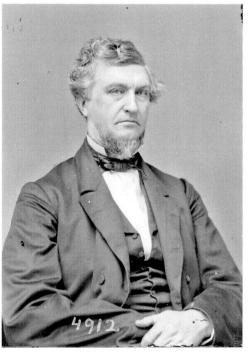

members of opposing parties, especially Democrats, who had a stronghold in the city.

The senator was labeled "radical" for his strident opposition to slavery and vocal denunciation of the 1857 Dred Scott Supreme Court decision that upheld the Fugitive Slave Law. He did not support compromise with the South and openly criticized President Lincoln for not taking stronger action immediately against those states that attempted to secede.

Chandler sent a strongly worded letter to Governor Austin Blair in which he accused the government of doing nothing. He cited how Generals Washington and Jackson quickly quelled rebellions, yet when six states seceded, the government did nothing but attempt to talk. The letter, which circulated nationally, stated, "Without a little bloodletting this Union will not, in my estimate, be worth a rush." Chandler's sentiments infuriated Southern lawmakers.

Chandler and a group of senators witnessed disastrous Union defeat at the First Battle of Bull Run. He quickly criticized General George McDowell for not aggressively pursuing victory on the battlefield.

After the war, Chandler called Lincoln's plan for Reconstruction "soft." Chandler was a driving force behind the campaign to impeach Lincoln's successor, President Andrew Johnson, whom he viewed as "an incompetent willing to sacrifice all the gains made during the war."

A massive headstone and an impressive mausoleum, in remembrance of Civil War soldiers Joseph S. Keen and Russell A. Alger, respectively, flank the main road at the cemetery entrance. The English-born Keen was awarded the Congressional Medal of Honor for carrying and reporting information on enemy troop movements near the Chattahoochee River. A member of the Thirteenth Michigan Infantry, Keen was wounded and captured in 1863 at Chickamauga, Georgia. He was confined to Confederate prisons at Richmond, Danville and Andersonville before escaping. As he fled, Keen observed the movement of General Hood's forces crossing the Chattahoochee River in an attempt to flank General Sherman's army in the rear. A daring Keen made his way through Confederate encampments on his way to Union lines where he reported this vital information.

Born in Ohio, General Russell A. Alger played a prominent role in Michigan history. In 1884, he was elected as the twentieth governor of Michigan and later served the state as a United States senator. During President McKinley's administration, General Alger was appointed secretary of war.

SOUTHEAST MICHIGAN

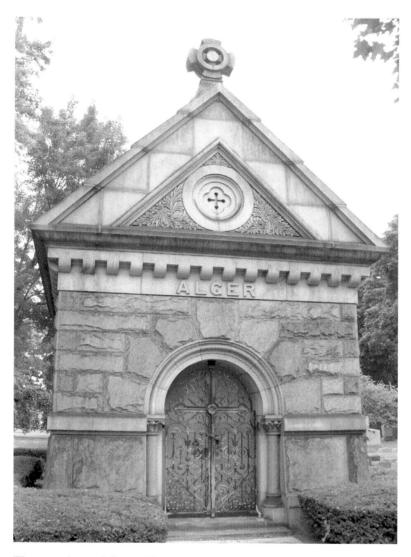

The mausoleum of General Russell Alger at Elmwood Cemetery, Detroit.

Alger enlisted in the Second Michigan Cavalry at the outbreak of the Civil War and was appointed captain of Company C. His later commissions included major in the Second Michigan, lieutenant colonel in the Sixth Michigan Cavalry and colonel in the Fifth Michigan Cavalry.

Wounded four times during the war, Alger participated in over sixty battles and skirmishes including Booneville, Mississippi; Gettysburg,

Pennsylvania; and the 1864 Shenandoah Valley Campaign, Virginia. At the Battle of Booneville on July 11, 1862, Alger was wounded and captured by the enemy but managed to escape the same day.

At the war's end, he was brevetted to the rank of brigadier general followed by major general. In 1889, General Alger was elected commander-in-chief of the Grand Army of the Republic. In this role, he helped improve pensions for Civil War veterans.

Lewis Cass, one of Michigan's most influential political figures, is buried at Elmwood Cemetery. He served as the second territorial governor and as a U.S. senator representing Michigan. In 1848, Cass lost a bid for president. Appointed secretary of state under President James Buchanan, he resigned from this position amidst frustration over the president's failure to protect federal interests in the South and lack of federal military action that may have prevented secession.

Thomas R. Williams, who attained rank of brigadier general of U.S. Volunteers, is buried in the family plot. He's the son of John R. Williams, a prominent military figure and Detroit's first mayor who served the city in this capacity for five terms.

The younger Williams's lengthy military career ended when he was shot in the chest at the Battle of Baton Rouge, Louisiana, on August 5, 1862, as he and troops under his command defended Louisiana's capital city from Confederate recapture. Numerous references are made about Thomas Williams in *A Confederate Girl's Diary*, a popular memoir written by Sarah Morgan Dawson.

Of special interest is the grave of Brevet Major General Philip St. George Cooke. Cooke serves as a reminder of how the Civil War divided not only the nation but families as well. This Virginian and career military man was the father of the Confederate brigadier general John Rogers Cooke, father-in-law of Confederate cavalry leader Jeb Stuart and uncle of author John Esten Cooke, who also served in the Confederate army. General Cooke chose to stay and serve the Union rather than fight with the Confederacy.

"I owe Virginia little, my country much, I shall remain under the flag as it waves the sign of National Constitutional Government," said Cooke.

Others with Confederate ties buried at Elmwood include Winifred Lee Brent Lyster and Emma Read Berry. Lyster, author of our state song, "Michigan, My Michigan," was the second cousin of Robert E. Lee. Berry served as an aide to President Jefferson Davis and assistant secretary of the treasury of the Confederacy.

Elmwood Cemetery features a Civil War memorial lot purchased by the State of Michigan in 1874 to be used exclusively for the internment of deceased

General Thomas Williams's gravestone reads: "In Battle and Victory. A Christian, he sleeps in the hope of the blessed redeemer."

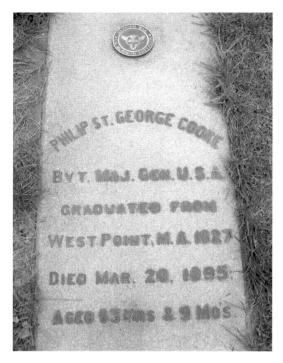

General Philip St. George Cooke, father-in-law to Confederate cavalry leader Jeb Stuart, remained loyal to the Union. He is buried at Elmwood Cemetery, Detroit.

Michigan soldiers and sailors who served in this war. This section contains the remains of 205 officers and men who fought in the Civil War and is one of the few places where the flag is flown both day and night in tribute to those patriots.

The names of those buried at Elmwood Cemetery with ties to the Civil War are too numerous to list here. You'll find Brigadier General Cyrus O. Loomis, of the famed Loomis Battery A of the Michigan Light Artillery; Frank Robinson, the drummer boy for the 102nd United States Colored Troops (First Michigan Colored Infantry); Julian Dickenson, captain of the Fourth Michigan Cavalry, the regiment responsible capturing Confederate for

president Jefferson Davis; and Jane Tinsdale, Civil War nurse.

All the stories of these deserving people need to be told, so take the time to fully explore this historic cemetery. Available for sale at the cemetery office are books and maps, including *Elmwood Endures: History of a Detroit Cemetery* by Michael S. Franck.

Camp Backus Opposite Elmwood Cemetery Entrance

Built in 1862, Camp Backus was a new cantonment used for recruiting, replacement and discharge. Originally, barracks for ten thousand men were erected. Shortly after the war, the fort was torn down. Nothing exists today to indicate a fort stood there.

Camp Ward / First Michigan Colored Regiment Marker Ralph J. Bunche Elementary and Middle School / 2715 Macomb Street

Initially, the United States government rejected offers by black men to fight on behalf of the Union. During the second year of war, opinion changed when the army needed more manpower.

When President Lincoln issued the Emancipation Proclamation (September 1862)—an executive order freeing all slaves in the Confederate States of America that did not return to Union control by a specified date—the door opened allowing black men to serve in the army. Many Northern states moved quickly to organize black troops, and many Michigan men left to join these regiments.

Henry Barns, editor of the *Detroit Advertiser and Tribune*, petitioned to organize a regiment in Michigan. Barns became colonel of the First Michigan Colored Infantry in August 1862 after Governor Austin Blair received permission to organize a black regiment.

On February 23, 1863, the First Michigan Colored Infantry organized at Camp Ward, a farm located where Ralph J. Bunche Elementary and Middle School now stands. Volunteering for the regiment were 845 men from Detroit, southern Michigan and Ontario, Canada. Some were escaped slaves, some fought to free family members still enslaved and others fought to ensure the rights enjoyed by Americans were granted to all.

Black soldiers served under white officers and received less pay than their white counterparts. They also endured inferior conditions. A report claimed the Camp Ward barracks were unfit for human habitation and stated better conditions could be found in any Detroit barn or pigsty. The regiment left this camp on March 28, 1864.

Freed slave Sojourner Truth resided in Battle Creek and traveled throughout Michigan and other Northern states speaking out against slavery and promoting equal rights for women. In 1863, she organized a food drive in Battle Creek for the soldiers stationed at Camp Ward.

When the state of Michigan transferred control of the regiment to the federal government, the First Michigan became part of the 102nd U.S. Colored Infantry. A state historic marker commemorating the First Michigan Colored Infantry can be found at this site.

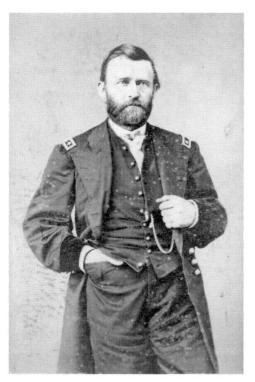

Portrait of Ulysses S. Grant, general-in-chief of the Armies of the United States. *Library of Congress*.

Detroit Barracks 1395 Antietam Street (Gratiot and Russell area)

A bronze tablet identifying this site as the Detroit Barracks once hung on the outside wall of the Leland School that once stood here. The marker was placed there in 1925 by Daughters of the Grand Army of the Republic.

Lieutenant Ulysses S. Grant, who went on to become the overall commander of the Union army, was stationed at the Detroit Barracks from 1849 to 1851. During the Civil War, the Detroit Barracks served as a training ground.

In the summer of 1862, the Seventeenth Michigan Volunteer Infantry organized here under the command of Colonel William H. Withington. The regiment was made up primarily

Detroit Lawyer Earns Medal of Honor

Major General Orlando B. Willcox, who is buried in Arlington National Cemetery, was from Detroit, where he practiced law prior to the Civil War. A West Point graduate, General Willcox commanded the First Michigan Infantry, the first Western regiment to arrive in Washington, D.C., following President Lincoln's plea for troops. Captured during the First Battle of Bull Run, General Willcox was sent to a Confederate prison and later released during a prisoner exchange. He received the

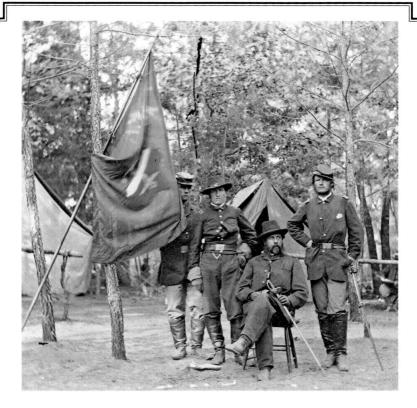

General Orlando Willcox and his staff. Library of Congress.

Medal of Honor for his actions at the First Bull Run. General Willcox advanced to brigade, division and corps commander and remained in the army after the Civil War.

of men from south-central Michigan. One company was made up almost entirely of students from Ypsilanti Normal School, now known as Eastern Michigan University. This regiment left Michigan on August 27, 1862, and earned the nicknamed "Stonewall Regiment" for the bravery exhibited at South Mountain during the Maryland Campaign just a few short weeks after leaving Detroit.

The fighting began early on September 14, and the Seventeenth held its position for hours. At 4:00 p.m., Union commanders gave orders for an assault.

The Confederates came out of the woods and positioned themselves along the crest of the hill before retreating behind a lengthy stone wall. In the midst of heavy fire, the Seventeenth advanced, overtaking the Confederates at the stone wall.

More Medals of Honors (eight) were awarded to members of the Seventeenth Michigan Infantry than any other Michigan regiment. Company B, Fortyseventh Ohio, composed of Michigan men, also earned eight medals.

Campus Martius Park Woodward and Michigan Avenues

Campus Martius, a popular urban park and gathering space, is the site of the state's foremost Civil War soldiers and sailors monument. Designed by American sculptor Randolph Rogers, it's one of Detroit's oldest pieces of public art and one of the first national monuments to honor Civil War veterans.

In 1865, former governor Austin Blair established an association to collect funds so that a monument dedicated to Michigan soldiers and sailors killed during the Civil War could be erected. Detroit, the state's largest city, won the right to display this tribute.

Made of granite and bronze, the sixty-foot-tall classical revival monument features medallion portraits of President Lincoln, Generals Grant and Sherman and Admiral Farragut along with four statues representing the four branches of the United States military: infantry, cavalry, artillery and navy.

Four female figures resting on pedestals above the male figures represent victory, union, emancipation and history. While no proof exists to support this belief, some claim renowned African American abolitionist and women's rights advocate Sojourner Truth served as Roger's inspiration behind the statue depicting emancipation.

A female figure, personifying a victorious Michigan, crowns the monument. Wearing a winged helmet and brandishing a sword and shield, the 3,800-pound statue depicts Michigan as strong, proud and brave. An inscription below this figure reads, "Erected by the people of Michigan in honor of the martyrs who fell and the heroes who fought in defense of liberty of union."

The monument was unveiled in April 1872 at a ceremony attended by throngs of people. In fact, the city could barely accommodate all who turned out. Civil War generals in attendance included George Armstrong Custer, Ambrose Burnside, Philip Sheridan, and Thomas J. Wood.

SOUTHEAST MICHIGAN

The 1914 GAR National Encampment parade through Campus Martius, Detroit. Library of Congress.

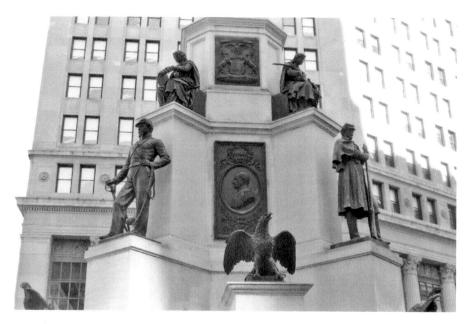

A section of the Michigan soldiers and sailors monument at Campus Martius in Detroit depicting men in the Civil War infantry, cavalry, artillery and navy.

The First Michigan Infantry—the first western regiment to arrive in Washington, D.C.—received its colors in a ceremony at Campus Martius attended by nearly all the citizens of Detroit. Following President Lincoln's assassination, a memorial mass meeting was held here and consisted of the largest assemblage of people in Detroit up to that time.

A two-sided plaque dedicated to the Twenty-fourth Michigan Infantry and Iron Brigade can be found at Campus Martius. The Twenty-fourth Michigan is known as the regiment "born of a riot."

In July 1862, recruiting efforts were underway at Campus Martius to raise a new regiment called the Twenty-third Michigan. Recruiting events were huge social affairs designed to invoke patriotism and get men to sign up on the spot. These events included guest speakers, military bands and patriotic decorations.

Confederate supporters disguised as locals were brought in from Canada and planted among the crowd. Their job was to spark dissent. Others mistakenly believed a draft was being imposed and began protesting. The celebration quickly turned into a riot.

The embarrassing incident not only tarnished the recruiting effort but also called into question the patriotism of Detroit, Wayne County and Michigan. Within a few days and without incident, a new regiment, the Twenty-fourth Michigan Infantry, was raised.

The Twenty-fourth Michigan, part of the famed Iron Brigade, opened the Battle of Gettysburg on July 1, 1863, and was almost destroyed while holding off Confederate advances until Union forces could get into position. It suffered the loss of nine color bearers and experienced the highest causality

Confederate Sympathizer and Legendary Lady Outlaw Becomes Detroit Jailbird

During the Civil War, teenager Belle Shirley reported the positions of Union troops to the Confederacy. Her brother, Bud, and childhood friend Cole Younger, along with Frank and Jesse James, fought for the Confederacy as part of William C. Quantrill's guerrillas. Belle Shirley later became the legendary outlaw Belle Starr and served a brief prison stint in the Detroit House of Correction.

rate—80 percent (dead, wounded and missing)—of any regiment in the battle.

The Twenty-fourth was called on to escort the funeral procession of slain President Lincoln. U.S. 12/Michigan Avenue, extending from Woodward Avenue and across the state, is named the Iron Brigade Memorial Highway in memory of its service.

Race Riot of 1863

Area between Monroe and Beaubien Streets, Lafayette Boulevard and Congress Street

"The bloodiest day that ever dawned upon Detroit" is how a local newspaper described the events of March 6, 1863, as a mob of angry white men swept through

the streets of this predominantly black section of town and set homes and businesses on fire and stoned and beat the residents. One man died as a result of the riot. An unsubstantiated account circulated at the time described how an infant was thrown to the ground and almost beaten to death after being wrenched from its mother's arms. Fearing for their lives, many black residents who had enjoyed a modicum of freedom in Detroit up to this point fled to Canada.

City officials responded slowly to the crisis. Order wasn't restored until late evening when Federal troops from nearby Fort Wayne and Ypsilanti finally arrived. By then, serious damage from fire, looting and vandalism had already occurred.

What caused this riot? A rape accusation of a local tavern keeper, who, until the time of the accusation, was believed to be white, ignited deeprooted prejudices. The previous month, two girls—one white and one black—accused William Faulkner of rape. Faulkner claimed Spanish-Indian heritage, and public records indicated he was a registered voter. Both local newspapers, however, consistently reported him as "Negro." The nature of the crime, coupled with a white victim and black perpetrator, incensed many in the white community.

When Faulkner's trial began on March 5, an angry crowd gathered outside the courthouse to await the verdict. They pummeled Faulkner with stones as he was escorted back to jail. The next day, an even larger crowd assembled. Anger permeated the air, and any blacks passing through risked verbal and physical abuse.

Found guilty and sentenced to life in prison, Faulkner was showered with bricks and stones as he and the guards made their way back to jail. Guards tried to quell the angry mob by firing a round of blanks into the crowd. They followed with a round of bullets and accidentally killed an innocent bystander.

A white man killed at the expense of a Negro? The crowd went crazy and descended on a nearby house occupied by a black family, terrorizing them with fire and rocks. The ugly scene quickly escalated, and violence spread throughout the area.

After the riot, the *Detroit Advertiser and Tribune*, considered then to be a radical-leaning Republican publication, labeled the mob a "*Free Press* mob" and accused the Democratic-leaning newspaper of inciting the riot by intending to "excite the ignorant and prejudiced against the negro [*sic*] primarily, and secondarily against the Republicans."

Years later, the two girls recanted their accusation and Faulkner's guilty sentence was reversed.

Detroit Historical Museum 5401 Woodward Avenue / (313) 833-1805

The Doorway to Freedom: Detroit and the Underground Railroad exhibit is fairly new and tells how slavery began in the United States. It then focuses on the unique stories of freedom seekers who made the journey through Detroit to Canada and the local Underground Railroad stationmasters who helped them on this final leg of the journey. Of particular interest are the narratives describing what became of the people who remained in Detroit as well as those who settled in Canada.

Detroit Public Library / Burton Historical Collection 5201 Woodward Avenue / (313) 833-1000

A Civil War picture album of the Third Michigan Cavalry is located within the Detroit Public Library's Burton Historical Collection. It consists of seventy-four cartes de visite photographs of regimental members taken between 1861 and 1864. Cartes de visite or calling cards used from 1860 to 1890 became popular collectables during the Civil War. Digital reproductions of all photographs have been made and are available for viewing.

The library also houses many interesting documents pertinent to this era. The Lincoln Collection features letters and Civil War commission appointments, among other things. Of special interest are telegrams sent to Michigan governor Austin Blair by President Lincoln. One telegram requesting more troops sent July 3, 1862, states, "The quicker you send the fewer you will have to send—time is everything—please act in view of this."

Another document signed by President Lincoln dated January 4, 1865, allows "Miss Cloud to pass Union lines 'with ordinary baggage' to return home to Virginia." And a letter dated October 15, 1860, was sent to Lincoln as he campaigned for president by eleven-year-old Grace Bedell of Westfield, New York, advising him to cover his thin face with whiskers. Grace wrote, "All the ladies like whiskers and they would tease their husbands to vote for you and then you would be President."

The forty-six-volume set of the Record of Service of Michigan Volunteers is available in the library Reading Room. For a fee, visitors can access materials in storage such as the Roster of Union Soldiers and Roster of Confederate Soldiers.

The Hackley Collection features sheet music published between 1799 and 1922. Song themes cover early nineteenth-century plantation life and the

SOUTHEAST MICHIGAN

Civil War era. Period songs composed by African American musicians are included in this collection.

Hart Plaza / Confederates Board Local Steamer Woodward and Jefferson Avenues

No marker denotes the spot, but the riverfront dock was once located near the foot of Woodward, now Hart Plaza. On September 19, 1864, John Yates Beall, a veteran Confederate blockade runner, and twenty co-conspirators out of Canada boarded the packet steamer *Philo Parsons* at its dock near the foot of Woodward. They dressed as ordinary citizens as to not rouse suspicion. The *Philo Parsons* traveled regularly between Detroit and Sandusky, making stops along the way in Sandwich and Amherstburg, Ontario, as well as Put-in-Bay and other Lake Erie islands.

At the Canadian stops, more Southern agents boarded, again disguised as ordinary passengers. While Canada, known then as British North America, remained neutral and opposed slavery, political sympathies leaned to the South, making it easier for Confederate conspirators to devise and launch attacks against the Union from there.

When the steamer entered Lake Erie, agents produced weapons and seized control of the vessel. Their goal was to capture the USS *Michigan*, a warship guarding Lake Erie, and the Confederate officers' prison located on Johnson's Island. Their plan then was to release thousands of Confederate prisoners held on the island. Federal counterspies learned of the plan and alerted the captain of the USS *Michigan*, thereby thwarting this bold attempt to free Confederate prisoners of war.

Lincoln Bust

This monument by Gutzon Borglum, sculptor of Mount Rushmore, can be found among the many monuments at Hart Plaza and plays tribute to President Lincoln, the sixteenth president of the United States. Mr. Borglum created the six-ton marble Lincoln head originally exhibited at the White House during the presidency of Theodore Roosevelt that now stands in the Capitol Rotunda in Washington, D.C. Grandiose displays of heroic nationalism and patriotism sweeping the nation at the time appealed to Borglum's artistic sensibilities. He was commissioned to create the statue

dedicated to General Philip Sheridan that stands prominently in Washington, D.C.'s Sheridan Circle.

Borglum was originally commissioned to create a memorial dedicated to the heroes of the Confederacy at Stone Mountain, Georgia. A disagreement with the commissioning organization resulted in Borglum's abrupt dismissal. While Borglum destroyed the models he created for this project, the final Stone Mountain memorial includes major elements the artist proposed.

Gateway to Freedom Underground Railroad Monument

This international memorial to the Underground Railroad is an impressive work by sculptor Ed Dwight. The bronze-and-granite sculpture is dedicated to the enslaved people who escaped the shackles of bondage and traversed this secretive and treacherous trail in search of freedom and to those who helped them in their flight. Fittingly, the monument depicts the tireless local antislavery advocate and an organizer of the First Michigan Colored Regiment, George DeBaptiste, pointing to freedom across the river to a

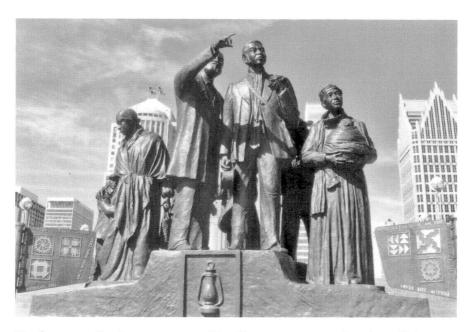

The Gateway to Freedom monument at Hart Plaza commemorates Detroit's UGRR history. Conductor George DeBaptiste points across Detroit River to freedom in Canada.

family of freedom seekers gathered around him. Perched symbolically at the edge of the Detroit River, the Gateway to Freedom monument represents the final steps to freedom.

Across the river in Windsor, Ontario (Canada), the Tower of Freedom stands representing the end of a long, dangerous struggle for freedom and a new beginning. The Tower of Freedom depicts a Quaker woman greeting two emancipated people.

Masonic Temple 500 Temple Street / (313) 832-7100

On display is a rare portrait of General Ulysses S. Grant painted by Emmanuel Leutz. The painting is one of only a few that show him seated instead of standing.

Mariners' Church 170 East Jefferson Avenue / (313) 259-2206

Mariners' Church history indicates it served as a station on the Underground Railroad. Organized in 1842 to meet the spiritual needs of the growing population of sailors and the greater community, the current stone structure of Mariners' Church was consecrated in 1849 and originally located nine hundred feet west on Woodward Avenue, which at the time, extended to the river. The church's proximity to the Detroit River and its mission of including marginalized people such as sailors lend credence to the congregation's claim that basement tunnels were used to lead former slaves to the waterfront and on to freedom. In 1955, the tunnels were exposed when the church was moved to its current location.

Little Rock Missionary Baptist Church 9000 Woodward Avenue / (313) 872-2900

This gorgeous Gothic-style church built in 1928 and designed by George Mason features a beautiful stained-glass window of President Abraham Lincoln holding the Emancipation Proclamation. Another window that was part of the initial construction pays tribute to our nation's first president, George Washington. Both windows were designed by A.K. Herbert.

The former Central Woodward Christian Church became Little Rock Missionary Baptist Church in 1978 when the building was sold to the new congregation. The new congregation installed more magnificent stained-glass windows that pay tribute to Dr. Martin Luther King Jr., as well as representing the social gospel and several prominent preachers, and nine of the new eighteen-foot windows depict the Stations of the Cross.

Grand Army of the Republic Building 1942 Grand River Avenue

Designed by architect Julian Hess, the GAR Building is one of the oldest buildings in Detroit. Construction began in 1887 and was completed in 1890. Built for the Detroit members of the Grand Army of the Republic, the building, dubbed "the castle" because of its turreted architecture, originally featured thirteen retail shops and a bank on the ground floor, office space on the second and third floors and a small auditorium on the fourth floor. GAR members gathered here for recreational purposes and official GAR business.

By the 1930s, GAR membership had aged and died off so the building was no longer needed to serve its original purpose. Ownership reverted to the city of Detroit who had supplied part of the initial construction funds. Vacancy plagued the building throughout the twentieth century, and it was last used as a recreation center in the 1980s before it was boarded up again. On February 13, 1986, the building was added to the National Register of Historic Places.

In November 2011, the owners of Mindfield, a local media production company, purchased the building, and extensive renovations to this grand building are still underway as of publication. When construction is completed, Mindfield will move its headquarters into the building. Additional office space will be available for lease and two restaurants will occupy the main floor. Plans also include a museum dedicated to Civil War veterans. Two of the Mindfield principals, Tom and David Carleton, are descendants of Civil War veterans.

Charles H. Wright Museum of African American History 315 East Warren Avenue / (313) 494-5800

Exhibits tell the story of African American history beginning with prehistoric Africa to ancient and modern cultures that evolved on the continent. The

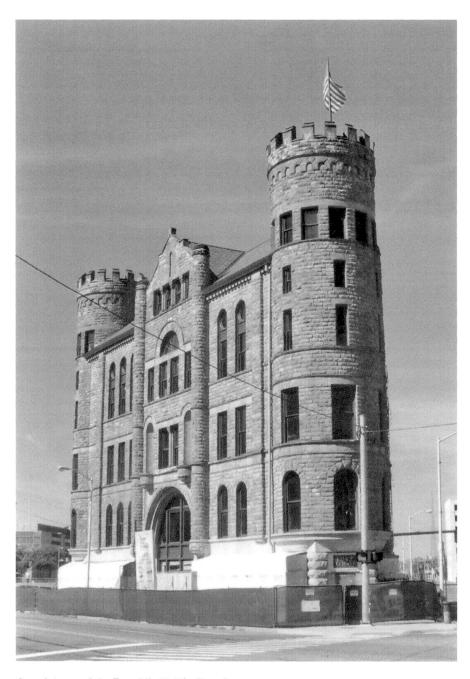

Grand Army of the Republic Hall in Detroit.

journey continues across the Atlantic Ocean with exhibits depicting the horrors of bondage, the harrowing escape to freedom via the Underground Railroad and the fight for equality and emancipation.

Exhibits pay tribute to famous African Americans such as Frederick Douglass and Sojourner Truth, who played major roles in the fight for freedom, as well as the efforts of everyday men and women who built families, businesses, educational institutions, spiritual traditions, civic organizations and a legacy of freedom and justice in past and present-day Detroit.

William Webb House Marker

North side of Congress Street near St. Antoine Street / house no longer exists

William Webb was a prominent black leader and abolitionist whose Detroit home served as a regular location for political meetings. In March 1859, two influential abolitionists on the national stage happened to be in town at the same time. Whether by coincidence or by design, both ended up at the Webb house. A radical plan revealed by one of the two prominent guests that evening is considered by many to be the real start of the Civil War.

A former slave born to a slave mother and white man, Frederick Douglass was a renowned author, editor and eloquent speaker who gave moving speeches on the evils of slavery. After delivering a rousing lecture at Second Baptist Church, Douglass was invited to the Webb house to meet with local abolitionists and continue the discussion.

John Brown, the outspoken and radical white abolitionist who promoted armed insurrection as a means to free slaves, also stopped by the Webb house after delivering fifteen escaped slaves—including one who had been born en route—to conductors of the Underground Railroad for safe transfer to Canada.

At this gathering, Brown revealed his plan to seize the federal arsenal at Harpers Ferry. Although Douglass believed the plan was flawed and warned Brown he'd never get out alive, Brown received financial support from several guests before moving on to Ontario, Canada where he recruited a small band of followers.

On October 16, Brown and his followers, two of whom were his sons, captured the arsenal and took sixty prominent citizens hostage, hoping their slaves would rise up and join the fight. No slaves came forth.

Instead, the local militia cornered Brown and his men, killing eight of the twenty-two-man army. Federal troops under the leadership of U.S. Army

colonel Robert E. Lee were dispatched to quell the uprising. Ten of Brown's men were killed and five escaped. An injured Brown was taken captive and tried, sentenced and executed.

The trial of John Brown was major news and caught the attention of the nation. The statements delivered by Brown during the trial and prior to his execution swayed public opinion in favor of abolishing slavery. To many, Brown became a martyr for the cause. Brown's martyrdom infuriated most southerners who viewed him as a zealot and cold-hearted killer. It further exemplified the deep chasm that had grown between northern and southern ideology. With such radically different views, it was apparent any compromise was futile. Therefore, it has been said that the raid and Brown's subsequent execution served to magnify political differences in ideology and ultimately hastened the start of the Civil War.

A historic marker at 633 East Congress Street identifies the site of the William Webb house and John Brown, Frederick Douglass meeting spot.

Finney Barn Site Northeast corner of State Street and Griswold Avenue

Seymour Finney, a tailor by trade, is most remembered in Detroit history as a station master on the Underground Railroad. Between 1850 and 1861, Finney was proprietor of the Finney Hotel, an inn that stood on the southeast corner of Woodward and Gratiot Avenues. In later years, this corner would be the site of the popular Kern's department store. In 1966, the building that housed the once popular department store was

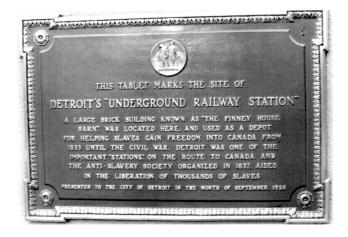

This plaque denotes the former site of Finney Barn, a hiding place for runaway slaves owned by innkeeper and abolitionist Seymour Finney in Detroit.

demolished. The recognizable Kern's clock still stands and marks the spot today.

Finney provided freedom seekers refuge in the hotel's nearby livery barn, located a block away at the northeast corner of State and Griswold, across the street from the site of Michigan's first state capitol. It was common knowledge among local abolitionists that Finney would ply Kentucky slave catchers with liquor at the inn and get them drunk while secretly housing the fugitive slaves they were seeking in his barn.

A plaque presented to the city of Detroit in 1926 marks the location of the former stable and station on the Underground Railroad. The plaque proclaims that the Detroit Anti-Slavery Society, organized in 1837, liberated thousands of slaves. A historic marker can also be found across the street in Capitol Park. Seymour Finney is buried in Woodmere Cemetery.

Second Baptist Church / Underground Railroad Reading Station and Bookstore 44I–46I Monroe Street / (313) 961-0325

Visit the Second Baptist Church's Connection to Freedom and take a historical ride aboard a train that traveled without tracks. Sit in the Crogan Street Station and hear the story of oppressed people escaping slavery who rested in secret at Second Baptist Church before crossing the Detroit River to Canada on the *T. Whitney*, a boat belonging to church member George DeBaptiste.

Founded by thirteen former enslaved Christians in 1836, the church served as the Crogan Street Station, a vital link in the complex and secret national network known as the Underground Railroad. In direct violation of federal and state laws, Second Baptist's first pastor, William C. Monroe, not only aided and abetted runaway slaves, but he also taught them to read. The mission of the early church was not only to offer refuge to freedom seekers but also to fight for emancipation and citizenship for all people of color.

The church offers tours by appointment, and the bookstore sells merchandise related to African and African American history.

George DeBaptiste Home Marker

Southwest corner of East Larned and Beaubien Streets / home no longer exists

A famous Michigan stockholder, black businessman and member of the Second Baptist Church of Detroit, George DeBaptiste claimed to have personally assisted 108 fugitive slaves escape to freedom before coming to Michigan in 1846. His trading business enabled him to travel via steamboat between cities, giving him the perfect opportunity to hide fugitive slaves aboard. DeBaptiste also worked as a personal valet to General William Henry Harrison during his presidential campaign and then accompanied him to the White House as a steward.

In Detroit, DeBaptiste was active in the Underground Railroad and antislavery activities. He served as a delegate to the Cleveland National Convention of Colored Citizens and as an agent for the Freedom's Aid Commission. During the Civil War, he helped organize the First Michigan Colored Regiment. A historical marker identifies the spot where DeBaptiste's house once stood.

William Lambert Home Site

Northeast corner of East Larned and St. Aubin Streets / home no longer exists

William Lambert, a tailor by trade and successful businessman, served as the manager and treasurer of the Detroit Terminal of the Underground Railroad and headed the Detroit Vigilance Committee.

Considered to be the city's leading black abolitionist at the time, Lambert was present at the 1859 meeting between John Brown and Frederick Douglass at William Webb's house. Lambert even made a financial contribution toward Brown's plan of raiding Harpers Ferry. Lambert organized the first State Convention of Colored Citizens and urged blacks to participate directly in their struggle for freedom and equality.

Historic First Congregational Church of Detroit 33 East Forest Avenue / (313) 831-4080

Established in 1844, the first two churches were located at Fort and Wayne Streets. The basement of the second church hid refugees of the Underground Railroad

as they awaited passage across the Detroit River to freedom in Canada. The current church offers the Living Museum's Underground Railroad Flight to Freedom, an experiential tour that draws on storytelling and simulation to re-create the harsh journey enslaved people faced on their way to freedom. Public and private tours are available daily. Contact the church for full details.

Grand Circus Park Woodward and East Adams Avenues

In this semicircle-shaped park flanking both sides of Woodward, you'll find several interesting statues. One prominent statue immortalizes Hazen S. Pingree, a four-term mayor of Detroit and Michigan's twenty-fourth governor. With his likeness depicted seated in a chair above the words "Idol of the People," this revered citizen was a veteran of the Civil War who served in the First Massachusetts Heavy Artillery where he was captured and confined to several different Confederate prisons including Andersonville.

During General Sherman's "March to the Sea," Pingree was transferred to a prison in Millen, Georgia, from which he escaped during roll call after pretending to be someone else. Pingree was witness to General Lee's surrender at Appomattox Court House in Virginia on April 9, 1865.

The fountain at Grand Circus Park pays tribute to General Russell A. Alger (see Elmwood Cemetery entry).

Grant House

Eight Mile Road and Woodward Avenue / former Michigan State Fair Grounds

General Grant's first of two Detroit homes is located here. He resided in Detroit from 1849 to 1851, when as a lieutenant he was stationed at the Detroit Barracks. The home was originally located at 253 East Fort Street between Russell and Rivard. The home is now boarded up and its fate unknown. Grant's second home was located on the northeast corner of Jefferson and Rivard. A motel occupies the site today.

Lieutenant U.S. Grant's Detroit home, now located at the former Michigan State Fairgrounds, *Library of Congress*.

Skillman Branch of the Detroit Public Library 121 Gratiot Avenue / (313) 481-1850

A statue of President Abraham Lincoln holding a copy of the Thirteenth Amendment is located here. The base of this reproduction of the Alfonso Pelzer statue once located on the vast grounds of the Lincoln automotive plant at Warren and Livernois Avenues proclaims: "Let Men be Free."

Old Fairgrounds Woodward and Canfield Avenues

This is the site of the old fairgrounds where the Twenty-fourth Michigan Infantry trained.

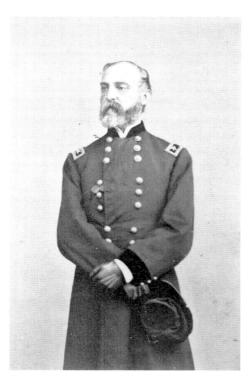

General George Meade, victor of Gettysburg, resided in Detroit prior to the Civil War. Library of Congress.

Harper Hospital Woodward Avenue and Martin Place

Now part of the Detroit Medical Center, Harper Hospital first stood at Woodward and Martin Place. The hospital opened in 1864 to care for those wounded in the Civil War.

> George Meade Residence Site Bagley Avenue and Clifford Street

Captain George Gordon Meade, victorious Union commander at Gettysburg, resided in Detroit from 1857 to 1861 while he oversaw the Corp of Engineers Great Lakes topographical survey. He resided at 3 Aspinall

Hero of Gettysburg

When Captain George Gordon Meade received his appointment to brigadier general of volunteers in 1861, he was stationed in Detroit, having been in command of the United States Lake survey for five years. He was very successful in mapping the Great Lakes, which included Huron, Saginaw Bay and the northeastern end of Lake Michigan. The task included mapping the lake shores and navigation hazards, charting the lake bottoms for hidden dangers, mapping possible ship channels, determining possible sites for harbors and improvements to current harbors.

Terrace, which was located at the corner of Bagley and Clifford. The building no longer exists. See sidebar for more on Meade's Michigan stay.

Camp Lyon

Jefferson Avenue near Van Dyke Road

The First Michigan Cavalry trained here at an old horseracing track from August to September 1861. The camp was named after General Nathaniel Lyon who was killed at the battle of Wilson's Creek.

Camp Banks

Jefferson and Mount Elliot Avenues

The Fifth Michigan Cavalry trained at Camp Banks during the summer of 1862.

DEXTER

Forest Lawn Cemetery 8000 Grand Street

The grave of Colonel Harrison H. Jeffords, commander of the Fourth Michigan Volunteer Infantry, can be found here. Jeffords was mortally wounded in the area known as the Wheatfield on July 2, 1863, during the second day of the Battle of Gettysburg as he tried to retrieve the regiment's flag, which he vowed to protect. Colonel Jeffords was the highest ranking officer to die by bayonet.

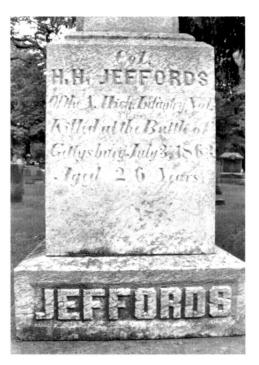

The grave of Colonel Harrison Jeffords, Fourth Michigan Infantry, at Forest Lawn Cemetery in Dexter.

Monument Park Baker Road at Main Street

A statue of a Civil War soldier at parade rest stands guard in this park situated in the center of downtown Dexter.

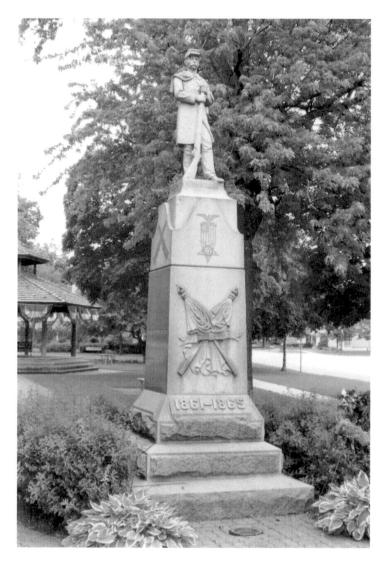

Dexter Civil War soldier statue at Monument Park.

Dexter Area Historical Museum 3443 Inverness Street / (734) 426-2519

Civil War artifacts relating to local history are displayed here.

Gordon Hall 8341 Island Lake Road / (734) 426-2519

A historic landmark, this Greek- and Antebellum-style home was built in the early 1840s for village founder Samuel W. Dexter. The home may have been used as a stop on the Underground Railroad.

VFW Post 557 8225 Dexter-Chelsea Road

Adjacent to the VFW stands the Parrott cannon originally presented to the Harrison Jeffords GAR Post No. 330.

DUNDEE

Triangle Park

Riley and Tecumseh (M-50) Streets

In the heart of the village of Dundee's historic triangle district is Triangle Park, home to a beautiful eight-sided limestone bandstand erected in 1913 as a soldiers' memorial, commemorating service by Dundee boys in the Civil and Spanish-American Wars. The Civil War memorial honors the Third Michigan Cavalry and the Seventh, Fifteenth, Seventeenth and Eighteenth Michigan Infantries. Prominently displayed near the bandstand is a one-hundred-pound Parrott rifled siege cannon.

Old Mill Museum 242 Toledo Street / (743) 529-8596

This unique museum features three floors of exhibits including GAR artifacts.

Civil War Memorial Bandstand and Parrott rifled siege cannon in downtown Dundee.

SOUTHEAST MICHIGAN

EAST LANSING

Alumni Memorial Chapel Michigan State University Auditorium Road

A stained-glass window by Odell Prather shows President Lincoln signing the Morrill Act of 1862. This bill provided each state with land to build colleges that would teach agriculture, science, mechanical science and liberal arts.

Buckskin Bested Booth

Buckskin was the horse used by detective Luther Byron Baker to track Lincoln assassin John Wilkes Booth to the Virginia barn where the fugitive met his demise. The horse became famous when he joined Baker onstage during lectures in which Baker gave his account of the assassin's capture. Photos of Buckskin with the details of the Booth pursuit printed on the backside became coveted souvenirs. When Buckskin died, a taxidermist preserved the horse, and he again shared the stage with Baker on the lecture circuit. Buckskin was later donated to the Michigan State University Museum.

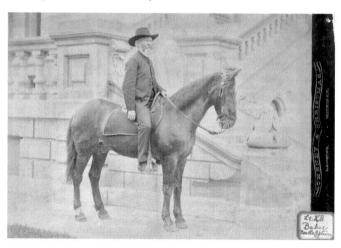

Detective Luther Baker on Buckskin at the state capitol in Lansing. Baker and Buckskin tracked Lincoln assassin John Wilkes Booth. Forest Parke Library & Archives, Capital Area District Libraries.

GROSSE ILE

James Vernor Home 7540 Horsemill Road / private residence

The James Vernor family resided in Detroit for many years, but the Horsemill Road residence was the Civil War veteran's final home. A widower for thirty-six years, Vernor died at the age of eighty-four in the upstairs library of this home on October 29, 1927. Additional information on the prominent Detroit businessman, founder of Vernors Ginger Ale and member of the Fourth Michigan Cavalry can be found under the Woodmere Cemetery listing.

Colonel Brodhead's Office 20604 East River Road / private residence

Colonel Thornton Fleming Brodhead served Michigan in many capacities, including lawyer, prosecuting attorney, deputy secretary of state and state senator. He was the owner and editor of the *Democratic Free Press* (forerunner to the *Detroit Free Press*) and *Detroit Commercial Bulletin*. Brodhead was the first Michigan newspaper publisher to own a steam printing press. In 1853, Brodhead became Detroit postmaster, appointed by President Franklin Pierce.

Brodhead served with distinction during the U.S.-Mexican War, earning the rank of full captain. When the Civil War broke out, he was commissioned to raise a cavalry regiment and became colonel of the First Michigan Cavalry.

Mortally wounded at the Second Battle of Bull Run on August 30, 1862, this husband and father of six children was shot point-blank by Adjutant Lewis Harman of the Twelfth Virginia near Lewis Ford after refusing to surrender. Harmon rode off with Brodhead's horse and weapons.

Before dying, Colonel Brodhead penned a letter to his wife, stating, "General Pope has been outwitted and that McDowell is a traitor. Had they done their duty, as I did mine; and had [they], as I had, the dear old Flag would have waived in triumph. Our Generals—not the Enemy's have defeated us." He ended the letter with a poignant farewell. See the dedication of this book for an excerpt.

Three days before he died, Colonial Brodhead received the deathbed brevet of brigadier general of the United States Volunteer. He died on September 2, 1862. A historic marker designates the site of his former office. The exterior shell of the building still stands; however, the office is on private property.

SOUTHEAST MICHIGAN

Gray Gables / Major Horace Gray Home 24140 East River Road / private residence

A prominent businessman, shipbuilder, politician, Detroit sheriff, federal Indian agent, Civil War officer and early real estate broker, Major Horace Gray was an energetic, patriotic and visionary individual remembered for his love of family, friendship, intelligence, quick wit and public service.

In 1861, Gray returned from the Dakotas where he had served as a Federal Indian Agent for the Sioux Nation at Yankton. At this critical time, many Michigan men were called into active service. Gray was offered a colonelcy but declined. A year later, Major Gray changed his mind and entered the fray. He organized the Fourth Michigan Cavalry and in this capacity, became a member of the elite Minty's Sabre Bridgade. Major Gray distinguished himself at Chattanooga, where he commanded the Union field force of six hundred, as well as at Chickamauga and Lookout Mountain.

Near the end of the war, Major Gray became ill and returned home to Grosse Ile where he led the life of a gentleman farmer and entrepreneur. Gray's military and tribal expertise was called on again in 1879 when an entourage that included the President and Mrs. Rutherford B. Hayes and General William Tecumseh Sherman visited him. The party arrived by boat and docked at the foot of Gray Gables.

Horace Gray lived at his Grosse Ile home for fifty years and died there in 1895. He is buried at Detroit's historic Elmwood Cemetery, which he had originally had a hand in creating.

Kirkland C. Barker House 24808 East River Road / private residence

Mayor of Detroit during the final year of the Civil War, Kirkland C. (K.C.) Barker became aware of the Confederate plot to hijack the *Philo Parsons* and capture the USS *Michigan*. The mayor's actions helped thwart what potentially could have been a disastrous situation for the Union. See entry under Detroit heading, Confederates Board Local Steamer, for more details.

Barker, who established Detroit's first nighttime police force, also thwarted a plan to interrupt the national election of 1864. Southern sympathizers from Canada hatched a plan to set Canadian border cities such as Detroit afire. They hoped the confusion created by the fires would influence the

The Grosse Ile home of Kirkland C. Barker, Detroit's mayor during the final year of the Civil War. Barker thwarted local Confederate plots that could have been disastrous.

election's outcome in favor of the South. Barker caught wind of the plan and put it down before anything materialized.

After the war, a friendship developed between Mayor Barker and General Custer, now a Civil War hero. Both George and his wife, Elizabeth (Libbie), spent time on Grosse Ile visiting the Barkers. Libbie stayed with the Barkers for weeks at a time during her husband's deployment to Kansas in 1868 and 1869. In her writings, Libbie made reference to the beautiful copper bathtub found in the Barker home where she bathed during her visits.

General Custer himself spent time on Grosse IIe after his court martial and forced one-year removal from duty in 1868. Custer was at the Barker home when he received the telegram from William T. Sherman calling him back to duty in Kansas, two months before his one-year sentence was up.

An avid yachtsman, Barker and three others, including the fourteenyear-old son of his gardener, drowned in the Detroit River, not far from Barker's Grosse Ile waterfront home. Aboard the boat *Mattie*, the four headed out to Stony Island to retrieve Barker's racing yacht *Cora* in preparation for the International Boat Club Regatta. The *Mattie* capsized; all were thrown overboard and drowned. Although his body was not recovered, a tombstone in remembrance of Mayor Barker stands at Elmwood Cemetery.

SOUTHEAST MICHIGAN

Sultana *Memorial* 29 North Howell Street

Located in front of the Hillsdale County Courthouse, this monument pays tribute to Union soldiers, a large number from Hillsdale County, who were killed in what is known as America's greatest maritime disaster. While the conclusion of the Civil War should have been a time of celebration, this fatal disaster was a sad blow for the families of soldiers who had managed to survive the cruelties of war only to perish upon their return trip home.

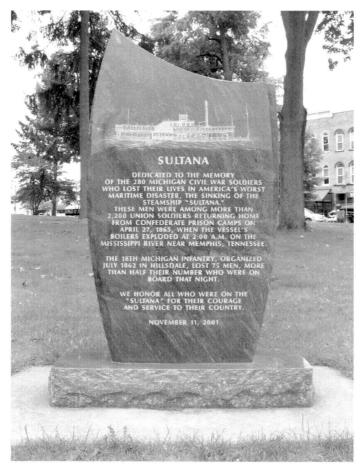

A memorial on the Hillsdale County Courthouse lawn dedicated to Michigan soldiers killed in an explosion aboard the *Sultana*, our nation's worst maritime disaster.

The steamboat *Sultana* departed port in New Orleans on April 21, 1865, bound for St. Louis, Missouri. Legally permitted to carry only 376 passengers, over 2,200 passengers, primarily Union soldiers making their long awaited journey home, boarded in Vicksburg, Mississippi. Many had been incarcerated at Confederate prison camps at Cahaba and Andersonville and were injured or sick.

Bursting at the seams with passengers packed into berths and no room to move on deck, the overcrowded ship made its way up river, past Memphis, Tennessee, where it exploded in the early hours of April 27. An estimated 1,800 passengers (280 from Michigan) either drowned or were blown to bits as a result of the explosion. Of the survivors, several hundred died days later from burns or exposure. Bodies were discovered for months downstream following the disaster, and many were never recovered.

Inside the courthouse is a small display of Civil War relics. Hillsdale was home to Major General Charles C. Doolittle, who is buried at Toledo, Ohio's historic Woodlawn Cemetery, and Colonel George W. Lombard of the Fourth Michigan Infantry. Colonel Lombard died from wounds received in the Battle of the

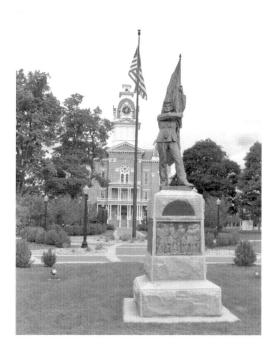

Lorado Taft Civil War soldier statue on the campus of Hillsdale College.

Wilderness in Virginia on May 6, 1864. The colonel's remains may still be buried on the battlefield, as his body was never identified during later attempts to recover the dead and rebury them.

Lorado Taft and Abraham Lincoln Statues

Hillsdale College / 33 East College Street

Erected in June 1895 by the Alpha Kappa Phi Literary Society, this statue of a Civil War soldier by Lorado Taft, a prominent sculptor from Illinois, pays tribute to the members of the society who served in the Civil War.

The inscription reads: "Our Roll of Honor, Alpha Kappa Phi volunteers in the War of the Rebellion. To the memory of our heroic dead who fell in defense of the Union." The inscription is followed by the names of the members who served. The monument stands prominently on campus in the center of Central, Moss and Delp Halls.

A life-size statue of President Abraham Lincoln was erected here in 2009.

Oak Grove Cemetery Montgomery Street / west of North Hillsdale Road

In Oak Grove Cemetery, 220 Civil War veterans are buried, including Brigadier General Christopher John Dickerson, originally colonel of the Tenth Michigan Infantry. General

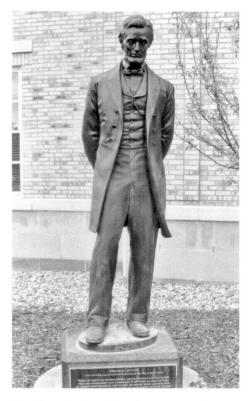

President Abraham Lincoln statue on the campus of Hillsdale College.

Dickerson was injured and taken prisoner in February 1864 at Buzzard's Roost, Georgia.

A monument featuring a Civil War soldier at parade rest dedicated to those who served can be found in the cemetery.

Lewis Emery Park / Camp Woodbury 2020 State Road

Location of Camp Woodbury, named after Colonel Dwight Woodbury, the encampment and training site of the Eighteenth Michigan Infantry from late July through September 18, 1862. This location was chosen because of the healthy natural spring water.

HUDSON

Hudson Museum

219 West Main Street / (517) 448-8858

Nice Civil War display and artifacts of interest including different kepis, accouterments, weaponry, a saddle and a field desk.

Maple Grove Cemetery Maple Grove Avenue and Cadmus Road

Two heroic battery captains from the First Michigan Light Artillery lie in rest at the Maple Grove Cemetery: the daring captain Samuel DeGoyler of Battery H, who was mortally wounded at Vicksburg, Mississippi, and Captain Jabez Daniels of Battery I, whose guns helped repulse Pickett's Charge on July 3, 1863, during the Battle of Gettysburg.

JACKSON

Under the Oaks Park / Birthplace of the Republican Party

Second and West Franklin Streets

A bronze marker at the northwest corners of Second and Franklin denotes the outdoor location "Under the Oaks" where the first state convention was held on July 6, 1854, by those supporting the end of slavery. Jackson is one of four communities claiming to be the birthplace

"Under the Oaks" Park in Jackson where the Republican Party was founded.

SOUTHEAST MICHIGAN

of the Republican Party. Since a slate of candidates was elected at this convention, Jackson is considered by most to be the true birthplace of the party.

Mount Evergreen Cemetery 1047 Greenwood Avenue

Mount Evergreen is the final resting place of Governor Austin Blair, Michigan's thirteenth governor who's best known as the "Civil War Governor." A founder of the Republican Party, Blair vehemently opposed slavery and Southern secession. Governor Blair personally raised about \$100,000 to equip the First Michigan Infantry Volunteer Regiment. President Lincoln relied heavily on the support from Governor Blair and the Michigan regiments he sent. A grand statue in front of the state capitol in Lansing pays tribute to Governor Blair.

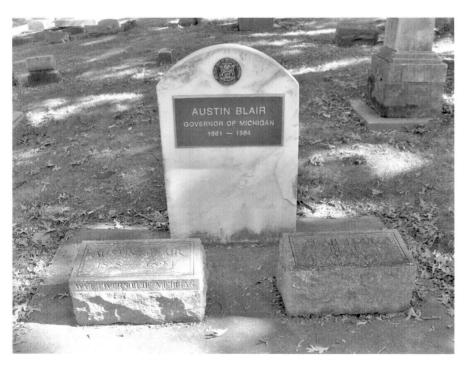

The grave of Michigan's Civil War governor Austin Blair at Mount Evergreen Cemetery in Jackson.

Brigadier General William H. Withington is buried at Mount Evergreen. As colonel, he commanded the Seventeenth Michigan Volunteer Infantry, also known as the Stonewall Regiment for its brave advancement and capture of the stone wall from Confederate troops during the Battle of South Mountain in Maryland on September 14, 1862, and forcing their retreat. Colonel Withington earned a Medal of Honor for his actions as captain of Company B, First Michigan Infantry, at the First Battle of Bull Run.

Buried here are Brigadier General Charles Deland and Sergeant Frederick Lyon. Deland was colonel of the First Michigan Sharpshooters and wounded in several battles.

Sergeant Lyon of the First Vermont Cavalry was awarded the medal for his actions on October 19, 1864, at the Battle of Cedar Creek, Virginia, where he captured a Confederate flag, three officers and an ambulance.

The grave of Captain Christian Rath of Company I, Seventeenth Michigan Infantry, can be found here as well. Captain Rath was the executioner of four of the eight Lincoln conspirators: David E. Herold, George Atzerodt, Lewis Powell and Mary E. Surratt. Innkeeper Mary

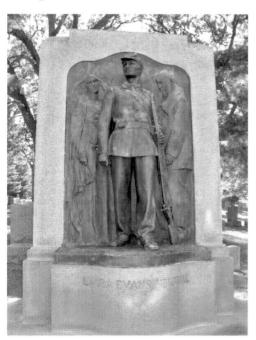

Laura Evans Civil War memorial at Mount Evergreen Cemetery in Jackson.

Surratt's role as a co-conspirator earned her the unfortunate distinction of being the first female executed by the United States federal government.

Captain Rath, a member of Major General John F. Hartranft's staff. charged with overseeing the conspirators' imprisonment at the Washington, D.C. Arsenal and Penitentiary. he selected hangman by the federal government. His responsibilities included setting up the gallows and carrying out the process.

Just before 2:00 p.m. on July 7, 1865, Captain Rath clapped his hands three times and sent the convicted to their fate. The captain, who received a

brevet of lieutenant colonel for his service, was supposedly haunted by his participation in the executions for the rest of his life.

A bronze-and-granite Civil War soldiers' monument stands near the cemetery gate. Jackson resident Laura Evans entrusted funds to be used to build the monument in remembrance of those who served in the Civil War and dedicated it in honor of her family members.

Created by sculptor Frederick C. Hibbard, who studied under Lorado Taft, the three-figure composition may represent Evans's parents and soldier husband or the parents of any young soldier, watching as he valiantly sets off for war, unsure if he'll ever return.

Michigan Participants in the Capture and Execution of the Lincoln Conspirators

Major Henry Smith from Monroe actually arrested suspects Mary Surratt and Lewis Powell. Detective Luther Baker (Lansing) led the party that caught up with John Wilkes Booth. Captain Richard Watts (Adrian) served on the staff of General Hartranft, who oversaw the

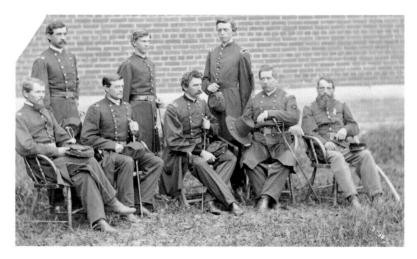

General Hartranft and his staff were responsible for the confinement of the Lincoln conspirators during the trial and execution. Identified in this photo are Captains Richard Watts (far left) and Christian Rath (far right). *Library of Congress*.

confinement and execution of the four condemned conspirators (Mary Surratt, Lewis Powell, George Atzerodt and David Herold). Captain Christian Rath (Jackson) was responsible for guarding the condemned and carrying out their executions.

Site of Former Austin Blair Home Lansing Avenue and Blackstone Street

A boulder with a bronze tablet proclaims: "Upon this site stood the home of Austin Blair, one of the founders of the Republican Party and Michigan's War Governor 1861–1865."

Governor Austin Blair Park Greenwood Avenue and South Jackson Street

This is the site of a state historical marker describing the life achievements of Michigan's Civil War governor.

State of Michigan Roadside Park U.S. 127, south of Jackson

A bronze plaque attached to a large bolder is dedicated to Governor Austin Blair.

Defense of the Flag at Withington Park Wildwood and West Michigan Avenues

Also known as the Jackson County Soldiers and Sailors Monument, Defense of the Flag is a memorial to the men of the First and Seventeenth Michigan Volunteer Infantry, erected at the expense of their commander General William H. Withington. Unfortunately, General Withington died in the year prior to the monument's dedication.

In Outdoor Sculpture, writer Michael W. Panhorst describes the bronze and granite Lorado Taft monument featuring the regimental battle flag

SOUTHEAST MICHIGAN

as waving in "the breeze above a defiant standard bearer and two of his valiant comrades. One soldier falls and grasps at the chest wound he has just received. The other kneels, peering into the face of the enemy, his rifle at the ready to defend his flag—a symbol more important to many soldiers than life itself."

Ella Sharpe Museum of Art and History 3225 Fourth Street / (517) 787-2320

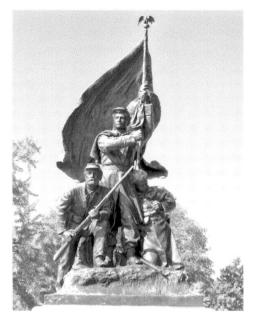

Defense of the Flag monument at Withington Park, Jackson.

Civil War artifacts are displayed here, including the "Resolution Table," which was used in the

1854 founding of the Republican Party popularly referred to as "Under the Oaks."

General Robert H.G. Minty Home 1912 Fourth Street / private residence

General Robert Horatio George Minty, commander of the famous Minty's Sabre Brigade, lived in this Jackson home from 1869 to 1876. The Irish-born general honed his saber skills as an ensign serving five years in the British army in the West Indies, Honduras and the West Coasts of Africa. Upon his retirement from British military service in 1853, Minty came to the United States. He married Grace Ann Abbott of London, Ontario, and they settled in Detroit.

When the Civil War broke out, Minty became major of the Second Michigan Cavalry, followed by lieutenant colonel of the Third Michigan and then colonel of the Fourth Michigan. In 1863, Minty commanded a cavalry brigade that included the Fourth Michigan. The brigade became

known for its excellent saber-wielding skills; hence it was nicknamed Minty's Sabre Brigade.

The Sabre Brigade captured Shelbyville, Tennessee, in June 1863. Minty commanded the cavalry on the left at Chickamauga and later covered General Thomas's retreat to Chattanooga. Minty's Sabre Brigade saw action at New Madrid, Farmington and the Atlanta Campaign, where Minty led a division in Kilpatrick's raid around that city. Minty is considered to be one of the top cavalry commanders in the western theater. Had he commanded troops in the eastern theater, many believe Minty would have received more recognition for his contributions to the Union. At the end of the war, Colonel Minty received the brevets of brigadier general and major general of volunteers for his distinguished service.

General Minty returned to Michigan and settled in Jackson, where he raised ten children. He later moved west and is buried in Ogden, Utah.

Camp Blair Marker

Wildwood Avenue between North Thompson and Hibbard Avenues

This state historical marker describes Camp Blair, named after Governor Austin Blair. The camp operated from 1864 to 1866 and served as a rendezvous point for troops to be mustered out of service. It included a hospital, barracks, a storehouse and offices.

Camp Jackson Clinton Street and Lansing Avenue

The Twentieth Michigan Infantry organized and trained at this location from July 26 to September 1, 1862. The Twenty-sixth Michigan Infantry used the site for training from September 10 to December 12, 1862.

Cascades Falls Park / CivilWar Reenactment 1401 South Brown Street

Michigan's oldest Civil War reenactment, the largest in the state and the Midwest, takes place annually in August at Cascades Park in Jackson. This event is attended by thousands of spectators and reenactors. Battle

The annual Jackson Civil War Muster, the largest in the Midwest, is held in August.

reenactments, presentations by historical interpreters, Civil War-era music and a grand ball and a period encampment and village with sutlers (merchants) can be experienced at this event.

First Congregational Church / GAR Pomeroy Post No. 48 120 North Jackson Street / (517) 784-8577

Jackson Blair Cadets and Jackson County Rifles gathered here for a send-off ceremony in September 1861 before joining the Eighth and Ninth Michigan Infantries in Detroit. A nearby plaque identifies the location as the former site of the GAR Pomeroy Post No. 48.

Jonesville

Sunset View Cemetery Chicago Road / U.S. 12

Major General Henry Baxter is buried here. Lieutenant colonel of the Seventh Michigan Infantry, Baxter's brigade played a major role during the

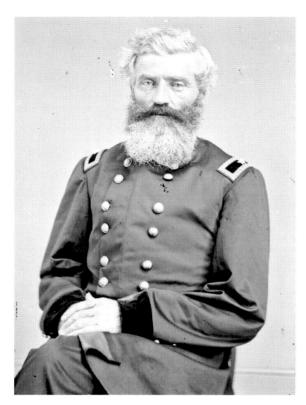

Left: General Henry Baxter. Library of Congress.

Below: Grosvenor House, Jonesville.

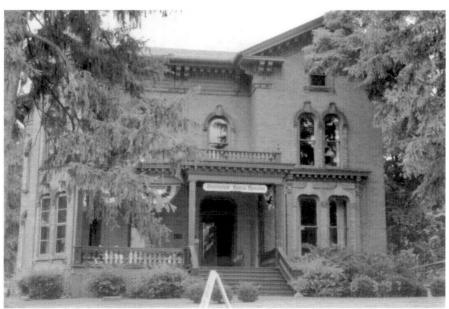

first day of the Battle of Gettysburg. General Baxter was wounded several different times during the war.

The grave of Ebenezer Oliver Grosvenor can be found here as well. Grosvenor was lieutenant governor of Michigan from 1865 to 1867. See entry below.

Carl Fast Park East Chicago Street (U.S. 12)

A monument depicting a Civil War soldier at parade rest stands in this park.

Grosvenor House Museum 211 Maumee Street / (517) 849-9596

This is the renovated home of Ebenezer Oliver Grosvenor who was elected seventeenth lieutenant governor of Michigan and served during Governor Henry H. Crapo's first term. In 1861, during Governor Blair's administration, Grosvenor was commissioned colonel on the governor's staff and appointed president of the military contract board. Grosvenor was head of the commission overseeing the construction of the state's Capitol. Elijah E. Meyers, architect of the Capitol, also designed the Grosvenor home.

Lansing

Michigan Historical Museum 702 West Kalamazoo Street / (517) 373-3559

An entire section of the Michigan Historical Museum is dedicated to a permanent exhibit of Michigan in the Civil War featuring guns, swords and accessories from Michigan soldiers. The unique Henry rifle once belonging to Battle Creek's Sergeant Lorenzo Barker of Company D, Sixty-sixth Illinois Infantry is displayed. Engraved on the gun's breech are the battles in which Barker fought.

The museum cares for and stores over 150 of Michigan's bloodstained and sacred Civil War battle flags, including the individual flags of the regiments comprising the Michigan Cavalry Brigade, the tattered Twenty-fourth Michigan Infantry's national colors from Gettysburg and flags of other Michigan regiments and batteries.

The flag exhibits can be accessed online at www.seekingmichigan.org.

State of Michigan Archives 702 West Kalamazoo Street / (517) 373-1408

The archives house primary resources from the Civil War including regimental records, letters, diaries, photographs, newspaper articles and books. Many records from this collection have been digitized and can be viewed online.

State of Michigan Capitol Building 100 North Capitol Avenue / (517) 373-2353

Reproductions of Michigan's coveted Civil War regimental flags can be viewed on the first floor of the Capitol rotunda. The original 157 tattered, bloody and bullet-ridden flags hung from the rotunda, a proud testament to those from our great state who served and sacrificed in order to preserve the Union. Unfortunately, age and exposure caused the flags to deteriorate, so they were moved to the Michigan

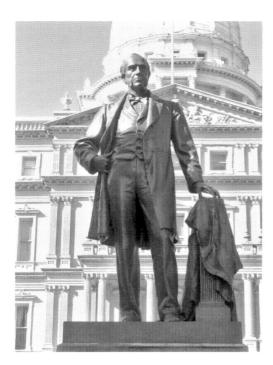

Governor Austin Blair statue on the grounds of the state capitol in Lansing.

Historical Museum for safe storage and repair.

Several notable Civil War monuments can be found on the capitol grounds in the area called Capitol Square. A bronze statue of Michigan's Civil War governor Austin Blair is the first and only statue of a person found in the square. Dedicated on October 12, 1898, the statue was designed by Edward Clack Potter, who also designed the equestrian monuments General Custer in Monroe and Generals Sedgeick and Slocum in Gettysburg. Monuments honoring the First Michigan Engineers and Mechanics and First Michigan Sharpshooters are present along with a boulder and bronze tablet erected by the Department of Michigan

Women's Relief Corps on June 11, 1924, in memory of the Grand Army of the Republic.

Michigan Women's Historical Center and Hall of Fame 213 West Malcolm X Street / (517) 484-1880

The center has inducted the following women from this era into the Women's Hall of Fame for their contributions in the areas of abolition, military and/or nursing: Elizabeth Margaret Chandler, Sara Emma Edmonds, Annie Etheridge, Julia Wheelock Freeman, Laura Smith Haviland, Eliza Seaman Leggett and Sojourner Truth.

Women's Hall of Fame Honors Three Civil War Women

Julia Wheelock Freeman (1833–1900) known as the "Florence Nightingale of Michigan," spent three years in the hospitals of Washington, D.C., nursing wounded and dying soldiers. A teacher in Palo, Michigan, when the Civil War broke out in April 1861, Freeman traveled to our nation's capital when she received news that her brother Orville was wounded. Although Orville died before she arrived, Freeman saw the desperate need for nurses and remained in Washington.

A volunteer with the Michigan Soldiers Relief Association, Freeman endured long hours cooking, cleaning and comforting Michigan's wounded soldiers sent to recover—and often die—in Washington-area hospitals. Freeman's detailed journal and her published memoir, *The Boys in White*, provide invaluable insight into period medical practices, burial procedures and daily life at the hospitals. Her writings also shed light on local and national events of interest including the assassination of President Lincoln. Freeman was inducted into the Michigan Women's Hall of Fame in 2002 for her achievement in the categories of military and nursing.

Twenty-year-old Canadian-born Sarah Emma Edmonds (1841–1898) was residing in Flint when she disguised herself as a male named Franklin Thompson and joined Company F of the Second Michigan Volunteer Infantry Regiment in Detroit on May 25, 1861. As Frank

Thompson, Edmonds bravely served in the army as a spy, field nurse, mail carrier and soldier. A master of disguise, Edmonds became adept at espionage and infiltrated Confederate lines eleven times dressed as a black slave, dry goods clerk or even a young Confederate boy.

In 1863, Edmonds contracted malaria while in Kentucky and requested a furlough, which was denied. Fearful her true identity would be discovered if she sought medical attention, Edmonds left her regiment and never returned. Thus, her alias, Franklin Thompson, was charged with desertion. After her recovery, Edmonds ditched her male disguise and worked as a nurse with the United States Christian Commission.

In 1864, she published *Nurse and Spy in the Union Army*, an autobiography that sold over seventy-five thousand copies. Edmonds donated the profits from this popular book to soldiers' aid groups.

Edmonds attended a Second Michigan reunion in 1876 where she was welcomed by her comrades, many of whom had no clue until after the war that Franklin was actually a woman. Regiment members helped Edmonds in her fight to have the charge of desertion removed from her military records and supported her application for a military pension. In 1884, following an eight-year battle and an Act of Congress, Franklin Thompson was cleared of desertion charges and Sara Edmonds awarded his pension. Edmonds, the only woman admitted into the Grand Army of the Republic, died in 1898 at her home in La Porte, Texas. In 1901, she was re-buried with full military honors in Houston's Washington Cemetery. Edmonds was inducted into the Michigan Women's Hall of Fame in 1992 for her achievement in the category of military.

Detroit's Annie Blair Etheridge (1839–1913) joined the Second Michigan infantry as the regiment's vivandiere, or Daughter of the Regiment, whose purpose was to rally the men in battle and provide aid as needed. Affectionately nicknamed "Gentle Annie" by the soldiers she tended, Etheridge eventually served in the Second, Third and Fifth Michigan Infantry regiments and saw some of the hardest fighting during the Civil War, including the battles of Fair Oaks, Second Bull Run, Chancellorsville, Gettysburg and the Wilderness.

Etheridge served as an army nurse on a hospital transport as well at an army hospital. She was awarded the Kearny Cross for the bravery and courage she demonstrated during the Civil War. The medal was named in honor of Major General Philip Kearny, commander of

the First Division, Third Army Corps, who was killed at the battle of Chantilly on September 1, 1862.

After the war, Etheridge was eventually given a monthly pension of twenty-five dollars for her unpaid military service. Upon her death in 1913, Etheridge was buried with full military honors in Arlington National Cemetery. Etheridge was inducted into the Michigan Women's Hall of Fame in 2010 for her achievement in the categories of military and nursing.

Mount Hope Cemetery 1709 Mount Hope Avenue

Assistant surgeon George E. Ranney of the Second Michigan Cavalry is buried here. Ranney was awarded the Medal of Honor for bravery exhibited during the Battle of Resaca, Georgia on May 14, 1864. Aware he could sustain serious injuries or even be killed, Ranney selflessly put himself in harm's way as he rescued wounded soldiers and carried them to safety.

First Lieutenant Luther Byron Baker—an agent in the national detective service in pursuit of President Lincoln's assassin, John Wilkes Booth—is buried here. Baker tracked Booth to the Virginia barn that was set afire after Booth refused to surrender. When Booth wouldn't leave the burning barn, he was shot and mortally wounded by Sergeant Boston Corbett of the Sixteenth New York Cavalry.

The Civil War section of the cemetery contains fifty headstones and Lansing's official Civil War monument. Erected in 1877, the monument was rededicated in October 2007 by descendants of Civil War veterans.

Mason

Ingham County Courthouse 341 South Jefferson Street

The recently dedicated Ingham County Civil War Memorial honors its soldiers who died in the Civil War. A thirty-pound Parrott rifled cannon stands in front of the courthouse.

Maple Grove Cemetery East and Columbia Streets

Lieutenant Colonel Amos E. Steele is buried here. He was killed in battle on July 3, 1865, while valiantly commanding the Seventh Michigan Infantry during the repulse of Pickett's Charge at the Battle of Gettysburg.

MILAN

Marble Park Cemetery 520 West Main Street

A Civil War monument of a soldier at parade rest can be found here.

Rice Cemetery Dennison Road

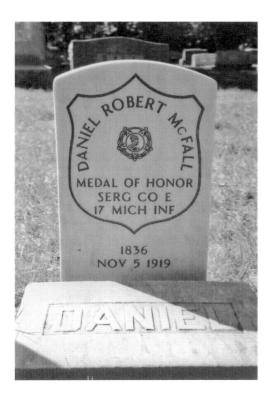

Medal of Honor recipient Sergeant Daniel McFall of the Seventeenth Infantry, Company E, is buried here. Sergeant McFall earned his medal for his actions on May 12, 1864, at Spotsylvania Court House, where he captured a Confederate colonel leading a brigade and also rescued his lieutenant from enemy capture.

The grave of Sergeant Daniel McFall, Seventeenth Michigan Infantry, at Rice Cemetery in Milan.

SOUTHEAST MICHIGAN

MONROE

Monroe County Historical Museum 126 South Monroe Street / (734) 240-7780

Prominent regiments, influential politicians and major military figures all hailed from Monroe County. The county produced five generals, seven colonels and eight Medal of Honor recipients, including Lieutenant Tom Custer, the first double honoree in our nation's history. Several exhibits illustrate the contributions by residents of this era and include coveted items such as a captain's frock coat belonging to Normal Hall, a colonel's frock coat belonging to Brigadier General George Spalding and the regimental flag of the Seventh Michigan Infantry with its handembroidered moniker "The Forlorn Hope at Fredericksburg."

Museum archives house correspondence, diaries, records, photographs from the Civil War kept by Custer family members and the community and an original set of the Record of Service of Michigan Volunteers in the Civil War, known as the "Brown Books," which provide detailed information on Michigan soldiers in the war and histories of each regiment. The collection also includes General Spalding's personal set of *The War of the Rebellion: A Compilation of the Original Records of the Union and Confederate Armies*, published by the federal government. (See Woodland Cemetery entry for information on General Spalding.)

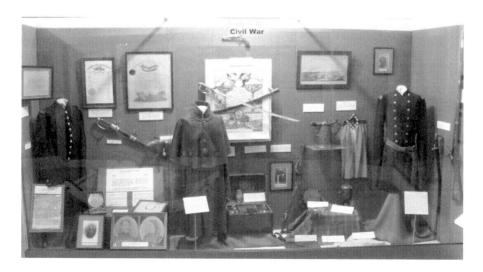

Monroe County Historical Museum Civil War display.

The second floor of the Monroe County Historical Museum features the largest exhibit in the world dedicated to General George Armstrong Custer. People from all over the globe, including renowned authors and historians, visit this exhibit. Personal items once belonging to Custer on display include his christening gown, a wedding invitation, family photos, a lock of hair, a buffalo coat and camp tent, a desk from Fort Abraham Lincoln and his Remington rolling block rifle. Custer was a skilled taxidermist, and the museum exhibits several of his mounted relics of the chase.

Civil War items related to Custer include his cavalry saber, his personal guidon (or flag) as commander of the Michigan Cavalry Brigade, period magazines featuring the general on the covers and a Confederate Bowie knife. Confiscated by Company A of the Fourth Michigan Infantry during an encounter with Wheat's Louisiana Tigers at the Battle of New Bridge on the Chickahominy River, this unique short sword had been presented to General Custer by members of the Fourth who had fought alongside him in the battle.

In all, approximately twenty exhibits are dedicated to Monroe's most famous citizen. The museum occupies the site where the family home of Elizabeth Bacon Custer once stood. (See next entry.) A guidebook of General Custer sites in Monroe is available at the museum.

The Bacon-Custer house in Monroe is now home to noted Custer reenactor Steve Alexander.

Bacon / Custer Home 703 Cass Street / private residence

Elizabeth "Libbie" Bacon Custer and her husband, George, inherited this house upon the death of her father, Judge Bacon. The couple resided in the home whenever they returned to Monroe for short visits and following the Civil War, when Custer was in between military assignments. Originally, the home stood at 126 South Monroe Street, the current site of the Monroe County Historical Museum. The restored home is the private residence of renowned Custer living historian Steve Alexander and his wife, Sandy.

Surrender Table Gifted to Libbie Custer

While George Armstrong Custer's legacy is overshadowed by his defeat at the Battle of the Little Big Horn, most people don't realize he was a celebrated Civil War hero revered by the men he led.

Major General Philip Sheridan acknowledged Custer's contributions to the Union by purchasing the writing table on which the terms of the Confederate surrender were written. He presented the table to Custer's

wife, Libbie, along with this personal note: "And permit me to say Madam that there is scarcely an individual in our service who had contributed more to bring about this desirable result than your very gallant husband."

The original table is at the Smithsonian, and a replica table is on exhibit at the Monroe County Historical Museum.

A replica of the writing table where General Grant drafted terms of Lee's surrender of the Confederate Army of Northern Virginia. *Monroe County Historical Museum*.

Old Fairgrounds / Camp Monroe Marker St. Mary's Avenue and Lorain Street

A historic marker denotes the site of Camp Monroe at the old fairgrounds where the Seventh and Fifteenth Michigan Infantry and the First Michigan Light Artillery, Battery H, trained and organized from August through September 1861 and November 1861 through March 1862. Local resident John M. Oliver, colonel of the Fifteenth, later commanded a brigade in General Sherman's army and was brevetted major general.

Sighting the Enemy / Custer Equestrian Statue Corner of Elm and Monroe Streets

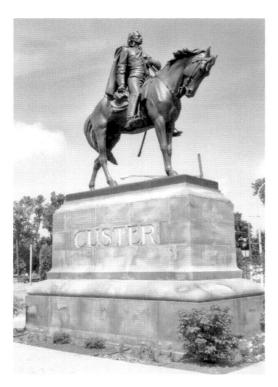

Sighting the Enemy, General Custer statue in Monroe.

Designed by sculptor Edward Potter, the statue entitled Sighting the Enemy depicts Custer at the Battle of Gettysburg. Originally unveiled on June 4, 1910, in a ceremony attended by President William Howard Taft and Custer's widow, Elizabeth Bacon Custer, a rededication ceremony was heldin 2010 to commemorate the statue's 100th anniversary.

The statue first stood in the center of Washington and First Streets, between the First Presbyterian Church where Custer wed hometown girl Libbie Bacon in what was then dubbed the "wedding of the century," and the courthouse, where Mayor George Spalding, a Civil War brigadier general, gave

a public eulogy for Custer and the Monroe men killed at the Battle of the Little Big Horn.

In 1923, the statue was deemed a traffic hazard and moved to Soldiers and Sailors Park. In 1955, it was moved again to its present location.

Lawrence A. Frost Collection of Custeriana

Ellis Reference and Information Center at Monroe County Library

3700 South Custer Road / (734) 241-5277

The George Armstrong Custer Collection at the Monroe County Library System is a multimedia resource center specializing in the life and times of General George Armstrong Custer. A major portion of this collection was acquired by Monroe resident and avid Custer historian the late Dr. Lawrence A. Frost, and it continues to grow steadily through additional acquisitions. The collection houses numerous books on the Civil War, Native Americans and the Custer story but also maintains a wide variety of maps, photographs, video tapes, slides, sound recordings, paintings and an extensive subject/vertical file. Color photocopies of Custer's West Point diploma and military commissions signed by Presidents Abraham Lincoln and Andrew Johnson can also be viewed here.

Custer Farm 3048 North Custer Road / private residence

George Custer, his brother Nevin and their wives jointly purchased this 116-acre farm in August 1871, where Nevin and his family resided. Visitors to the farm included Buffalo Bill Cody and Annie Oakley. Dandy, Custer's favorite horse, was buried in the orchard near the barn. While Custer met his demise astride Vic at the Battle of Little Big Horn, Dandy survived because he was left behind with the pack train. A historic marker stands on the front lawn of the farmhouse.

Martha Barker Country Store (former Paper Mill School)

3815 North Custer Road / (734) 240-7780

Monroe is the hometown of Colonel Norman Hall, who learned of his acceptance to West Point Military Academy while attending the rural Paper Mill School. After entering the service in 1859, Hall, a twenty-five-year-old second lieutenant, witnessed the execution of John Brown and the opening shots of the Civil War when Confederate batteries fired on the Union-held Fort Sumter in April 1861.

In July 1862, Hall earned the rank of colonel of volunteers and was appointed commander of the Seventh Michigan Infantry, which served heroically in the West Woods at Antietam. The following December, Hall volunteered his brigade for a dangerous mission that involved crossing the Rappahannock River under heavy enemy fire. Traveling in pontoon boats, the brigade managed to outwit the enemy and reached Fredericksburg, where they rid the city of Confederate sharpshooters who impeded the ability of Union engineers to lay pontoon bridges. The mission earned the Seventh Michigan the moniker "The Forlorn Hope at Fredericksburg."

Colonel Hall also witnessed the carnage at Gettysburg. During the breach at "the Angle" of the Union line, Hall's troops were among the last remaining Union soldiers to assist in repulsing Pickett's Charge, thus saving Union forces from defeat.

Early in his military career, Colonel Hall contracted a disease in South Carolina, possibly typhoid fever or malaria. The effects of the disease, combined with the continuous hardships of war, took a toll on his health. Colonel Hall died on May 26, 1867, at the age of thirty.

Historic Woodland Cemetery East Fourth and Jerome Streets

Established in 1810, Historic Woodland Cemetery is one of Michigan's oldest cemeteries. It's the final resting place of 120 Civil War soldiers as well as influential politicians of this turbulent time.

Henry D. Gale, a sergeant in Company C, of the Fifth Michigan Cavalry, died on May 11, 1864, from wounds sustained at the Battle of Yellow Tavern, Virginia. It was during this battle that Confederate general Jeb Stuart was mortally wounded by a Fifth Michigan trooper. Two years earlier, Gale's

SOUTHEAST MICHIGAN

younger brother, Franklin, died in action at Malvern Hill, Virginia, on July 1, 1862. The brothers are buried next to each other.

Medal of Honor recipient Peter Sype, a private in Company B of the Forty-seventh Ohio Volunteer Infantry, is buried in the Trinity Lutheran section of the cemetery. Sype earned our nation's highest military honor for demonstrating "gallantry of action" at Vicksburg, Mississippi, on May 3, 1863, when he and several volunteers attempted to ram the enemy's batteries with a steam tug and two barges carrying explosives. Although severely wounded in battle in 1864, Sype survived and lived until the age of eighty-two.

Brigadier General Joseph R. Smith, seriously wounded in the Mexican War, offered his service as drill master of Company A, Fourth Michigan Infantry, known as the "Smith Guards" in his honor. He became chief mustering officer for the State of Michigan. Monroe's GAR Post was named after him as well.

Smith's son, Major Henry W. Smith, is also buried here. After President

Lincoln's assassination, Smith was the commanding officer in charge of arresting all the occupants of the Surratt boardinghouse, which included Mary Surratt and Lewis Powell.

There are other notables buried at Woodland as well. Brigadier General George W. Spalding enlisted as a sergeant in the Fourth Michigan Infantry and was promoted to lieutenant colonel of the Eighteenth Michigan Infantry and colonel the Twelfth Tennessee of Cavalry (Union). For his bravery in the Battle of Nashville in 1865, Spalding became a brevet brigadier general. General Spalding, who later became mayor of Monroe and a United States congressman, is known for his unique attempt to rid Nashville of venereal disease while serving as the city's provost marshal.

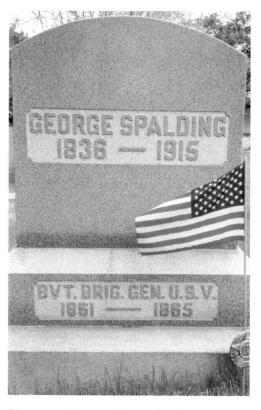

The grave of General George Spalding at Woodland Cemetery in Monroe.

Dr. Eduard Dorsch attended President Lincoln's inauguration and served as a surgeon on the U.S. Pension Board.

Businessman William H. Boyd and Michigan Supreme Court chief justice/ United States senator Isaac P. Christiancy were founding members of the Republican Party.

The Bacon and Custer family plots are here as well. Although General Custer and his wife, Elizabeth, are buried at West Point, family members, including George's brother Boston and nephew Autie Reed, are buried here. Both died with General Custer at the Battle of the Little Big Horn on June 25, 1976.

Colonel Ira R. Grosvenor recruited and organized the Seventh Michigan Infantry. He is the brother of Michigan lieutenant governor Ebenzer Oliver Grosvenor.

Monroe's Woodland Cemetery Tour pamphlet, written by David Ingall, identifies the grave sites of prominent Monroe residents buried here. It is available at the Monroe County Historical Museum.

Monroe County Civil War Fallen Soldiers Memorial Monument

Soldiers and Sailors Park / East Front Street

This beautiful new memorial lists over 430 names of those from Monroe County who died in the Civil War and the eight county recipients of the Civil

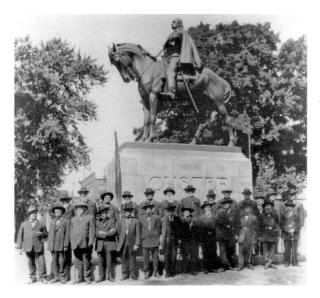

War Medal of Honor. It was dedicated on May 27, 2012. The park also contains a plaque honoring the Joseph R. Smith GAR Post No. 76.

GAR Smith Post No. 76 members in front of the Custer statue in Monroe. Monroe County Historical Museum Archives.

Frederick Nims House 206 West Noble Avenue / private residence

This stately Greek Revival home built in the 1830s belonged to Frederick Nims, aide to General Custer during the Civil War. A first lieutenant in the Fifth Michigan Cavalry, Nims was the last surviving officer on General Custer's staff. The home is listed on the National Register of Historic Places and was renamed Shadowland in 1914 after undergoing extensive remodeling.

Monroe Golf and Country Club 611 Cole Road

The country club was once the home of Colonel Ira R. Grosvenor, who raised and organized the Seventh Michigan Infantry, which trained in Monroe. He led the regiment through the Peninsular Campaign battles in 1862. Colonel Grosvenor named the home Fair Oaks because the grounds reminded him of the Virginia terrain where the 1862 battles took place. Legend claims a ghost haunts the upper floor of the building.

Confederate General George Pickett's Michigan Connection

Lieutenant George Pickett Jr., son of General Pickett of "Pickett's Charge" of Gettysburg fame, married Ida Elizabeth Christiancy in 1891. Elizabeth was the daughter of Lieutenant Henry Clay Christiancy of the First Michigan Infantry from Monroe. She was the niece of Medal of Honor recipient Lieutenant James Christiancy of the Ninth Michigan Cavalry and

Lieutenant Henry Clay Christiancy, First Michigan Infantry. Bentley Historical Library, University of Michigan.

staff officer under General Custer. She also was the granddaughter of U.S. senator Isaac P. Christiancy. The Christiancy-Pickett papers are in the Library of Congress.

MOUNT CLEMENS

Clinton Grove Cemetery 21189 Cass Avenue

Brigadier General Henry Dwight Terry, colonel of the Fifth Michigan Infantry, is buried here. He became a brigade commander and the commandant of Johnson's Island Confederate Prison in Sandusky Bay, Ohio.

Camp Stockton South Gratiot and Robertson Streets

The training site of the Eighth Michigan Cavalry and Battery M, First Michigan Light Artillery, extended from this intersection to the Clinton River.

Macomb County Building 10 North Main Street

A replica ten-pound Parrott cannon monument representing Battery M, First Michigan Light Artillery, stands in front of the building. The original cannon had been donated to the World War II metal scrap drive.

ORCHARD LAKE

Orchard Lake St. Mary's Preparatory School (former home of Brigadier General Joseph Copeland) 3535 Indian Trail / (248) 683-0514

Michigan Supreme Court justice Joseph Copeland built this home in 1858. He organized the Fifth Michigan Cavalry and was unceremoniously relieved

SOUTHEAST MICHIGAN

of command of the Michigan Cavalry Brigade just before the Battle of Gettysburg and replaced by Brigadier General George Custer. The home was also part of the Michigan Military Academy campus from 1877 to 1909.

PLYMOUTH

Plymouth Historical Museum 155 South Main Street / (734) 455-8940

Civil War exhibits related to Plymouth and Michigan including Company C, Twenty-fourth Michigan Infantry, can be found here. Members of Company C were recruited in August 1862 at the village green, which is now known as Kellogg Park.

The Weldon Petz Abraham Lincoln Collection features artifacts from Lincoln's life including a rare book once belonging to him, family genealogy and photographs, a lock of hair, a life mask circa 1860, handwritten legal documents, law books, Civil War art and artifacts relating to his assassination.

Dr. Petz acquired over twelve thousand Lincoln artifacts, research

papers and resource materials over a period of seventy years, making this the largest collection in Michigan, the second largest in the Midwest and one of the finest private collections in the country.

Plymouth Community Veterans Memorial Park South Main and Church Streets

A red brick path winds through this peaceful park lined with monuments paying tribute to veterans of all wars from the city of Plymouth and Plymouth Township. Amidst the other monuments stands a beautiful and unique Civil

Plymouth Man Commands Elite Unit

Brigadier General Hiram Berdan spent most childhood in Plymouth where his parents had settled. General Berdan organizer was the and commander of Berdan's Sharpshooters, which included the famous First and Second U.S. Sharpshooters, known for their expert marksmanship and green uniforms. He is buried in Arlington National Cemetery.

War monument dedicated to "Those Sons of Plymouth Who Offered Their Lives in the War Between the States."

The gift of Harry E. Bradner was originally unveiled in a ceremony on September 9, 1917, in Kellogg Park. The monument was later moved to Riverside Cemetery, where it stood for many years before being moved to its current location at the park.

PONTIAC

Oak Hill Cemetery 216 University Drive

Oak Hill Cemetery is the final resting place of Major General Israel B. Richardson and Governor Moses Wisner. Mortally wounded at Antietam, the injured general was visited by President Lincoln. It has been said Lincoln cried upon receiving the news of General Richardson's death. General Richardson was one of the Army of the Potomac's best generals who may have become its overall commander had it not been for his unfortunate death.

Governor Moses Wisner, the twelfth governor of Michigan, organized the Twenty-second Michigan Infantry, which trained at the Pontiac fairgrounds. Within five months of departing Pontiac with his regiment, the governor contracted typhoid fever in Kentucky and died. His estate is now home to the Pine Grove Historical Museum.

Also buried here are Brigadier General Joseph T. Copeland, who preceded General George A. Custer as commander of the Michigan Cavalry Brigade, and Salmon S. Mathews, lieutenant colonel of the Fifth Michigan Infantry. Mathews was severely wounded at the battles of Malvern Hill, Gettysburg and the Wilderness. He was brevetted colonel and brigadier general for gallant and meritorious service in those battles.

Lieutenant Colonel Melvin Brewser is also buried here. Brewser, one of Custer's finest officers, was killed at the Battle of Third Winchester, Virginia, on September 19, 1864, while commanding the Seventh Michigan Cavalry.

A cenotaph for Private John Stevens, who enlisted in Company G, Fifty-fourth Massachusetts Infantry (an all-black regiment) is here. Private Stevens died during the assault on Fort Wagner, South Carolina, on July 18, 1863. This action was depicted in the movie *Glory*. He was buried on the battlefield in a mass grave that, over time, has been washed into the sea.

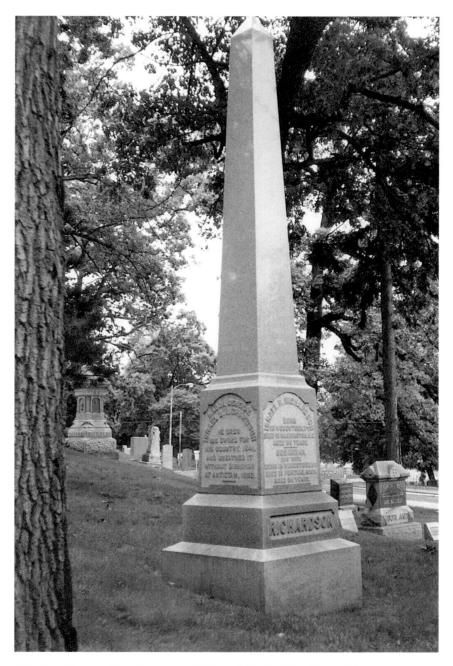

"He drew his sword for his country, 1841, and sheathed it without dishonor at Antietam, 1862," states the grave of General Israel Richardson in Oak Hill Cemetery.

Pontiac City Hall Woodward Avenue and Water Street

A bronze Civil War monument of a soldier at parade rest can be found here.

Old Fairgrounds Fairgrove and Saginaw Streets

A carved stone denotes the site where the Twenty-second Michigan Infantry trained during the summer of 1862.

Pine Grove Historical Museum 405 Cesar Chavez Avenue / (248) 338-6732

The museum is the former estate of Governor Moses Wisner, who was also colonel of the Twenty-second Michigan Infantry. The museum contains Civil War artifacts.

PORT HURON

Pine Grove Park / GAR—St. Clair County Civil War Monument

This tall Grand Army of the Republic Civil War monument features two stone carved soldiers at the base along with the original cannons fired during the Siege of Vicksburg, Mississippi, and a standard bearer on top. Also located in the park is a stone marker and text for Fort Gratiot, which was built in 1814 and abandoned in 1879. It was garrisoned with soldiers at different times through the Civil War.

Lakeside Cemetery 3663 Tenth Avenue

William Sanborn, lieutenant colonel of the Twenty-second Michigan Infantry, is buried here. He was brevetted colonel and brigadier general for

conspicuous gallantry at the battle of Chickamauga and meritorious service during the war. The Port Huron GAR Post was named after him.

William Hartsuff, captain in the Tenth Michigan Infantry and lieutenant colonel/assistant inspector general in the Army of the Ohio, is also interred here. He was brevetted brigadier general of the United States Volunteers on January 24, 1865. He and his two brothers all became generals.

Hartsuff accepted General Joseph E. Johnston's sword when Johnston surrendered his Confederate Army of Tennessee to General Sherman's Union forces at Bennett Place, North Carolina, on April 16, 1865. He supervised the parole of forty thousand men and secured records belonging to the Confederate government that Johnston's command was carrying. A tall Civil War monument of a soldier at parade rest is located in the soldiers' lot.

SALINE

William Webb Harwood Home

6356 East Michigan Avenue / private residence

A conductor on the Underground Railroad, William Webb Harwood hid fugitive slaves in his home's basement. The Harwood family is buried in the family cemetery on the

home's grounds.

STOCKBRIDGE

Stockbridge Town Hall 123 South Clinton Street

A nice example of a Civil War monument of a soldier at parade rest and a thirty-pound rifled Parrott cannon are on display. In the town hall basement is a large period print of the infamous Andersonville Prison

Prominent Officers of the Second Michigan

The Second Michigan Cavalry enjoys the distinction of producing several prominent officers who would go on to become major contributors to the Union cause: Colonel Phillip Sheridan, Colonel Gordon Granger, Major Russell Alger and Major Robert H.G. Minty.

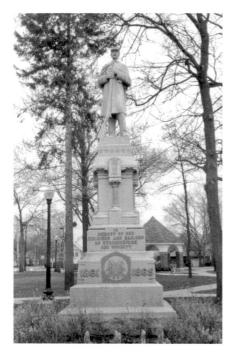

Left: Stockbridge Civil War soldier statue.

Below: Nolan Medere stands in front of Tecumseh's Brookside Cemetery GAR plot. Ron Medere.

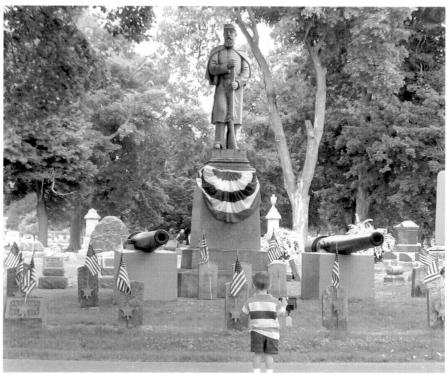

in Georgia, where many Union soldiers were imprisoned and endured horrendous treatment.

TECUMSEH

Brookside Cemetery 501 North Union Street

This Civil War monument, erected in 1882 as a tribute to the war's veterans, was moved to the entrance of Brookside Cemetery in 1928. The cemetery is the final resting place for several Civil War soldiers, including Captain Elliot Grey, a member of the Seventh Michigan Cavalry under General Custer's command. After the Civil War, Custer entrusted Grey with the care of his prized horse Don Juan when he was away on military assignments.

Rhoda Wells Pitts Bacon, stepmother to Elizabeth Bacon Custer, is buried in Brookside Cemetery alongside her first husband.

Don Juan's Grave

West Russell and South Occidental Roads / private property

Tecumseh is the burial site of General Custer's horse Don Juan. Custer had bequeathed his prized horse to Captain Elliot Grey. The horse became famous after bolting forward near the review stand during the Grand Review parade in Washington, D.C., at the end of the Civil War, taking the spotlight momentarily off the president and other important officials and on to the dashing young general. Custer, who ironically was an excellent horseman, attributed this mishap to the horse being spooked when a young girl attempted to put a wreath around its neck. The grave is marked by a large bolder with bronze plaque.

Tecumseh Museum 302 East Chicago Boulevard / (517) 423-2374

The museum contains information on local Civil War stories and soldiers.

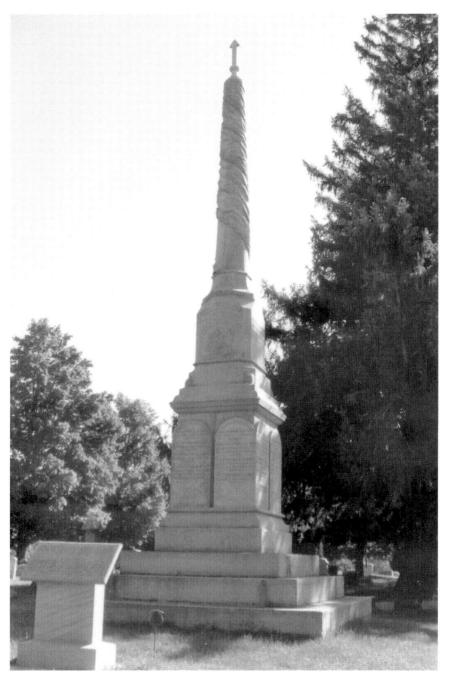

The first Civil War monument in the state is at Franklin Cemetery in Tipton.

SOUTHEAST MICHIGAN

TIPTON

Franklin Cemetery

North Tipton Highway / quarter mile north of M-50

Dedicated on July 4, 1866, this flag-draped obelisk is the first Michigan monument erected to honor Civil War veterans and lists the names of those from the Tipton area who died during the war.

YPSILANTI

Ypsilanti Historical Museum 220 North Huron Street / (734) 482-4990

This museum houses a good display of Civil War artifacts and cartes de visite.

Highland Cemetery 943 North River Street

Brigadier General Byron M. Cutcheon, colonel of the Twentieth Michigan Infantry and brigade commander, is buried here. General Cutcheon was awarded the Medal of Honor for leading his regiment in a charge against the enemy at Horseshoe Bend, Kentucky, on May 10, 1863.

Brigadier General Justus McKinstry is buried in the family plot. The West Point graduate was appointed U.S. quartermaster and provost marshal of St. Louis but later was arrested for alleged corruption and fraud. Charges were dropped upon his resignation.

The Ypsilanti Civil War Memorial is located at the south end of the cemetery. Erected by Mary Ann Starkweather and the Women's Relief Corps of Ypsilanti, the statue was unveiled on Memorial Day in 1895 and dedicated "in memory of the men who in the War of the Great Rebellion fought to uphold their country's flag. They died to make their country free," which is carved on the monument.

Thompson Block Marker

Initially called the Norris Block after its builder Mark Norris, an Ypsilanti pioneer, this Italianate three-story building designed for residential and retail use played a prominent role in Ypsilanti history. Completed in 1861, the building served as barracks for the Fourteenth Michigan Infantry in 1862 when it was mustered into service in February of that year.

According to early newspaper accounts, the Norris Block barracks was a comfortable and fun dwelling that offered a basement kitchen where each company prepared its own food and rooms on the upper floors to host dances and spirited debates.

The Fourteenth Michigan remained at the Norris Block barracks for two months. In 1863, the Norris Block was again used for training by the Twenty-seventh Michigan Infantry. Throughout the years, the building was used for many different commercial ventures. Recent plans were underway to convert the building into luxury residential lofts and retail space when a 2009 fire caused major damage.

A new state historical marker now tells the story of the Norris Block Barracks and Ypsilanti in the Civil War.

Grand Army of the Republic Hall, Carpenter Post No. 180

108 Pearl Street

This was the original meeting site of Civil War Veterans Carpenter Post No. 180 and Women's Relief Corps No. 65 of Ypsilanti.

Harriet Tubman Statue

229 West Michigan Avenue / plaza adjacent to the library

This bronze, lifelike statue of Harriet Tubman leading a child pays tribute to this remarkable woman, an escaped slave who, in turn, led others to freedom as a conductor on the Underground Railroad. It serves as a testament to the area's rich abolition and Underground Railroad history.

Dubbed the "Moses of her people," this suffragist and humanitarian became the first woman to command an armed military raid. In June 1863, she guided Colonel James Montgomery and his Second South Carolina black regiment up the Combahee River where they took overwhelmed Confederate outposts; destroyed stockpiles of cotton, food and weapons; and liberated over seven hundred slaves.

Michigan's Military Might

The state of Michigan's Civil War contributions included thirty-one infantry regiments, eleven cavalry, one engineers and mechanics, one sharpshooters, fourteen batteries of light artillery and several companies in other state and U.S. regular army regiments.

The First Michigan Engineers and Mechanics were the backbone of General Sherman's army, building fortifications, roads, bridges and railroads as well as destroying them during the Atlanta Campaign, the "March to the Sea" and the Carolina Campaign.

The First Michigan Engineers and Mechanics monument is located on the grounds of the state capitol in Lansing.

ORGANIZATION OF A CIVIL WAR ARMY

Army: two to four corps / 100,000 soldiers Corps: two to four divisions / 30,000 soldiers Division: three to four brigades / 10,000 soldiers Brigade: three to six regiments / 4,000 soldiers

Regiment: ten companies / 1,000 soldiers

Company: 100 soldiers

Officers of the Twenty-first Michigan Infantry. Library of Congress.

Chapter 2

SOUTHWEST MICHIGAN

Southwest Michigan provided excellent soldiers and leadership to the Union cause, as well as vocal opposition to slavery. Grand Rapids major general Byron Root Pierce, colonel of the Third Michigan Infantry and brigade commander, was seriously wounded at Gettysburg. Injuries didn't prevent him from becoming a division commander and one of Michigan's best citizen soldiers.

Major General Russell A. Alger of Grand Rapids became colonel of the Fifth Michigan Cavalry and led them gallantly at Gettysburg. Alger went on to become governor of Michigan, a U.S. senator, U.S. secretary of war and national commander-in-chief of the Grand Army of the Republic.

Major General William L. Stoughton of Sturgis was colonel of the Eleventh Michigan Infantry. This brigade staunchly defended Snodgrass Hill at the Battle of Chickamauga and thus helped save the Union army.

Under the command of Allegan's Benjamin D. Pritchard, lieutenant colonel of the Fourth Michigan Cavalry, Confederate president Jefferson Davis was tracked down and captured. The lieutenant colonel was brevetted brigadier general for this action.

Although the members of the Twenty-fifth Michigan were outnumbered ten to one, their commander, Schoolcraft's Colonel Orlando H. Moore refused to surrender on Independence Day. The Twenty-fifth Michigan stood their ground and defeated Brigadier General John Hunt Morgan's Confederate cavalry on July 4, 1863, at the Battle of Tebb's Bend, Kentucky.

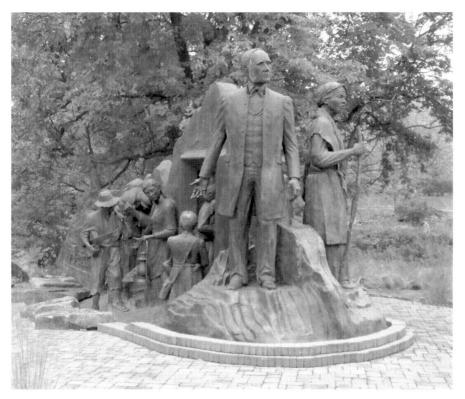

An Underground Railroad monument depicting Erastus and Sarah Hussey, as well as Harriet Tubman, leading escaped slaves to freedom. Kellogg House Park, Battle Creek,

Abolitionists in southwest Michigan welcomed freedom seekers arriving from Southern states into their communities or helped them continue their journey eastward to Detroit and across the river to Canada. History has not forgotten the determination of the abolitionists and freedom seekers. The largest memorial in the nation commemorating the Underground Railroad and the quest for freedom is located in Battle Creek, home of escaped slave Sojourner Truth, who became an influential abolitionist and women's rights activist during the nineteenth century. The southwest community of Vandalia became known as the "hotbed of abolition" due to the large amount of antislavery activity that took place here.

ALBION

Riverside Cemetery 1301 South Superior Street

William Henry Harrison Beadle, lieutenant colonel of the First Michigan Sharpshooters, is interred here. After being severely wounded in battle, which forced him to resign his officer's commission, Lieutenant Colonel Beadle rejoined the army in the Veterans Reserve Corps and was brevetted a brigadier general on March 13, 1865.

After the war, he became the Dakota Territory superintendent of public instruction. In this position, he championed the schools lands program to fund public education. He also served as president of the Madison State Normal School in South Dakota. A statue of General Beadle in the U.S. Capitol rotunda states, "He saved the school lands."

A GAR monument with a bronze tablet listing the names of the members of the E.W. Hollingsworth Post No. 210 stands here.

ALLEGAN

Old Jail Museum 113 Walnut Street / (269) 673-8292

Civil War artifacts, including personal items of Brigadier General Benjamin Dudley Pritchard, are housed here. See Oakwood Cemetery entry for more on Pritchard.

General Benjamin Pritchard House 330 Davis Street / private residence

This home was once the family residence of General Benjamin Pritchard.

Allegan County Courthouse 113 Chestnut Street

An impressive Civil War monument of a flag bearer with drawn sword stands outside the Allegan County Courthouse.

Michigan Cavalry Snags Jeff

Detachments of the Fourth Michigan Cavalry commanded by Lieutenant Colonel Benjamin Pritchard of Allegan caught up with fleeing Confederate president Jefferson Davis and his escort on May 10, 1865, near Irwinville, Georgia, and captured him when he tried to escape wearing his wife's coat and shawl, which led to reports that he tried to flee "dressed as a woman."

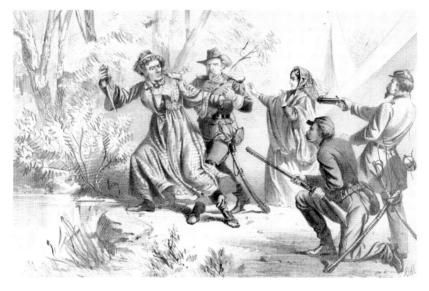

Jeff's Last Shift depicting members of the Fourth Michigan Cavalry capturing Confederate president Jefferson Davis. Library of Congress.

Oakwood Cemetery Western Avenue (M-89)

Brigadier General Benjamin D. Pritchard, lieutenant colonel of the Fourth Michigan Cavalry, is interred here. As commander of the Fourth, he led his men in the capture of the fleeing Confederate president Jefferson Davis at Irwinville, Georgia, on May 10, 1865.

Brigadier General Elisha Mix, colonel of the Eighth Michigan Cavalry, is also buried here.

ALLEN

Allen Township Cemetery 700 Edon Road / south of U.S. 12

A Civil War monument of a soldier at parade rest can be found here, along with the grave of Captain William G. Whitney of the Eleventh Michigan Infantry. Captain Whitney received the Medal of Honor for actions at the Battle of Chickamauga on September 20, 1863. The second lieutenant went out among the dead and wounded enemies

General Benjamin Pritchard. Allegan County Historical Society.

to retrieve their cartridge boxes containing much-needed ammunition. He and his comrades used the confiscated ammunition to repulse the Confederate attack.

The grave of Captain William Whitney, Eleventh Michigan Infantry, at Allen Township Cemetery in Allen.

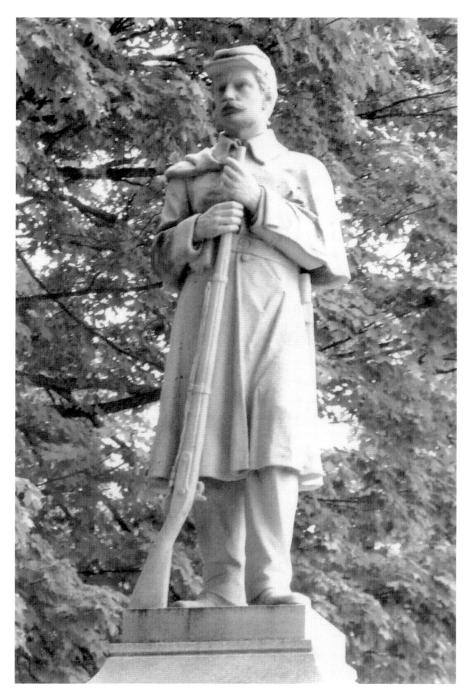

A close-up of a Civil War soldier statue in Allen Township Cemetery.

SOUTHWEST MICHIGAN

BATTLE CREEK

Soldiers and Sailors Civil War Monument

Monument Square / intersection of East Michigan and Washington Avenues and Van Buren Street

Dedicated in 1901, the thirty-five-foot Soldiers and Sailors Monument features two bronze soldiers atop a granite pillar carrying the American flag.

Underground Railroad Sculpture

East Michigan Avenue / located between Capital Avenue and Division Street

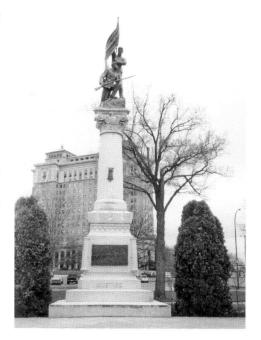

Civil War Soldiers and Sailors Monument, Monument Square, Battle Creek.

Standing fourteen feet high and

twenty-eight feet long, this monument is the nation's largest tribute to the Underground Railroad. Commissioned by the W.K. Kellogg Foundation, the massive monument honors the brave men and women who demonstrated moral fortitude by leading or housing refugees on their journeys to freedom despite severe consequences, including hefty fines, injury, death or imprisonment. It also pays tribute to those who embarked on this treacherous journey amidst an uncertain future in search of the coveted ideals of liberty and freedom.

An Ed Dwight design (he designed the Gateway to Freedom monument in Detroit, as well as other national monuments of prominent African Americans), this bronze statue depicts abolitionist Harriet Tubman, known as the "Black Moses," and local Underground Railroad conductors Erastus and Sarah Hussey leading a group of freedom seekers to safety.

Erastus Hussey served as mayor of Battle Creek and editor of the antislavery Liberty Press and was a member of Michigan's Anti-Slavery

Society. As a state senator, he helped to introduce Michigan's Personal Freedom Act of 1855, which blocked the Federal Fugitive Slave Act of 1850 in Michigan. Hussey may have assisted over one thousand escaped slaves in their journey to freedom. A nearby state historical marker titled "Erastus Hussey, Stationmaster Working for Humanity" denotes the spot where his home, a station on the Underground Railroad, once stood.

Sojourner Truth Monument Monument Park at the end of Sojourner Truth Downtown Parkway

This dramatic outdoor testament pays tribute to a remarkable woman far ahead of her time who was once buried in an unmarked grave. A twelve-foot bronze statue designed by sculptor Tina Allen honors the outspoken antislavery and women's rights activist. The bold monument, framed by the First United Methodist Church and city hall, takes center stage in the large plaza that features an amphitheater and meandering stonewalls. Two quotations by this inspirational woman can be found on bronze plaques.

Sojourner Truth Institute / Heritage Battle Creek Research Center

165 North Washington Street / (269) 965-2613

The Sojourner Truth Institute was established to expand the historical and biographical knowledge of Sojourner Truth's life work and carry on her mission by educating others and supporting projects that reflect the ideals and principles for which she stood. The Battle Creek Research Center houses one of the most extensive archives of Sojourner Truth artifacts and records in the United States.

Kimball House Historical Museum 196 Capital Avenue Northeast / (269) 966-2496

Rooms at this museum contain special exhibits dedicated to the life story of Sojourner Truth.

The Sojourner Truth monument at Monument Park in Battle Creek is part of the nation's largest tribute to the Underground Railroad.

Oak Hill Cemetery 255 South Avenue

Born into slavery in New York, Sojourner Truth, a well-known abolitionist and women's rights activist, is buried here. She escaped slavery with her infant daughter in 1826 and later went to court to recover her son, becoming the first black woman to win this type of case against a white man.

Truth toured the country speaking out against slavery, recruited black soldiers into the Union army and provided aid to freed slaves. Prior to the Civil War, she moved to Michigan.

Also buried here are Sergeant Charles M. Holton, Sergeant Edward Van Winkle and Erastus Hussey. Holton, sergeant of Company A, Seventh Michigan Cavalry, earned the Medal of Honor for capturing the flag of the Fifty-fifth Virginia Infantry at Falling Waters, Virginia, on July 14, 1863.

Van Winkle, sergeant of the 145th New York Infantry, Company C, earned the Medal of Honor for taking an advanced position along the skirmish line and charging the enemy, driving them from their cannons.

Hussey, a Quaker and ardent abolitionist, was stationmaster on the Underground Railroad. According to his personal estimation, he assisted one thousand people in their journey to freedom. When asked in later years if stationmasters received pay, the editor of the antislavery publication *Michigan Liberty Press* stated, "We were working for humanity." Hussey was mayor of Battle Creek and a state representative and senator. He attended the "Under the Oaks" meeting in Jackson in which the Republican Party was founded.

The cemetery also displays cannons from the ship USS Cumberland.

Cassopolis

Cass County Courthouse 120 North Broadway Street

A marker commemorating the Kentucky Raid of 1847 stands on the lawn of the Cass County Courthouse where the trial was held that resulted in the disputed fugitive slaves being freed and escaping to Canada. A mural on Broadway Street in downtown Cassopolis depicts events of the raid.

Shaffer Cemetery 66801 Lamb Road

Brigadier General George T. Shaffer, lieutenant colonel of the Twenty-eighth Michigan Infantry, is buried in the family cemetery.

CENTREVILLE

Prairie River Cemetery North Nottowa Street

A unique Civil War monument with a granite base features a soldier holding his gun in his left hand while shielding his eyes with this right hand as if he were scanning the battlefield.

Coldwater

Oak Grove Cemetery West Chicago Street and U.S. 12

A tall memorial pays tribute to Company B of the Forty-fourth Illinois Infantry made up of men from Coldwater and surrounding towns.

The cemetery is the final resting place of several Civil War veterans including Major General Clinton C. Fisk, the founder of Nashville, Tennessee's Fisk University; Brigadier General John G. Parkhurst, originally colonel of the Ninth Michigan Infantry; and Medal of Honor recipient Joseph E. Brandle. Brandle, a private in Company C, Seventeenth Michigan Infantry, was cited for his bravery at the battle of Lenoire, Tennessee, on November 16, 1863. Although severely wounded—including the loss of sight in one eye—Brandle still held to the colors until ordered to the rear by his regimental commander.

Historic markers in Coldwater denote the Fisk and Parkhurst family homesteads. Colonel Henry Clarke Gilbert of the Nineteenth Michigan Infantry is also buried at Oak Grove. Gilbert was mortally wounded during the Battle of Resaca, dying on May 24, 1864.

Old Sam—one of two hundred horses supplied to the famous Loomis Battery involved in twelve battles, including the bloody battle at Chickamauga—is buried here. Sam pulled streetcars prior to being

The grave of Sergeant Joseph Brandle, Seventeenth Michigan Infantry, at Oak Grove Cemetery in Coldwater.

called into war service and was a favorite among the troops. Although wounded several times, Sam was the only one of the two hundred horses supplied to Loomis Battery to survive. He mustered out of service in 1865. When Old Sam returned to Coldwater, he was met at the depot by hundreds of citizens and given a hero's welcome. When Old Sam died in November 1876 at the ripe old age of twentyseven, fellow battery members snuck the dead horse into the cemetery after sundown and buried him with full honors including taps. Although Sam's burial was secretive, a marker now denotes his grave.

A memorial stone in the Harrington family plot at Oak Grove Cemetery is dedicated to Lieutenant Henry Harrington,

commander of Company C of the Seventh U.S. Cavalry, part of Lieutenant Colonel George A. Custer's troops. This West Point graduate died at the Battle of the Little Big Horn in Montana on June 25, 1876. His body was never identified and lies on the battlefield. Lakota and Cheyenne eyewitness battle accounts describe the actions of one cavalryman whom they called the "bravest man they ever fought." Some believe Lieutenant Harrington is the "bravest man" to whom they refer.

Four Corners (Loomis) Park U.S. 27 and U.S. 12

An original ten-pound Parrott rifled cannon from the Loomis Battery A, First Michigan Light Artillery, originating in Coldwater is located here.

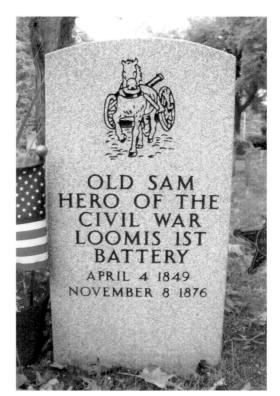

Right: The grave of Old Sam, Coldwater's favorite work horse for the Union cause, at Oak Grove Cemetery.

Below: Loomis Battery A, First Michigan Light Artillery, Parrott rifled cannon at Loomis Park in Coldwater.

Commemorative plaques list all the members of this battery. A plaque also honors Old Sam, a faithful horse that served the battery.

Across the street, next to the library, stands a Civil War monument of a soldier at parade rest.

Parkhurst Homestead 55 North Clay Street / private residence

This is the former home of General John Parkhurst, colonel of the Ninth Michigan Infantry.

Old Fairgrounds State and Marshall Streets

The training site for First Michigan Light Artillery Batteries: A (Loomis), F, L and Ninth Michigan Cavalry.

Home Depot U.S. 12 near I-69

This is the former location of the large horse farm where many horses sold to the Union army were raised. Prior to the advent of the automobile, Coldwater was known nationally and internationally for its horses. During the Civil War, the Union relied heavily on this area to supply the war effort with much needed draft and cavalry horses used to move troops and equipment.

DOWAGIAC

Dowagiac Area History Museum 201 East Division Street / (269) 783-2560

The museum features an Underground Railroad and Cass County in the Civil War exhibit.

Burke Park Soldiers and Sailors Civil War Monument

Main, Lowe and Spruce Streets

This impressive Civil War memorial features five individually carved stone soldiers representing the infantry, cavalry, artillery and navy with a standard bearer at the top.

McKinley Elementary School / Camp Willcox First and Paris Avenues

This is the former site of Camp Willcox where the Nineteenth Michigan Infantry organized and trained before going off to war in September 1969. It is nowed for 6

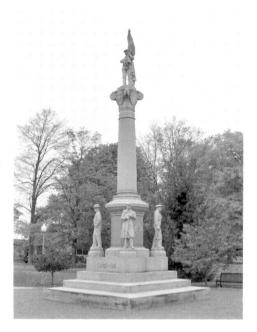

Dowagiac Civil War Soldiers and Sailors Monument at Burke Park.

September 1862. It is named for General Orlando Willcox.

EATON RAPIDS

GAR Park

200 East Hamlin Street / (517) 663-8118

The Eaton County Battalion of the GAR erected an encampment on this island for one week every August from 1908 until 1929. The park contains two Parrott rifled cannons as well as a monument to "Our Fallen Heroes 1861–1865."

GAR James B. Brainerd Post No. 111 Memorial Hall and Museum

224 South Main Street / (517) 256-9460

Originally a GAR hall from 1890 until 1922, it was named for Lieutenant James B. Brainerd of the Sixth Michigan Infantry who died of disease on June 3, 1864, in New Orleans. This new museum contains an outstanding collection of GAR memorabilia.

Former Austin Blair Home Site 248 South Main Street

This state marker denotes where Civil War governor Austin Blair once lived. In 1842, he moved his law practice to Eaton Rapids but later moved back

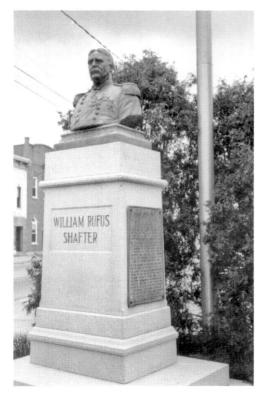

General William Schafter monument in downtown Galesburg.

to Jackson after the death of his wife and child and ensuing financial problems.

GALESBURG

Shafter Monument M-96 and Michigan Avenue / downtown

This bust statue with a granite base immortalizes Civil War brigadier general William R. Shafter. After serving as first lieutenant in the Seventh Michigan Infantry, he was awarded the Medal of Honor for heroism in leading a charge during the Battle of Fair Oaks, Virginia. Shafter served as a major in the Nineteenth Michigan Infantry and as colonel of the Seventeenth U.S.

Colored Troops. Later he fought in the Indian Wars and was promoted to major general in command of U.S. expeditionary forces in Cuba during the Spanish-American War.

Birthplace of General William R. Shafter Thirty-fifth Street, north of I-94

A stone monument denotes the birthplace and childhood home of this Medal of Honor recipient and describes his military service. See previous entry for detailed information.

GRAND RAPIDS

Grand Rapids Home for Veterans (formerly Michigan Soldiers Home) and Cemetery

3000 Monroe Avenue Northeast / (616) 364-5389

On a national level, the Civil War left an estimated half million veterans disabled from wounds or disease. When a proposed federal plan failed to materialize, Michigan chose to honor a debt to its wartime veterans by opening a state home for those in need. Passed by the Michigan legislature and signed by Governor Russell A. Alger (see Elmwood Cemetery entry), Public Act 152 of 1885 established a home for disabled soldiers, sailors and marines.

In 1886, five acres of the property was set aside for use as a cemetery. The Grand Rapids post of the Grand Army of the Republic dedicated the cemetery

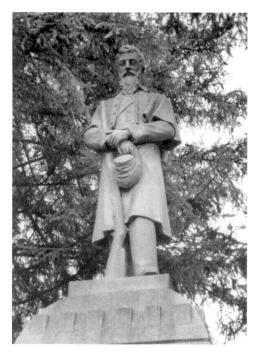

Michigan Soldiers Home Cemetery Civil War soldier statue in Grand Rapids.

on Memorial Day, May 31, 1886. In 1894, the cemetery's statue of an older Civil War soldier in repose with kepi in hand and head bowed was completed as a tribute to the Civil War veterans buried here. It is in the center of the cemetery, which is shaped in a Maltese cross. The cemetery has the largest number of Civil War veterans buried in the state at 2,412.

Seaman Franklin L. Wilcox and Brigadier General Frederick S. Hutchinson are buried here. Wilcox was awarded the Medal of Honor for bravery exhibited on January 15, 1865, when he jumped onto the beach from the USS *Minnesota* and assaulted North Carolina's Fort Fisher. At nightfall, he helped bring back the wounded as well as the ship's colors.

Hutchinson was colonel of the Fifteenth Michigan Infantry.

Fulton Street Cemetery 791 Fast Fulton Street

Brigadier Generals Stephen G. Chaplin and William P. Innes, Major General Byron Root Pierce and Major Peter Weber are buried here.

Chaplin died in January 1864 as a result of a lingering hip wound received in 1862 at the Battle of Fair Oaks, Virginia.

The grave of General Byron Pierce at Fulton Street Cemetery in Grand Rapids.

Innes was colonel of the First Michigan Engineers and Mechanics, one of the best engineering regiments in General William T. Sherman's army.

Pierce was seriously wounded on July 2, 1863, while leading his brigade, including the Third Michigan Infantry, in the Peach Orchard during the Battle of Gettysburg. One of Michigan's outstanding "citizen soldiers," Major General Pierce served as commander of the Michigan Soldiers Home and was the last surviving Michigan Civil War general.

Weber, another fine officer in the Michigan Cavalry Brigade, was killed leading a charge of the Sixth Michigan Cavalry at the Battle of Falling Waters, Maryland, on July 14, 1863.

Grand Rapids Public Museum 272 Pearl Street Northwest/ (616) 929-1700

Many Civil War artifacts are on display at the museum including the frockcoat and sword belonging to Brigadier General Stephen G. Champlin. Personal effects of Major General Byron Root Pierce are also on display.

Kent County Civil War Soldiers Monument

Monument Park / 2 North Division Street

The impressive Kent County Civil War Soldiers Monument is in Monument Park. This unique zinc memorial was recently restored to its original grandeur.

The monument was officially dedicated on September 17, 1885. Partially cast in Bridgeport, Connecticut, and assembled at

General Stephen Champlin's uniform frock coat on display at Grand Rapids Public Museum.

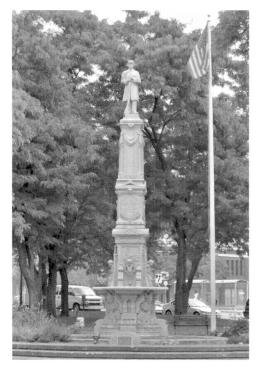

Kent County Civil War soldiers monument at Monument Park in Grand Rapids.

the Detroit Bronze Company, it pays tribute to the 4,214 Kent County soldiers who served in the Civil War. It's the first Civil War monument in the nation to include a fountain and to pay tribute to women in the war.

Oak Hill Cemetery 647 Hall Street Southeast

Behind the office, on the north-side section, is the "Soldiers Cemetery" established in 1861. On the south-side section stands the GAR Custer Post No. 5 monument, memorial obelisk and burial area.

Brigadier General Israel C. Smith, a West Point graduate and colonel of the Tenth Michigan Cavalry, is buried here. As a captain in the Third Michigan Infantry, Smith was commended

for his gallantry during the Battle of Gettysburg, in which he was wounded.

St. Mark's Episcopal Church 134 North Division Avenue / (616) 456-1684

Several memorial plaques are dedicated to those parishioners who served in the Civil War, including Major Peter Weber. The Bible used by the chaplain of the Third Michigan Infantry is on display.

Lincoln Place Corner of State Street and Washington Southeast

A bronze bust of Abraham Lincoln by sculptor Adolph Weinman can be found in the park.

Gerald R. Ford Job Corps Center 110 Hall Street Southeast

On the former site of Grand Rapids South High School stands a boulder with the inscription: "Cantonment Anderson." This tribute to the Third Michigan Volunteers Infantry rests on the site of the regiment's original muster in May 1861.

First dedicated in a reunion of surviving regiment members held in 1911, the boulder was rededicated in a memorial ceremony in June 2011, two days shy of the regiment's 150-year departure anniversary. An informational tablet was unveiled at the recent rededication detailing the history of the spot and the men who left there to fight and die in the war.

The Third Michigan organized into companies on forty acres at the Kent County Agricultural Fairgrounds along Kalamazoo Plank Road, now South Division Avenue. Amidst swamp-like conditions, soldiers drilled on a racetrack and bunked in a smelly two-story hall where bedding made from straw was a far cry from the comforts of home such as feather comforters or handmade quilts.

At 1,040 men strong, the Third Michigan saw action in a dozen campaigns including the First and Second Battles at Bull Run, Fredericksburg, Chancellorsville, the Wilderness, Spotsylvania, Cold Harbor, Petersburg, Appomattox and Gettysburg.

The regiment was commanded by Colonel Stephen Champlin, who took command when Colonel Daniel McConnell resigned. The Third's men disbanded mid-war when the remaining men were absorbed into the Fifth Michigan regiment.

Nearly one quarter of the Third Michigan died in service. Many soldiers were captured by the Confederacy and became prisoners of war. Benjamin K. Morse (see Lowell section) and Walter L. Mundell (see St. Johns section) were awarded Congressional Medals of Honor.

Cantonment Anderson was named in honor of Major Robert Anderson, the commander and defender of South Carolina's Fort Sumter. The Eighth Michigan Infantry, Second Michigan Cavalry and First Michigan Light Artillery, Battery K, trained here as well.

Central High School 421 Fountain Street Northeast

A bronze plaque and boulder denotes where Camp Kellogg and Camp Lee once stood, now Central High School. The Sixth and Seventh Michigan

Female Spy Avoids Hanging

Actress Pauline Cushman, who grew up in Grand Rapids, was a Union spy who fraternized with Rebel commanders and obtained valuable information. She was caught, tried by a military court and sentenced to death. She was saved three days before her hanging by invading Union troops. President Lincoln made her a brevet major, and she lectured around the county about her exploits in uniform. She is buried at the Presidio National Cemetery in San Francisco.

Cavalry, part of the famed Michigan Cavalry Brigade led by General George A. Custer, trained here. The Tenth Michigan Cavalry trained and organized here as well.

HASTINGS

Historic Charlton Park Village and Museum 2545 South Charlton Park Road / (269) 945-3775

Civil War—era buildings and artifacts are on display. The second largest Civil War reenactment in the state takes place here in July.

Tyden Park 304 North Broadway Street

A tall Civil War monument of a soldier at parade rest is located here.

Riverside Cemetery 1003 West State Road

Interred here is Brigadier General William H. Dickey. Dickey joined the Sixth Michigan Infantry as a first lieutenant and later became the colonel of the Eighty-fourth U.S. Colored Troops, leading them in the Red River Campaign.

HOLLAND

Holland Museum

31 West Tenth Street / (616) 392-9084

Civil War memorabilia of local interest is displayed here.

Centennial Park Tenth and River Streets

The Holland Area War Dead Monument located at Centennial Park pays tribute to those from the Holland area who died in all American conflicts including the Civil War.

Pilgrim Home Cemetery 370 East Sixteenth Street

A Civil War monument of a soldier at parade rest honors those who served.

KALAMAZOO

National Driving Park (Site of Old Racetrack and National Fair Grounds)

Portage Street, between Stockbridge Avenue and Reed Street

At this site of Camp Fremont, the Sixth Michigan Infantry trained and organized from June through August 1861. Also, the Thirteenth Michigan Infantry trained here at Camp Douglas from September 1861 through February 1862, and the Twenty-fifth Michigan Infantry was organized here in August 1862.

General's Famous Ride Astride Michigan-Bred Morgan

Reinzi, the celebrated black Morgan horse ridden by General Phillip Sheridan during the Battle of Cedar Creek in Virginia, was raised in Fair Plain Township in Montcalm County and gifted to the general by members of the Second Michigan Cavalry. After the famous ride immortalized by the Thomas Buchanan Read poem "Sheridan's Ride," the horse's name was changed to Winchester. Upon his death, Winchester was preserved and is on display at the Smithsonian.

Kalamazoo Valley Museum 230 North Rose Street / (269) 373-7990

Collections contain the uniform and field desk of Schoolcraft native Colonel Orlando H. Moore of the Twenty-fifth Michigan Infantry.

Colonel Moore, the hero of the Battle of Tebbs Bend, Kentucky, refused to surrender to a much larger Confederate cavalry force led by Brigadier General John Hunt Morgan on July 4.

The Spencer carbine used by Corporal George Munger during the capture of Confederate president Jefferson Davis is also part of the collection. It has a silver plate on the stock that reads, "The Gun That Stopped Jeff Davis."

Olde Peninsula Brewpub 200 East Michigan Avenue

A military recruiting office once occupied the main floor of this building where the brewpub is now located. To meet the growing demand for medical treatment required by injured and sick Civil War veterans, the Ladies' Soldiers Aid Society converted the upper floors into a hospital.

Bronson Park / Lincoln at Kalamazoo Marker South Park Street (downtown)

Abraham Lincoln made only one Michigan appearance. On August 27, 1856, Lincoln visited Kalamazoo, where he gave a speech for Republican presidential candidate John C. Freemont and spoke against extending slavery into new states. A GAR boulder with a descriptive plate marks the spot where Lincoln stood during his speech.

A Civil War-era Columbiad cannon is on display in the park, and another commemorative boulder salutes the Eleventh Michigan Cavalry, which trained and organized at Kalamazoo in 1863.

A ten-inch Columbiad cannon at Bronson Park in Kalamazoo.

Mountain Home Cemetery 1402 West Main Street

Brigadier Generals Dwight May and Charles E. Smith are buried here. May served as colonel of the Twelfth Michigan Infantry and as Michigan's lieutenant governor from 1867 to 1869. Smith, lieutenant colonel of the Eleventh Michigan Cavalry, was brevetted a brigadier general for faithful and meritorious service during the war.

Riverside Cemetery

A Civil War monument of a soldier at parade rest is located here.

LOWELL

Oakwood Cemetery 301 East Main Street

Buried here is Corporal Benjamin Morse of the Third Michigan Infantry. He was awarded the Medal of Honor for capturing the flag of the Fourth Georgia Battery on May 12, 1864, during the Battle of Spotsylvania Court House, Virginia.

A monument depicting a young Civil War soldier and cannon can be found in the cemetery.

Marshall.

Grand Army of the Republic Hall 402 East Marshall Street / (269) 781-8544

One of the few remaining GAR halls, it was built in 1902 for the Marshall Chapter of the Union Civil War Veterans. The attractive red brick building now houses the Marshall Historic Society's archives and artifacts from the Civil War, Spanish-American War and World Wars I and II along with other Marshall memorabilia. Built at a cost of \$3,000, this hall was named for Marshall's Corporal Calvin Colegrove, color-bearer for the Michigan First Infantry. Colegrove was killed at the First Battle of Bull Run on July 21, 1861. The GAR's motto was "Fraternity, Charity and Loyalty." The Union veteran's group promoted pensions and care for veterans and their families.

A boulder and plaque in front of the GAR Hall marks the site of Camp Owen where the First Michigan Engineers and Mechanics organized and trained from October to December 17, 1861.

Oakridge Cemetery 614 Homer Road

Lieutenant George A. Woodruff, commander of Battery I, First U.S. Artillery, is buried here. He died in battle on July 3, 1863, courageously directing the fire of his cannons during Pickett's Charge at Gettysburg.

Adam Crosswhite, an escaped slave who settled in Marshall, is interred here. Crosswhite, along with his wife, Sarah, and children, moved to Marshall

GAR Hall in Marshall.

in 1843 after escaping from a Kentucky plantation when they heard their son John would be sold off. Marshall, with its strong antislavery sentiment, was part of the Underground Railroad and a hospitable place for blacks to settle. Even at this time, the local school was racially integrated.

In 1847, Kentuckian Francis Giltner, claiming legal ownership of the Crosswhites, sent agents to arrest and retrieve the family. Neighbors were alerted and prevented the agents from confiscating the family. A historic marker on U.S. 12 marks the spot of this event.

While the agents were jailed and tried for assault, battery and housebreaking, the Crosswhites escaped to Canada. Mr. Giltner sued the leaders behind the agents' arrests and won. Banker Charles T. Gorham was determined the sole defendant and fined \$4,800. Detroit businessman and abolitionist Zachariah Chandler paid the fine. See Elmwood Cemetery entry for more information on Chandler and George DeBaptiste who helped the Crosswhites get to Canada.

The harsh Fugitive Slave Law of 1850, also known as the "bloodhound law," was enacted after the Crosswhite incident and similar events to appease Southern slaveholders who complained Northerners where brazenly interfering with their rights to retrieve their property.

MARTIN

East Martin Cemetery Eighth Street

Private Andrew Bee, Company L, Fourth Michigan Cavalry, is buried here. Bee claimed to be the first Union soldier to recognize fleeing Confederate president Jefferson Davis as he tried to escape capture wearing his wife's coat and shawl on May 10, 1865, at Irwinsville, Georgia. His tombstone states that he "was the first man to lay hands on Jeff Davis at his capture."

New Buffalo

New Buffalo Welcome Center

Amidst the numerous historical markers in this vicinity, one pays tribute to the Iron Brigade and Twenty-fourth Michigan Infantry. See Campus Martius, Detroit entry for more details.

NILES

Fort St. Joseph Museum 508 East Main Street / (269) 683-4702

Hand-drawn pictographs by Lakota chief Sitting Bull are on display. The pictographs include events in his life that occurred during the Civil War period. The museum also contains information about southwest Michigan's role in the Underground Railroad.

Silverbrook Cemetery 1400 East Main Street

Major General Henry A. Morrow is interred here. As colonel of the famed Twenty-fourth Michigan Infantry, he courageously led the regiment into the Herbst Woods along McPhearson Ridge during the first day of the Battle

Southwest Michigan

of Gettysburg, buying the Union army much needed time.

At 80 percent, the Twenty-fourth experienced the highest casualty rate of any regiment at Gettysburg. This figure includes killed, wounded and missing. Colonel Morrow was severely wounded but recovered and later commanded a brigade. He remained in the regular army after the war and commanded the Twenty-first U.S. Infantry.

General Morrow's brother-inlaw, Colonel Frank Graves, of the Eighth Michigan Infantry, is also buried here. Colonel Graves was taken prisoner at the Battle of the Wilderness and murdered by his captors over his fancy boots.

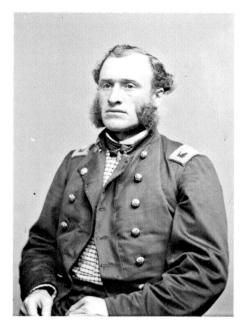

General Henry Morrow. Library of Congressv

Veterans Park East Main Street and Front Street

A one-hundred-pound Parrott rifled cannon stands here.

Camp Barker

720 South Eleventh Street

A supermarket stands near the former location of Camp Barker, where the Twelfth Michigan Infantry organized and trained from February to March 1862 before heading off to the Battle of Shiloh in April 1862.

SARANAC

Saranac Cemetery David Highway

Brigadier General Ambrose A. Stevens, colonel of the Twenty-first Michigan Infantry, is buried here. Seriously wounded at the Battle of Perryville, Kentucky, on July 25, 1862, Colonel Stevens was made brevet brigadier general for gallant and meritorious service.

SCHOOLCRAFT

Underground Railroad Home of Dr. Nathan Thomas 613 East Cass Street

Dr. Nathan Thomas was one of Michigan's most active Underground Railroad conductors, a founding member of the Republican Party and Kalamazoo County's first physician. He and his wife helped between 1,000 and 1,500 fugitive slaves escape to freedom.

Schoolcraft Cemetery U.S. 131 and West Lyons Street

Dr. Nathan Thomas (previous entry) is buried here.

Harrison Cemetery South Tenth Street and West University Avenue

Corporal George M. Munger of the Fourth Michigan Cavalry is buried here. Munger claimed to have recognized Confederate president Jefferson Davis as he fled allegedly dressed as a woman and ordered him to surrender near Irwinsville, Georgia, on May 10, 1865.

SOUTHWEST MICHIGAN

STURGIS

Oaklawn Cemetery 300 South Street

Major General William L. Stoughton, colonel of the Eleventh Michigan Infantry and a United States congressman, is interred here. General Stoughton led a brigade in the defense of Snodgrass Hill at the Battle of Chickamauga, Georgia, on September 20, 1863.

Oaklawn is the final resting place of Phillip Schlachter, a member of the Seventy-third New York Infantry. Schlachter was awarded the Medal of Honor for capturing the flag of the Fifteenth Louisiana Infantry on May 12, 1864, during the battle of Spotsylvania Court House, Virginia.

Sunfield

Grand Army of the Republic Hall 115 Main Street

The Samuel W. Grinnell Post No. 283 is the only GAR hall in Michigan that has remained in continuous service. Today, it's used by Sons of Union Veterans, Curtenius Guard Camp No. 17.

THREE RIVERS

Bowman Park
East Hoffman and
North Main Streets

This tall Civil War monument of a soldier at parade rest lists battles in which local soldiers served.

Bowman Park Civil War soldiers statue in Three Rivers.

Riverside Cemetery Evans Street and Fourth Avenue

John Ayers of the Eighth Missouri Infantry is buried here. He received the Medal of Honor for gallantry in a charge at Vicksburg, Mississippi, on May 22, 1863.

Scidmore Park Michigan and Spring Streets

A pre—Civil War smoothbore cannon used by the local militia is displayed here along with a sign describing the cannon's history.

Union City

Riverside Cemetery North Broadway Street

Brigadier General George S. Acker is buried here. General Acker enlisted as captain in the First Michigan Cavalry and progressed to colonel of the Ninth Michigan Cavalry. This regiment was instrumental in chasing down Brigadier General John Hunt Morgan and his Confederate Raiders in southeastern Ohio. He was part of Sherman's "March to the Sea" and through the Carolinas.

Civil War Soldier Monument Main Street

A nice Civil War monument of a soldier at parade rest and two Parrott cannons stand next to the church.

Vandalia

Milo Barnes Park M-60 west of Main Street

An Underground Railroad State of Michigan historical marker stands at the site of O'Dell's Mill where slave catchers and local abolitionists met

SOUTHWEST MICHIGAN

in a confrontation during the Kentucky Raid of 1847. The result of the action by local abolitionists led to the implementation of a stringent fugitive slave law in 1850 that became one of the catalysts that led to the Civil War. Attached to the marker is a box containing driving guides featuring Cass County Underground Railroad sites. The Vandalia area was known as the "hotbed of abolitionism."

Bonine Home and Carriage House M-60 and Penn Road

Quaker abolitionist James E. Bonine and his family lived here. The carriage house is a documented station on the Underground Railroad. Both buildings are being restored by the Underground Railroad Society of Cass County.

Stephen Bogue House and Stone Marker 20257 M-60

This was the home of Stephen Bogue, a prominent abolitionist who played a major role in the August 1847 Kentucky Raid. His home served as a station on the Underground Railroad.

Prairie Grove Cemetery Penn Road, north of Fox Street

Underground Railroad conductors James Bonine and Stephen Bogue are buried here.

WHITE PIGEON

Depot Park / Camp Tilden
West Peck Avenue and St. Joseph Street

A boulder and a bronze plaque erected in 1915 mark the site of Camp Tilden where the Eleventh Michigan Infantry and Church's Battery D, First Michigan Light Artillery, encamped and trained.

Famous Farnsworth House Inn Named After Local Lad

The famous Farnsworth House Inn in Gettysburg is named in memory of Elon John Farnsworth. Farnsworth was killed in battle at Gettysburg during an ill-advanced charge. Born in Livingston County's Green Oak Township, Farnsworth was the nephew of John F. Farnsworth, a prominent politician and Civil War general.

Prior to joining the service, Farnsworth attended the University of Michigan where he was a member of the Chi Psi fraternity. Farnsworth and other members of the fraternity were expelled following a raucous drinking party that resulted in a classmate dying after being tossed out the window.

At the outbreak of the Civil War, Farnsworth was appointed a first lieutenant with the Eighth Illinois Cavalry and served with distinction throughout the early years of the war. On June 29, 1863, just two days before the Battle of Gettysburg, Captain Farnsworth was one of three young captains to receive an unexpected promotion in rank to brigadier general by Brigadier General Alfred A. Pleasonton. George Custer and Wesley Merritt were the other two to receive promotions.

On July 3, just days after his promotion, Brigadier General Farnsworth was ordered to make a change with his cavalry brigade against Confederate positions below Little Round Top. Although General Farnsworth objected, claiming there was no hope of success, he agreed to the plan when his commanding officer General Judson "Kilcavalry" Kilpatrick accused him of cowardice. The entrenched Confederates repulsed the charge, and Farnsworth's brigade sustained heavy losses. The young brigadier general received numerous wounds and died needlessly on the battlefield. He is buried in Rockton, Illinois.

Authors' Top Ten State Civil War Monuments

Soldiers and Sailors Monument, Hackley Park, Muskegon Michigan Soldiers and Sailors Monument, Campus Martius, Detroit In Defense of the Flag Monument, Withington Park, Jackson Soldiers and Sailors Monument, Monument Square, Battle Creek First Michigan Sharpshooters Monument, Capitol Square, Lansing Soldiers and Sailors Monument, Burke Park, Dowagiac Kent County Zinc Soldiers and Sailors Monument, Monument Park, Grand Rapids

Soldier Statue, Soldier's Home Cemetery, Grand Rapids Soldier Statue, Ionia County Courthouse, Ionia Monroe County CivilWar Soldiers Fallen Memorial Monument, Monroe

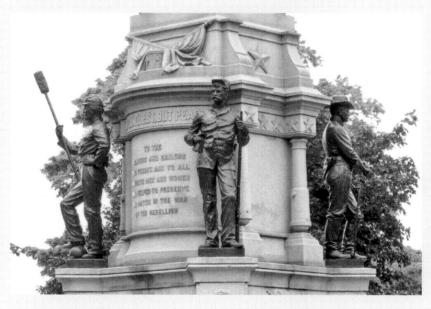

A close-up of the Civil War soldiers and sailors monument at Hackley Park, Muskegon.

Chapter 3

MID-NORTHERN MICHIGAN

Inspired by stories from his childhood told by local Civil War veterans, Michigan-born author Bruce Catton introduced a new generation to this definitive chapter in American history with the release of his popular Civil War trilogy in the 1960s. Many Civil War buffs today trace their fascination with the Civil War back to early encounters as children to the spellbinding pages of Catton's books.

First-person accounts—such as those written by mid-Michigan authors Sarah Emma Edmonds, who enlisted in the army as Franklin Thompson, and General James Harvey Kidd, who wrote about his service with General Custer and the Michigan Cavalry Brigade—provide us with valuable insider information on the hardships and triumphs faced by the people of this era both on the home front and battlefield.

It was from the counties in mid- and northern Michigan where Native Americans, who were not even United States citizens, joined the fray and fought courageously alongside their American brothers and sisters with one common purpose—to preserve and protect the Union.

ALMA

Riverside Cemetery 800 Washington Street

Brigadier General Ralph Ely, colonel of the Eighth Michigan Infantry, is buried in Riverside Cemetery. He fought with his regiment in many major battles including Antietam, Fredericksburg, Vicksburg, Wilderness, Spotsylvania and Petersburg.

BAY CITY

Historical Museum of Bay County 321 Washington Avenue / (989) 893-5733

Civil War artifacts are on display here including Captain James Birney's sword given to him by General George A. Custer.

Bay County War Memorial 515 Center Avenue

Standing in front of the county building, the memorial lists the names of county soldiers who have died in the nation's wars, including the Civil War.

Elm Lawn Cemetery 300 Ridge Road

Brigadier General Benjamin Franklin Partridge is buried here. Partridge enlisted in the Sixteenth Michigan as a first lieutenant and rose through the ranks to become regimental colonel. He was wounded twice in battle.

Pine Ridge Cemetery southeast corner of Ridge and Tuscola Roads

An abandoned pioneer burial ground, Pine Ridge is the final resting place for many of Bay City's earliest pioneers. The cemetery was founded by

Judge James Birney, an abolitionist who served as lieutenant governor of Michigan in 1861. Judge Birney, the brother of Major General David Birney of Pennsylvania, is also interred here.

The cemetery includes a Soldiers Rest, where individual soldiers could be buried together with their comrades. The Grand Army of the Republic Post No. 67 once maintained the plot where 150 Civil War veterans are buried. A monument made of Whitney granite and erected by the local GAR Post reads, "They saved their country and fought for freedom. They are quietly sleeping Under the 'Red, White and Blue' to preserve and strengthen those kind and fraternal feelings which bind together the soldiers and sailors of the rebellion."

BENZONIA

Benzonia Township Cemetery Love Road

This is the final resting place of Michigan author Bruce Catton (1899–1978), who is best known for his two Civil War trilogies: *The Army of the Potomac* and *The Centennial History of the Civil War*. The historian, author and editor was born in Petoskey but spent most of his childhood in Benzonia. At the age of fifty-one, following careers in the navy, journalism and the federal government, Catton published his first Civil War book, Mr. Lincoln's Army. In 1954, he became the editor of *American Heritage* magazine and was awarded the Pulitzer Prize for *A Stillness at Appomattox*. In 1978, Catton died at his Frankfort, Michigan summer home.

Catton attributed his fascination with the Civil War to growing up with the Civil War veterans in Benzonia. He said that they "gave a color and a tone, not merely to our village life, but to the concept of life with which we grew up."

In the 1970s, Catton turned to his native state for inspiration and wrote Waiting for the Morning Train, an account of his Michigan childhood, and Michigan: A Bicentennial History.

Benzonia Area Historical Museum 6941 Traverse Avenue / (231) 882-5539

Several exhibits highlighting the life and accomplishments of author Bruce Catton can be found here.

Mills Community House 841 Michigan Avenue (U.S. 31)

A state historical marker denotes the former Benzonia Academy where historian and author Bruce Catton resided with his family when his father accepted a teaching position there. In 1906, Catton's father became the academy's principal. The Cattons lived in the building, which served as the principal's home and the female dormitory.

BIG RAPIDS

Highland View Cemetery

Brigadier Generals Stephen Bronson and Joseph O. Hudnutt are buried here. General Bronson joined the 12th Illinois Cavalry as a private and fought in the Battle of Gettysburg. He was appointed colonel of the 153rd Illinois Infantry and then brigadier general commanding the 1st Brigade of the Division of Western Tennessee.

Hudnutt, lieutenant colonel of the Thirty-eighth Iowa Infantry, was brevetted a brigadier general for faithful and meritorious service in the war.

Mecosta County Building southeast corner of Stewart and Elm Streets

A Civil War soldier monument erected by the women of Mecosta County and dedicated in 1893 depicts a lone soldier bearing a flag.

BOYNE CITY

Veterans Memorial Park 207 North Lake Street

An eight-inch Rodman cannon is displayed in the park.

Maple Lawn Cemetery 417 Elm Street

A Civil War soldier at parade rest statue is located here.

Corunna

Shiawassee County Courthouse 208 North Shiawassee Street

On the grounds of this beautiful and historic courthouse designed by Claire Allen stands an unusual Civil War monument with large draped American flags, similar in style to General Sherman's grave marker found at Cavalry Cemetery in St. Louis, Missouri.

FLINT

Aventine Cemetery /
Camp Thomson
Chavez Drive and
Geneseret Street

A recently dedicated historical marker denotes Camp Thomson, the training site of the Tenth Michigan Infantry from November 1, 1861, to April 22, 1862.

Genesee County Courthouse

900 South Saginaw Street

A state historic marker pays tribute to Flint resident Sarah Emma Edmonds who enlisted in the Union army on May 25, 1861, under the

Confederate General Longstreet's Michigan Connection

Lieutenant General lames Longstreet, known as General Lee's "Old War Horse," owned property in the Flint area before the war. He also visited the area after the war. His first wife, Maria Louisa Garland Longstreet, the granddaughter Jacob Smith, founder of Flint. Longstreet's youngest Louise "Lulu" Longstreet, was born in Flint in 1872 while her mother was visiting her sister Mary Garland Deas.

Last Surviving Civil War Veterans

The last two surviving Civil War veterans living in Michigan were Privates Orlando LeValley and Joseph Clovese. Private LeValley, a member of the Twenty-third Michigan Infantry, died on April 19, 1948, at age ninety-nine. He was the last surviving Civil War soldier from Michigan and is buried in Fairgrove's Brookside Cemetery. A granite monument was recently dedicated in his honor.

Clovese is not only the state's last surviving Civil War veteran, but he's also the last surviving black soldier of the Union army. Born a slave in St. Bernard Parrish, Louisiana, Clovese was a young teen when he escaped bondage and joined the Union army. He became a member of the Sixty-third United States Colored Infantry who recruited out of Louisiana. Near the end of his life, Clovese moved to Pontiac to be with family. He died on July 13, 1951 at age 107, while a patient at the former veteran's hospital in Dearborn. He is buried in Pontiac's Perry Mount Cemetery.

name of Franklin Thompson. Fearing her abusive father, the Canadian-born Edmonds fled New Brunswick and settled in Flint. Here, she sold books, disguised as a male, until entering the army.

Two thirty-pound Parrott rifled cannons, a monument to the GAR Crapo Post No. 145, a monument to the Tenth Michigan Infantry and a state historical marker entitled Resisting Slavery can also be found here.

Glenwood Cemetery 2500 West Court Street

Governor Henry H. Crapo is interred here. Crapo served as Michigan's fourteenth governor from January 1865 to January 1869 during the latter part of the Civil War and early years of Reconstruction.

Also buried here are Brigadier General William Hawley and Confederate lieutenant colonel George Deas. Hawley, colonel of the Third Wisconsin Infantry, participated in Sherman's "March to the Sea." Deas was assistant adjustant general on the staff of General Robert E. Lee. He is the brother-in-law of famous Confederate general James Longstreet, also known as Lee's "Old War Horse."

Spring Grove 720 Ann Arbor Street / private residence

This home belonged to Colonel Thomas Stockton, a West Point graduate who raised and commanded the Sixteenth Michigan Infantry. His niece Maria Louisa Garland married Confederate general James Longstreet.

Frankenmuth

Michigan's Own Military and Space Museum 1250 Weiss Street /(989) 652-8005

This museum displays the nation's largest collection of Medals of Honor including medals belonging to Civil War heroes General William Withington and Thomas Bourne.

GRAND HAVEN

Lake Forest Cemetery 1304 Lake Avenue

Buried here is Major Noah Ferry of the Fifth Michigan Cavalry. Ferry was killed instantly when shot through the head during the fight with Jeb Stuart's Confederate cavalry at East Cavalry Field, Gettysburg, on July 3, 1863. Moments before he was shot, he could be heard motivating his men with the battle cry, "Rally boys! Rally for the fence!"

The cemetery contains a Civil War monument of a soldier at parade rest.

GRAYLING

Hartwick Pines State Park I-75 (exit 259) and M-93 / (989) 348-7608

An interpretative display tells the history of Michigan's logging industry in the 1800s and the white pine forests of Michigan that covered a large part of the state during that period. Lumber, farming, iron and copper

were the main industries in Michigan at the time of the Civil War. These industries played an integral role in Union success as they provided the raw materials necessary to produce weapons, ammunition and other much-needed supplies.

HART

Oceana County Courthouse 100 State Street

A detailed Civil War soldier monument stands on the front courthouse lawn.

IONIA Highland Park Cemetery East Main Street

This cemetery is the final resting place of Brigadier General James Harvey Kidd, General Kidd rose in rank to become colonel of the Sixth Michigan Cavalry by recommendation his commanding officer, General George A. Custer. He was brevetted brigadier general for gallant and meritorious service in the Shenandoah Valley Campaign. General Kidd would also command the

General James Kidd, colonel of the Sixth Michigan Cavalry and author of Recollections of a Cavalryman. Bentley Historical Library, University of Michigan.

Michigan Cavalry Brigade. Later in life, General Kidd published his memoirs, titled *Recollections* of a Cavalryman with Custer's Michigan Cavalry Brigade in the Civil War.

Ionia County Courthouse 100 West Main Street / (616) 527-5322

The regimental flag the Twenty-first Michigan Infantry, with a separate battle honors banner, is displayed in all its glory on the first floor. The Twenty-first trained at Camp Sigel, which was located near here. On the courthouse grounds stands unique Civil War soldier monument depicting the soldier's thumb on the hammer of his rifled

A GAR Civil War soldier statue on the Ionia County Courthouse lawn.

musket as if getting ready to fire. Two nearby monuments mark the GAR Borden Post No. 211 and honor local Medal of Honor recipient Sergeant Alonzo Woodruff of the First U.S. Sharpshooters.

Camp Sigel Boulder and Plaque East Main Street

The Twenty-first Michigan Infantry trained and organized at Ionia (Prairie Creek) from late August through September 12, 1862. They would go to fight at Perryville and Chickamauga and in the Atlanta Campaign, Sherman's "March to the Sea" and the Carolinas.

Camp Sigel, named after General Franz Sigel, was the training ground of the Twenty-first Michigan Infantry. The tablet was dedicated on

Camp Sigel marker at the Ionia training site of the Twenty-first Michigan Infantry.

September 12, 1912, by the citizens of Ionia and surviving members of the regiment to commemorate the fiftieth anniversary of the regiment's departure for the South.

ITHACA

Ithaca Cemetery Spring and West North Streets

In this cemetery lies Lieutenant Colonel Nathan Church of the Twenty-sixth Michigan Infantry whom General Nelson Miles called "one of the best soldiers in the Army of the Potomac." On May 12, 1864, at the Battle of Spotsylvania Court House, Virginia, Church was one of the first soldiers to enter the Confederate works and engage in hand-to-hand combat at the "Bloody Angle." He was cited for gallantry at Petersburg and the Appomattox Campaign.

When the war ended, Church became assistant adjutant general on General Miles's staff at Fortress Monroe. Here, he supervised the imprisonment of former Confederate president Jefferson Davis.

Kalkaska

Evergreen Cemetery 209 Laurel Street

Two Medal of Honor recipients from the same regiment, the First Michigan Sharpshooters, lie in rest at Evergreen Cemetery. Sergeant Charles H. DePuy was awarded his medal for aiding General Barlett in working the guns in battle at Petersburg, Virginia, on July 30, 1864.

Private Charles M. Thatcher received his medal for actions on July 30, 1864, as well. Thatcher didn't retreat or surrender when the works was captured. Without regard for his own personal safety, Private Thatcher continued to return enemy fire.

GAR Baker Post No. 84 Cherry Street and Fourth Street

This monument honors the Colonel Baker Post No. 84.

MACKINAW CITY

Marina Park South Huron Avenue

Three nine-inch Dahlgreen cannons from the USS *Hartford*, Admiral David G. Farragut's famous flagship from the Battle of Mobile Bay, can be found here.

USS Hartford Dahlgren cannon at Marina Park in Mackinaw City.

MANISTEE

Manistee County Historical Museum 425 River Street / (231) 723-5531

Civil War artifacts belonging to a local veteran are exhibited here.

Oak Grove Cemetery 330 Fifth Street

Interred here is Medal of Honor recipient John Hyland, an assistant gunner on the navy ship USS *Signal*. Hyland was awarded the medal for his courageous actions on the Red River on May 5, 1864. Although wounded, he attempted to save his vessel while in full view of hundreds of Confederate sharpshooters.

Veterans Memorial 173 Memorial Drive

The Civil War tribute section lists the names of area men who served and sacrificed.

MIDLAND

Northwood University Campus 4000 Whitting Drive

A statue of a young Abe Lincoln on horseback stands behind Jordan Hall.

Muskegon

CivilWar General Kearny Statue Peck and Terrace Streets

This statue pays tribute to Major General Philip Kearny Jr. who was killed at the Battle of Chantilly, Virginia, on September 1, 1862.

Hackley Park West Clay Avenue and Third Street

An impressive eighty-foot-tall Civil War soldiers' monument commands center stage in Hackley Park. Around the base, four bronze soldiers depict the

General Ulysses S. Grant statue at Hackley Park in Muskegon.

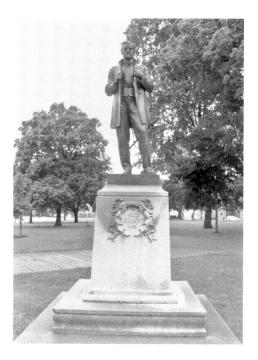

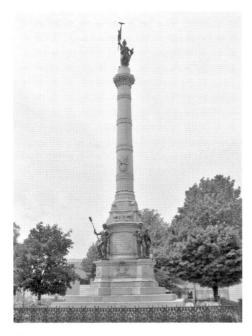

Civil War soldiers and sailors monument in Hackley Park in Muskegon.

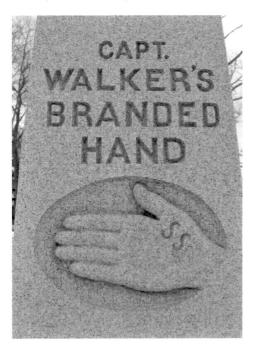

Civil War military branches of infantry, cavalry, artillery and navy. Flanking the four corners of the park are commemorative statues of Admiral Farragut, General Sherman, General Grant and President Lincoln. A nearby monument pays tribute to William McKinley, a Civil War veteran and our nation's twenty-fifth president.

Evergreen Cemetery Irwin Avenue and Pine Street

Captain Jonathan Walker, a fishing boat captain who was caught trying to help seven slaves escape from Pensacola, Florida, in 1844 is buried here. A West Florida judge and jury found Captain Walker guilty and sentenced him to one hour in the pillory where he was pelted with eggs along with imprisonment, a fine and branding. The letters "SS" for slave stealer were burned into his right hand by a United States marshal. The outcry over what many deemed cruel punishment propelled Captain Walker into the national spotlight.

Captain Jonathan Walker's hand was branded as punishment for assisting escaped slaves. His grave marker is at Evergreen Cemetery in Muskegon.

In demand as a speaker on the abolitionist lecture circuit, Walker was the subject of the John Greenleaf Whittier poem "The Man with the Branded Hand." A daguerreotype of Captain Walker's hand was made, and images were reprinted in newspapers, abolitionist pamphlets and Walker's bestselling autobiography and carved into the obelisk that marks his grave.

PETOSKEY

Petoskey District Library Carnegie Building 451 East Mitchell Street (231) 758-3100

A memorial stone pays tribute to historian and author Bruce Catton, who was born in Petoskey on October 9, 1899. See Benzonia entry for more information on Bruce Catton. Local sculptor Stanley Kellogg designed the stone with a bronze plaque featuring an image of the author. The marker was presented to the city in July 1965.

Little Traverse History Museum 100 Depot Court / (231) 347-2620

An exhibit dedicated to Bruce Catton, probably the most well-known and respected Civil War author, can be found here. He's known for his three-volume study on the Army of the Potomac and was awarded a Pulitzer Prize in history for *A Stillness at Appomattox*, the third book in the trilogy.

Arlington Park U.S. 31 and Lewis Street

A rare twelve-pound, cast-iron Confederate Napoleon Howitzer cannon can be found here marking the site of the 1899 GAR encampment. It's the only Confederate cannon on display in Michigan. City officials and historians are not sure how it ended up here. An encampment is a gathering or reunion of GAR members or a regiment's veterans that happened nationally, statewide and/or locally, usually once a year.

Also located here is a boulder with a plaque commemorating the GAR Lombard Post No. 170.

Confederate Iron Napoleon Howitzer cannon at Arlington Park, Petoskey. Courtesy Bob Pieknik.

Guns off the USS Hartford

Eight of the surviving fortyeight nine-inch Dahlgren cannons from Admiral David Farragut's famous flagship USS Hartford are displayed in Michigan. Communities given these cannons in the early 1900s were Mackinaw City, Cheboygan, Harbor Springs, Petoskey, Gaylord, Coleman and Bay City. Bay City donated its cannons, which were located in Battery Park, to the World War II war effort, and they were melted down. This occurred with many cannons throughout the country.

Pennsylvania Park East Lake Street

A nine-inch Dahlgreen cannon from the USS *Hartford* is displayed here.

Greenwood Cemetery 105 Greenwood Street

A Parrott cannon is on display here.

SAGINAW

Boulder with Bronze Tablet Court Street and Washington Avenue

A boulder with a bronze tablet marks the camp training site of the Twenty-third Michigan Infantry, which utilized the site from August 10 to September 18, 1862.

Boulder with Bronze Tablet North Michigan Avenue and Houghton Street

A boulder with a bronze tablet marks the area where the Twenty-ninth Michigan Infantry organized and trained from August 15 to October 6, 1864.

St. Johns

Clinton County Veterans Memorial Near Clinton Avenue and Railroad Street

This recently dedicated monument lists all Clinton County war dead including those from the Civil War and Medal of Honor recipients. Engraved on six of the ten tablets are the names of over 350 of Clinton County's "Boys in Blue" who never returned home.

Mount Rest Cemetery 706 East Steel Street

Brigadier General Oliver Lyman Spaulding is interred here. Spaulding was commissioned captain of the Twenty-third Michigan Infantry in 1862 and promoted to colonel of the regiment in 1864. He was also a U.S. congressman.

Martha Brown Davis, sister of the fiery and controversial abolitionist John Brown, is buried here. The abolitionist was hanged for his armed occupation of the federal armory and arsenal at Harpers Ferry, Virginia, in an attempt to raise a revolt against slavery.

A Civil War monument of a soldier at parade rest stands in remembrance within the cemetery.

Oak Ridge Cemetery 2518 South Lowell Road

Medal of Honor recipient Walter L. Mundell, of the Third Michigan Volunteer Infantry, lies in rest here. Before the Civil War's end, he served

as a corporal in both the Third and Fifth Michigan Volunteer Infantries and was wounded twice. On April 6, 1865, Corporal Mundell captured a Confederate battle flag at the Battle of Saylor's Creek, Virginia.

St. Louis

Civil War Soldier Monument M-46 and Michigan Avenue

A nice example of a traditional Civil War monument of a soldier at parade rest can be found here. It's worth a trip to this picturesque small town just to say you have been to the middle of the mitten. St. Louis is the geographic center of Michigan's Lower Peninsula.

Traverse City

Grand Traverse County Courthouse Boardman and Washington Streets

Located here are a Parrott cannon and a Civil War soldier monument made of zinc, which lists various battles on the base. The deteriorating monument was restored in 2005.

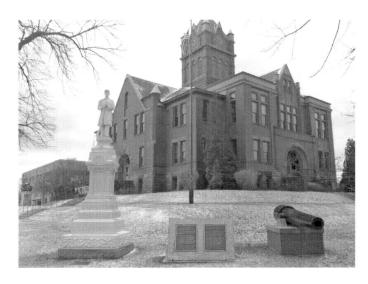

Civil War soldier statue and Parrott cannon in front of the Traverse City courthouse.

Oakwood Cemetery 806 Hastings Street

A parade rest soldier statue and GAR McPherson Post No. 18 monument are located here. The post is possibly named after Major General James B. McPherson.

Veterans Memorial Park North Division Street

A monument dedicated to local veterans includes the names of Civil War soldiers.

AUTHORS' TOP TEN MICHIGAN CIVIL WAR DESTINATIONS

Annual Civil War Muster, Cascades Park, Jackson
Historic Fort Wayne, Detroit
Monroe County Historical Museum
Michigan Historical Museum / State Capitol, Lansing
Elmwood Cemetery, Detroit
Fort Wilkins, Copper Harbor
The Henry Ford, Dearborn
Fort Mackinac, Mackinac Island
Grand Rapids Museum, Grand Rapids
Copper Country, Keweenaw Peninsula

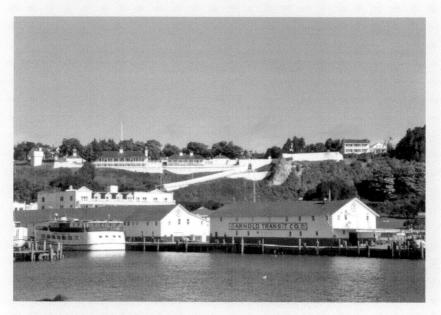

Fort Mackinac on Mackinac Island.

Chapter 4

Upper Peninsula

In addition to manpower, the Union relied heavily on the valuable natural resources found in Michigan's Upper Peninsula. The region supplied the military with two essential metals: copper and iron ore. At this time, copper could be found in almost everything from apparel to weapons. It was used to make the buttons and buckles on uniforms, as well as the bronze cannons used to repulse the enemy on the battlefield. Iron ore was crucial to the production of guns, cannonballs, cannons, railroad tracks, steam boilers and steel used to construct bridges.

Massive quantities of copper and iron ore were mined to fulfill the huge demand and ongoing need. If the North didn't have access to these vital mines, the outcome of the Civil War may have been different. Therefore, we cannot emphasize enough the importance these mines found in Michigan's Upper Peninsula—along with the miners themselves—played in the Union victory.

CALUMET

Lakeview Cemetery 24090 Veteran's Memorial Highway

A Civil War monument of a soldier at parade rest is located here.

Robert E. Lee and the Upper Peninsula

In 1835, Lieutenant Robert E. Lee and two other U.S. army engineers were sent to the Michigan/Ohio border to survey and map the area in order to settle a dispute known as the Toledo War. In dispute was the "Toledo Strip." Based on findings, the dispute was settled without shots fired or bloodshed. The compromise between the two states gave Toledo to Ohio and the Upper Peninsula to Michigan, paving the way for Michigan statehood, which occurred in 1837.

Keweenaw National Historic Park

25970 Red Jacket Road and Calumet Avenue / Highway 41 / (906) 483-3176

A park interpretation focuses on buildings and sites associated with the former Calumet & Hecla Copper Mining Company. Michigan was the number-one provider of copper to the Union army.

COPPER HARBOR

Fort Wilkins State Park
U.S. Highway 41 / (906) 289-4215

Built in 1844 to keep the peace during the state's copper boom, Fort Wilkins is a well-preserved fort sitting atop the northernmost point in Michigan. Abandoned and then re-

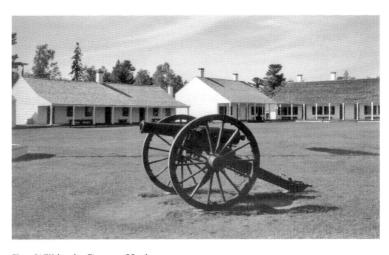

Fort Wilkins in Copper Harbor.

UPPER PENINSULA

garrisoned in the 1860s, the fort received Civil War veterans sent here after the war as part of their duty assignments.

U.S. Highway 41, twelve miles south of Copper Harbor / (906) 289-4688

Used from 1847 to 1887, the mine was a major supplier of copper to the Union effort.

HANCOCK

Quincy Mine and Hoist 49750 U.S. Highway 41 / (906) 482-3101

Established in 1848, the Quincy Mine and Hoist flourished during the Civil War with the increased demand for copper used in munitions.

Houghton

Veterans Memorial Park Emerald Street and College Avenue

A monument of a Civil War marching soldier with a musket on his shoulder is located here.

MACKINAC ISLAND

Fort Mackinac

7029 Huron Road / (906) 847-3328

Three prominent financiers of the Confederacy were imprisoned here as political prisoners during the summer of 1863. A plaque honors Union brigadier general Thomas R. Williams of Detroit who commanded the fort from 1852 to 1856. Major General John Pemberton, a native of Pennsylvania and the Confederate commander at Vicksburg, Mississippi, served here in the 1850s.

Mackinac State Park Post Military Cemetery Garrison Road / (248) 847-3507

Second lieutenant Garrett A. Graveraet, First Michigan Sharpshooters, Company K, is buried here. An artist, musician and teacher at L'Abre Croche (the Crooked Tree), Lieutenant Graveraet helped recruit Native Americans from northwest Michigan to enlist in the First Michigan Infantry, Company K. See sidebar on the next page for more on Company K. His mixed European and Native American ancestry resulted in Graveraet being listed on census and war reports as a "half-breed."

The only enlisted white man recruited into Company K was Henry Graveraet Jr., formerly the probate judge of Emmett County and the lieutenant's fifty-five-year-old father. On May 12, 1864, Henry was killed at the battle of Spotsylvania Court House in Virginia. His son carefully marked the grave and surrounding trees so he could later locate it and bring his father's body back to Michigan for a proper burial, according to the memoirs of Major Edward J. Buckabee, the regiment's adjutant.

Sadly, the twenty-three-year-old lieutenant would not return to claim his father's body. He died on July 1, 1864, from complications resulting

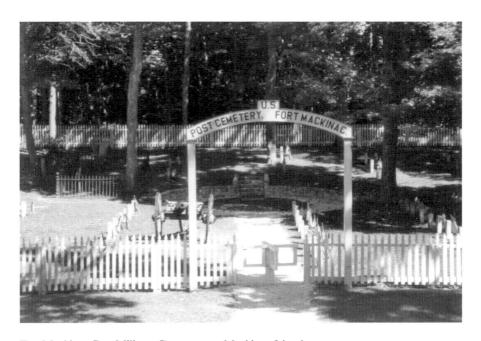

Fort Mackinac Post Military Cemetery on Mackinac Island.

UPPER PENINSULA

from an injury sustained in battle outside Petersburg, Virginia, on June 17.

The bodies of father and son were transferred to this Mackinac Island Cemetery, where a marker honors them today.

Native Americans Compose First Michigan Sharpshooters Company K

Native Americans residing in Michigan, especially members of the Ojibwa, Odawa and Potawatomi nations, composed the unit known as Company K of the First Michigan Sharpshooters.

In May 1861, George Copway, a Chippewa Indian and Methodist minister, first proposed the idea of mustering a Native American regiment from Michigan. Although he touted their suitability for warfare, prejudice toward Native Americans—most of who were not American citizens—prevailed in the Michigan legislature, and the proposal was rejected.

With the war escalating and the realization it would not be short, a desperate need

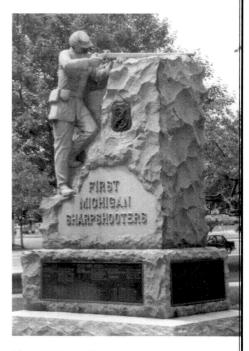

First Michigan Sharpshooters monument on the grounds of the state capitol in Lansing.

for draftees emerged. The value of American Indians as excellent marksmen and warriors became apparent, and recruitment ensued. The First Michigan Sharpshooters, including Company K, drilled at Detroit's Fort Wayne. In August 1863, they departed Detroit to

guard Confederate prisoners at Fort Douglas in Chicago. In March 1864, the company received orders to join General Ambrose Burnside and the Ninth Corps in Annapolis, Maryland.

Fierce, unconventional fighters, members of the First Michigan saw action at the Battle of the Wilderness, Spotsylvania Court House, Cold Harbor, Petersburg, Battle of the Crater, Ream's Station, Peebles Farm and Hatcher's Run. Over 150 Native Americans served in Company K. More than half died from wounds or disease. Nearly every man suffered some type of wound in battle. The First Michigan Sharpshooters mustered out of service in Jackson, Michigan, on August 7, 1865.

MARQUETTE

Marquette Regional History Center 145 West Spring Street / (906) 226-3571

Civil War artifacts and GAR memorabilia are exhibited here.

Lakeside Park South East Street

A boulder with bronze plaque commemorates the local GAR Jackson Post No. 300.

MUNISING

Russell A. Alger Monument
William G. Mather High School / Elm Avenue and
Chocolay Street

A bust monument pays tribute to Russell A. Alger, Civil War major general, United States senator and secretary of war, whom Alger County is named after.

UPPER PENINSULA

NEGALINEE

Michigan Iron Industry Museum 73 Forge Road / (906) 457-7857

Michigan's iron ore was critical to the Union army in the production of ironbased products such as cannons. Exhibits document the mining industry's contribution to the war efforts.

Jackson Mine

Intersection of Business Route M-28 and Cornish Town Road

A designated Michigan State Historic Site and listed on the National Register of Historic Places, Jackson Mine was the first iron mine in the Lake Superior region. It's here that iron ore was first discovered, the first mining done and the first iron manufactured for its ore.

Jackson Mine was one of only three iron mines operating at the start of the Civil War. The company declared its first dividend in 1862 as production soared to fulfill the war's need for iron. In fact, demand was so high that ten new companies had formed by 1864.

ROCKLAND

Military Road Historical Plaque
U.S. 45, two-mile stretch south of M-26/38 junction

A plaque reads: "In 1864, Abraham Lincoln commissioned this road extending from Green Bay to Fort Wilkins as a military highway to secure copper supplies for the Union forces."

SAULT STE. MARIE

Soo Locks 312 West Portage Avenue / (906) 253-9290

The largest of the Soo Locks is Poe Lock, named for its original designer and builder Brigadier General Orlando Poe, who is buried at Arlington National

Army of the Potomac Chief of Artillery

Major General Henry J. Hunt was born in Detroit in 1819 and named after his uncle, who served as the city's second mayor. A West Point graduate, Hunt spent thirty-four years in the army. Known as a great artillery tactician and strategist, Hunt and two other authors revised the Instructions for Field Artillery, a guide used by Union field artillerists during the war. At the Battle of Gettysburg on July 3, 1863, the Union artillery utilized his brilliant strategy during Pickett's Charge, and that helped turn the tide, resulting in Union victory. He is buried at Soldiers Home Cemetery in Washington, D.C.

Cemetery. General Poe commanded the Second Michigan Infantry as its colonel and then became Sherman's chief engineer during the Atlanta Campaign and the "March to the Sea." He died on October 2, 1895, from complications due to an accident that took place at the locks. A visitors' center is open seasonally from mid-May to mid-October

Riverside Cemetery 3260 Riverside Drive

First Sergeant Stephen O'Neill of Company E, Seventh U.S. Infantry, is buried here. The Medal of Honor recipient earned his medal for actions at Chancellorsville, Virginia, on May 1, 1863, where he picked up the unit's colors and carried them through the rest of the battle after the flag bearer was shot down.

St. Ignace

Fort De Buade Museum 334 North State Street / (906) 643-6627

This museum features Civil War artifacts from First Michigan Sharpshooters, Company K, a regiment made up of resident Native American soldiers primarily from Ottawa and Ojibwa tribes.

CIVIL WAR EQUESTRIAN STATUES

Equestrian monuments are common in eastern states but rare in Michigan. Only a handful can be found in the entire state. Three equestrian statues represent the Civil War era: General George Armstrong Custer, Monroe; General Alpheus Williams, Detroit; and President Abraham Lincoln, Midland.

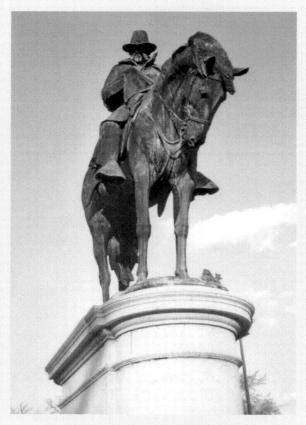

General Alpheus Williams astride his war horse Plug Ugly in Belle Isle, Detroit.

Map Legend: Michigan Civil War Landmarks

Southeast	Michigan

- 1. Adrian
- 2. Ann Arbor
- 3. Armada
- 4. Blissfield
- 5. Bloomfield Hills
- 6. Brooklyn
- 7. Dearborn
- 8. Detroit
- 9. Dexter
- 10. Dundee
- East Lansing
- 12. Grosse Ile
- 13. Hillsdale
- 14. Hudson
- 15. Jackson
- 16. Jonesville
- 17. Lansing18. Mason
- 19. Milan
- 20. Monroe
- 21. Mount Clemens
- 22. Orchard Lake
- 23. Pontiac
- 24. Port Huron
- 25. Saline
- **26.** Stockbridge
- 27. Tecumseh
- 28. Tipton
- 29. Ypsilanti

Southwest Michigan

- 30. Albion
- 31. Allegan
- 32. Allen
- 33. Battle Creek
- 34. Cassopolis
- 35. Centreville
- **36.** Coldwater
- **37.** Dowagiac
- 38. Eaton Rapids39. Galesburg
- 40. Grand Rapids
- 41. Hastings
- 42. Holland43. Kalamazoo
- 44. Lowell
- 45. Marshall
- 46. Martin
- 47. New Buffalo
- 48. Niles
- 49. Saranac
- 50. Schoolcraft
- 51. Sturgis
- 51. Sturgis
 52. Sunfield
- **53.** Three Rivers
- 54. Union City
- 55. Vandalia
- **56.** White Pigeon

Mid/Northern Michigan

- 57. Alma
- 58. Bay City
- 59. Benzonia
- 60. Big Rapids
- 61. Boyne City
- 62. Corunna
- 63. Flint
- 64. Frankenmuth
- 65. Grand Haven
- **66.** Grayling
- **67.** Hart
- 68. Ionia
- 69. Ithaca
- 70. Kalkaska
- 71. Mackinaw City
- 72. Manistee
- 73. Midland
- 74. Muskegon
- 75. Petoskey
- 76. Saginaw
- 77. St. Johns
- 77. St. Johns
- 78. St. Louis
- 79. Traverse City

Upper Peninsula

- 80. Calumet
- 81. Copper Harbor
- 82. Hancock
- 83. Houghton
- 84. Mackinac Island
- 85. Marquette
- 86. Munising
- 87. Negaunee
- 88. Rockland
- 89. Sault St. Marie
- 90. St. Ignace

Map of Michigan Civil War landmarks covered in this book. Courtesy of Chad Bianco.

Chapter 5

Extending Your Tour

Michigan Civil War Monuments and Markers in Other States

GEORGIA

Andersonville National Historic Site

A state monument is located here dedicated "In memoriam to Michigan Soldiers and Sailors imprisoned on these grounds."

Chickamauga National Military Park

Located in the park are these individual state regimental and battery monuments: Ninth Michigan

A monument dedicated to Michigan soldiers and sailors imprisoned at Georgia's Andersonville Prison.

Horrific Conditions at Andersonville Prison

In the fourteen months (February 1864 to May 1865) that Andersonville was in operation, 28 percent of those incarcerated died. Built for 10,000 Union prisoners, it held approximately 33,000 at its peak in 1864. More than 12,000 out of 42,000 actual prisoners died within its confines, including 735 Michigan soldiers. Private John Ransom of the Ninth Michigan Cavalry from Jackson wrote a diary chronicling the horrors of Andersonville that was published into the well-known book entitled *John Ransom's Andersonville Diary*.

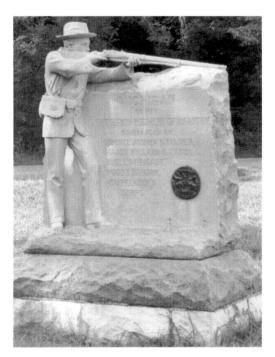

Thirteenth Michigan Infantry monument at Chickamauga and Chattanooga National Military Park, Georgia.

Infantry; Eleventh Michigan Infantry; Thirteenth Michigan Infantry; two monuments to the Twenty-first Michigan Infantry; Twenty-second Michigan Infantry; Second Michigan Cavalry; two monuments to the Fourth Michigan Cavalry; First Michigan Light Artillery, Battery A, also known as Loomis's battery; and First Michigan Light Artillery, Battery D, also known as Church's battery.

KENTUCKY

Perryville Battlefield State Historic Site

A state marker lists the Michigan regiments and batteries that fought in the Battle of Perryville. Two

cannons displayed represent Loomis's First Michigan Light Artillery, Battery A.

EXTENDING YOUR TOUR

Richmond Battlefield

A state marker describes the actions of the First Michigan Light Artillery, Batteries F and G, during the Battle of Richmond.

Tebbs Bend Battlefield, Campbellsville

A state marker pays tribute to the Twenty-fifth Michigan Infantry's refusal to surrender to General John Hunt Morgan's Confederate cavalry on the Fourth of July. Although heavily outnumbered, the Michigan soldiers successfully repelled eight attacks at the Battle of Tebbs Bend.

MARYLAND

Antietam National Battlefield, Sharpsburg

A mortuary cannon tube marks site where Major General Israel B. Richardson was mortally wounded.

South Mountain State Battlefield at Fox's Gap, Middleton

A state marker pays tribute to the Seventeenth Michigan Infantry known as the Stonewall Regiment, named for their heroic charge and capture of the stone walls that occurred at this location.

Mississippi

Raymond Military Park

A replica cannon representing DeGoyler's First Michigan Light Artillery, Battery H, stands here as well as an interpretive panel describing the battery's maneuvers during the Battle of Raymond.

MICHIGAN CIVIL WAR LANDMARKS

Vicksburg National Military Park

A large monument honors Michigan soldiers who served in the campaign and siege of Vicksburg. A plaque listing all Michigan regiments involved in the campaign and six cannons representing DeGoyler's First Michigan Light Artillery, Battery H, can also be found here.

PENNSYLVANIA

Gettysburg National Military Park

Located in the park are these individual state regimental and battery monuments: First Michigan Infantry; Third Michigan Infantry; Fourth Michigan Infantry; Fifth Michigan Infantry; Seventh Michigan Infantry; Sixteenth Michigan Infantry; two monuments to the Twenty-

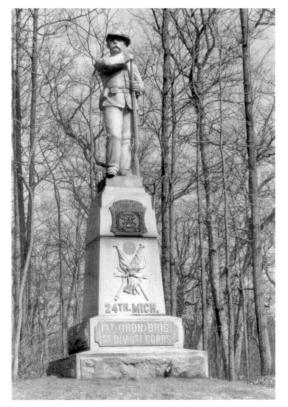

fourth Michigan Infantry; U.S. Sharpshooters, First Regiment, Companies C, I and K; Second Regiment, Company Β, Michigan Cavalry Brigade (First, Fifth, Sixth and Seventh Michigan Cavalry Regiments); First Michigan Light Artillery, Battery I (Daniels); and a bust of Brigadier General Elon I. Farnsworth Farnsworth House the restaurant.

Twenty-fourth Michigan Infantry monument at Gettysburg National Military Park, Pennsylvania.

EXTENDING YOUR TOUR

Hanover

A plaque, a star and four horseshoes in downtown Hanover mark the spot where Brigadier General George Armstrong Custer tied his horse to a tree.

Hunterstown

A monument to George Armstrong Custer, then a newly appointed brigadier general, describes his nearly fatal encounter with the enemy at the Battle of Hunterstown.

Monterey Pass Battlefield Park, Waynesboro

A state marker describes the Michigan Cavalry Brigade's hand-to-hand combat with Confederate cavalry at the Battle of Monterey Pass. General Lee's men were protecting the Army of Northern Virginia's retreating wagon train after their defeat at Gettysburg.

Tennessee

Campbell's Station Battlefield, Farragut

A monument honors Captain Frederick Swift and Sergeant Joseph Brandle of the Seventeenth Michigan Infantry who were awarded Medals of Honor for rallying the regiment during the Battle of Campbell's Station, which took place near this site.

Chattanooga National Military Park at Orchard Knob

Two Michigan regiments have monuments located here: the Tenth Michigan Infantry and First Michigan Engineers and Mechanics.

MICHIGAN CIVIL WAR LANDMARKS

Shiloh National Military Park

Located here is a state monument dedicated in memory of Michigan soldiers who fought and fell in the Battle of Shiloh. Cannons representing Ross's First Michigan Light Artillery, Battery B, are positioned in the Peach Orchard.

Stones River National Battlefield, Murfreesboro

A state marker located near what is often called the "slaughter pen" area is dedicated to the Michigan soldiers and regiments who fought at the Battle of Stones River. A cannon located in the cemetery represents Loomis's First Michigan Light Artillery, Battery A.

Famous Michigan Drummer Boys

Johnny Clem of the Twentysecond Michigan Infantry is known as the drummer boy of Chickamauga Robert Hendershot of the Eighth Michigan Infantry as the drummer boy of the Rappahannock. Clem shot and captured a Confederate colonel at Chickamauga. Hendershot Rappahannock crossed the River at Fredericksburg in a pontoon boat under heavy enemy fire. Clem is buried in Arlington National Cemetery and Hendershot at Home Cemetery near Chicago.

Virginia

Fredericksburg National Military Park

A commemorative boulder with plaque describes the Seventh Michigan Infantry's heroic pontoon boat river crossing and landing site.

Spotsylvania National Military Park

A monument to the Seventeenth Michigan Infantry describes the regiment's desperate hand-to-hand fighting near this location during the Battle of Spotsylvania Court House.

MICHIGAN'S REGIMENT TRAINING SITES

Regiments that Mustered, Trained and Organized in Eastern Michigan

REGIMENT	COMMUNITY
1 st Infantry	Detroit, Ann Arbor
2 nd Infantry	Detroit
4 th Infantry	Adrian
5 th Infantry	Detroit
7 th Infantry	Monroe
8 th Infantry	Detroit
9 th Infantry	Detroit
10th Infantry	Flint
14 th Infantry	Ypsilanti
15th Infantry	Monroe
16th Infantry	Detroit
17th Infantry	Detroit
18 th Infantry	Hillsdale
20 th Infantry	Jackson
22 nd Infantry	Pontiac

APPENDIX I

REGIMENT	COMMUNITY
23 rd Infantry	East Saginaw
24 th Infantry	Detroit
26th Infantry	Jackson
27th Infantry	Ypsilanti
29th Infantry	Saginaw
30th Infantry	Detroit
102 nd U.S. Colored Infantry	Detroit
1 st Cavalry	Detroit
4 th Cavalry	Detroit
5 th Cavalry	Detroit
8 th Cavalry	Mt. Clemens
1st Michigan Light Artillery, Battery H	Monroe
1st Michigan Light Artillery, Battery I	Detroit
1st Michigan Light Artillery, Battery M	Mt. Clemens
1st Michigan Sharpshooters	Dearborn
1 st U.S. Sharpshooters, Companies C, I and K	Detroit
2 nd U.S. Sharpshooters, Company B	Detroit

Regiments that Mustered, Trained and Organized in Western Michigan

REGIMENT	COMMUNITY
3 rd Infantry	Grand Rapids
6 th Infantry	Kalamazoo
11 th Infantry	White Pigeon, Jackson
12 th Infantry	Niles
13 th Infantry	Kalamazoo
19 th Infantry	Dowagiac
21st Infantry	Ionia
25 th Infantry	Kalamazoo
28th Infantry	Kalamazoo
2 nd Cavalry	Grand Rapids
3 rd Cavalry	Grand Rapids
6 th Cavalry	Grand Rapids

APPENDIX I

REGIMENT	COMMUNITY
7 th Cavalry	Grand Rapids
9 th Cavalry	Coldwater
10 th Cavalry	Grand Rapids
11th Cavalry	Kalamazoo
1st Michigan Light Artillery, Battery A	Coldwater
1st Michigan Light Artillery, Battery B	Grand Rapids
1st Michigan Light Artillery, Battery C	Grand Rapids
1st Michigan Light Artillery, Battery D	White Pigeon
1 st Michigan Light Artillery, Battery E	Marshall
1 st Michigan Light Artillery, Battery F	Coldwater
1st Michigan Light Artillery, Battery G	Kalamazoo
1 st Michigan Light Artillery, Battery K	Grand Rapids
1 st Michigan Light Artillery, Battery L	Coldwater
1 st Michigan Light Artillery, 13 th Battery	Grand Rapids
1st Michigan Light Artillery, 14th Battery	Kalamazoo
1st MI Engineers and Mechanics	Marshall

Monroe County Civil War Fallen Soldiers Memorial at Soldiers and Sailors Park, Monroe.

PROMINENT CIVIL WAR MONUMENTS AND STATUES IN MICHIGAN (176)

Town	Location	Type of Monument or Statue
Adrian	Monument Park	memorial column
Adrian	Historical Museum	Laura Haviland statue
Algonac	Boardwalk Park	parade rest soldier
Allegan	Courthouse Lawn	standard bearer soldier with drawn sword
Allen	Allen Cemetery	parade rest soldier
Allendale	Community Park	veterans memorial
Alma	Riverside Cemetery	GAR monument
Alma	Riverside Cemetery	Kimmel soldier statue
Ann Arbor	Forest Hill Cemetery	parade rest soldier
Ann Arbor	Fairview Cemetery	monument with carved eagle
Athens	Burr Oak Cemetery	parade rest soldier
Battle Creek	Monument Square	soldiers and sailors monument
Battle Creek	Monument Park	Sojourner Truth statue
Battle Creek	Kellogg House Park	Underground Railroad sculpture
Battle Creek	Oak Hill Cemetery	cannon from the USS Cumberland
Bay City	Pine Ridge Cemetery	GAR monument
Big Rapids	Courthouse Lawn	standard bearer soldier

Town	LOCATION	Type of Monument or Statue
Birmingham	Shain Park	soldiers and sailors obelisk
Blissfield	Ogden Zion Cemetery	Civil War monument
Blissfield	Pleasant View Cemetery	Columbiad cannon
Bloomfield Hills	Christ Church Cranbrook	President Abraham Lincoln statue
Boyne City	Maple Lawn Cemetery	parade rest soldier
Boyne City	Veterans Park	Rodman cannon
Breckenridge	Ridgeway Cemetery	Civil War monument
Brownstown	Lake Erie Metropark	two Columbiad cannons
Bunker Hill	Fitchburg Cemetery	stone monument
Burr Oak	Burr Oak Cemetery	parade rest soldier
Byron	Byron Cemetery	monument with carved eagle
Calumet	Lakeview Cemetery	parade rest soldier
Capac	Capac Cemetery	parade rest soldier
Carson City	City Park	parade rest soldier
Caseville	Village Park	parade rest soldier
Cedar Springs	Cedar Springs Cemetery	parade rest soldier
Centreville	Prairie River Cemetery	soldier gazing over horizon
Charlotte	Courthouse Lawn	two Parrott cannons
Cheboygan	County Building Lawn	Dahlgren cannon
Chelsea	Oak Grove Cemetery	parade rest soldier and two Parrott cannons
Clare	Cherry Grove Cemetery	parade rest soldier
Coldwater	Loomis Park	original Battery A Parrott cannon
Coldwater	Loomis Park	"Old Sam" war horse monument
Coldwater	Public Library	parade rest soldier
Coleman	Public Park	Dahlgren cannon
Concord	Maple Grove Cemetery	Civil War monument
Corunna	Courthouse Lawn	Flag-draped memorial
Detroit	Hart Plaza	President Abraham Lincoln bust
Detroit	Hart Plaza	Gateway to Freedom sculpture
Detroit	Campus Martius Park	Michigan soldiers and sailors monument

Town	LOCATION	Type of Monument or Statue
Detroit	Belle Isle	General Alpheus Williams equestrian statue
Detroit	Belle Isle	GAR soldier statue tribute
Detroit	Public Library on	President Abraham Lincoln
	Library St.	statue
Detroit	Grand Circus Park	Russell Alger memorial fountain
Detroit	Grand Circus Park	Hazen Pingree statue
Detroit	Woodmere Cemetery	parade rest soldier
Detroit	Fort Wayne	two Parrott cannons
Dexter	Village Park	parade rest soldier
Dexter	American Legion Post 557	Parrott cannon
Diamondale	Diamondale Cemetery	Civil War monument
Dowagiac	Burke Street Park	soldiers with standard bearer
Dundee	Village Triangle Park	memorial bandstand with Parrott cannon
Eaton Rapids	GAR Park	monument to GAR and cannons
Farmington	Memorial Park	memorial to area war dead
Fenton	Oak Hill Cemetery	parade rest soldier
Flint	Courthouse Lawn	Tenth Michigan Infantry monument
Flint	Courthouse Lawn	two Parrott cannons
Flushing	Flushing Cemetery	parade rest soldier
Fremont	Veterans Memorial Park	veterans memorial
Galesburg	Downtown Square	General William Shafter bust
Gaylord	Courthouse Lawn	Dahlgren cannon
Grand Haven	Lake Forest Cemetery	parade rest soldier
Grand Rapids	Monument Park	zinc parade rest soldier
Grand Rapids	Soldiers Home Cemetery	soldier with bowed head and hat in hand
Grand Rapids	Lincoln Place	President Abraham Lincoln bust
Grandville	Grandville Cemetery	parade rest soldier
Grant	Ashland Center Cemetery	parade rest soldier

APPENDIX II

Town	LOCATION	Type of Monument or Statue
Harbor Springs	Zorn Park	Dahlgren cannon
Hart	Courthouse Lawn	parade rest soldier
Hastings	Tyden Park	parade rest soldier
Hillsdale	Courthouse Lawn	Sultana memorial
Hillsdale	Hillsdale College	President Abraham Lincoln statue
Hillsdale	Hillsdale College	standard bearer honoring student soldiers
Hillsdale	Oak Grove Cemetery	parade rest soldier
Holland	Pilgrim Cemetery	parade rest soldier
Holly	Lakeside Cemetery	stacked muskets zinc monument
Houghton	Veterans Memorial Park	marching soldier
Howell	Lakeview Cemetery	parade rest soldier
Hudson	Lime Creek Cemetery	carved obelisk
Ionia	Courthouse Lawn	soldier cocking musket hammer
Ironwood	Riverview Cemetery	parade rest soldier
Jackson	Withington Park	In Defense of the Flag soldier statue
Jackson	Mount Evergreen Cemetery	Laura Evans soldier memorial
Jonesville	Village Park	parade rest soldier
Kalamazoo	Bronson Park	Columbiad cannon and many plaques
Kalamazoo	Riverside Cemetery	parade rest soldier
Kalkaska	Downtown Park	GAR memorial
Lake Odessa	Lakeside Cemetery	soldier in loading position
Lake Orion	Orion Veterans	Civil War fallen plaque
	Memorial Park	
Lansing	State Capital Lawn	Governor Austin Blair statue
Lansing	State Capital Lawn	First Michigan Sharpshooters monument
Lansing	State Capital Lawn	First Michigan Engineers and Mechanics monument
Lansing	Mount Hope Cemetery	carved obelisk
Leonidas	Leonidas Cemetery	parade rest soldier
Lowell	Oakwood Cemetery	parade rest soldier
Ludington	Lakeside Cemetery	parade rest soldier

APPENDIX II

Town	Location	Type of Monument or Statue
Mackinaw City	Marina Park	three Dahlgren cannons
Manchester	Oak Grove Cemetery	parade rest soldier
Manchester	Sharon Township Cemetery	monument with carved eagle
Manistee	U.S. Post Office	honor roll memorial
Marshall	GAR Hall	Parrott cannon
Mason	Courthouse Square	Parrott cannon
Memphis	Memphis Cemetery	parade rest soldier
Menominee	Riverside Cemetery	parade rest soldier
Midland	Northwood University	young Abraham Lincoln equestrian statue
Milan	Marble Park Cemetery	parade rest soldier
Milford	Oak Grove Cemetery	parade rest soldier
Monroe	Monroe and Elm Streets	General George Custer equestrian statue
Monroe	Soldiers and Sailors Park	Monroe County Civil War fallen memorial
Morenci	Oak Grove Cemetery	GAR memorial with two cannons
Mount Clemens	County Building Lawn	Parrott cannon
Munising	William Mather High School	Russell Alger bust
Muskegon	Hackley Park	soldiers and sailors monument
Muskegon	Hackley Park	President Abraham Lincoln statue
Muskegon	Hackley Park	General Ulysses Grant statue
Muskegon	Hackley Park	General William Sherman statue
Muskegon	Hackley Park	Admiral David Farragut statue
Muskegon	Hackley Park	President William McKinley statue
Muskegon	Peck and Terrace Streets	General Philip Kearny statue
Napoleon	Napoleon Cemetery	marble obelisk
Niles	Riverfront Park	Parrott cannon

Town	Location	Type of Monument or Statue
Otsego	Mountain Home Cemetery	parade rest soldier and cannon
Owosso	Oak Hill Cemetery	parade rest soldier
Petersburg	Downtown Park	parade rest soldier
Petoskey	Arlington Park	Confederate Napoleon Howitzer cannon
Petoskey	Pennsylvania Park	Dahlgren cannon
Petoskey	Greenwood Cemetery	Parrott cannon
Plymouth	Veterans Park	Plymouth fallen sons memorial
Plymouth	Veterans Park	Civil War monument and veterans memorial
Pontiac	City Hall	parade rest soldier
Port Huron	Lakeside Cemetery	parade rest soldier
Port Huron	Pine Grove Park	soldiers with standard bearer
Portland	Portland Cemetery	parade rest soldier
Quincy	Lakeview Cemetery	zinc parade rest soldier
Richmond	Richmond Cemetery	parade rest soldier
Rochester	Mount Avon Cemetery	parade rest soldier
Rochester	Near Police Station	Harris fountain
Rockford	Memorial Park	parade rest soldier
Romeo	Romeo Cemetery	parade rest soldier
Roscommon	County Building Lawn	granite cannon memorial
Saginaw	Oakwood Cemetery	parade rest soldier
Sand Lake	Sand Lake Cemetery	parade rest soldier
Scottville	Lakeview Cemetery	parade rest soldier
Sharon Twp.	Sharon Center Cemetery	marble column
Shelby	Village Park	parade rest soldier
Shepherd	Coe Township Cemetery	parade rest soldier
South Haven	Hebrew Cemetery	parade rest soldier
South Lyon	South Lyon Cemetery	Civil War monument
Springport	Springport Cemetery	parade rest soldier
St. Johns	Near Public Library	Clinton County veterans memorial
St. Johns	Mount Rest Cemetery	parade rest soldier

APPENDIX II

Town	LOCATION	Type of Monument or Statue
C. I. I	City Park	
St. Joseph		Dahlgren cannon
St. Louis	M-46 and Michigan Avenue	parade rest soldier
Stockbridge	Public Square	parade rest soldier and Parrott cannon
Sunfield	GAR Hall	two iron cannons
Tecumseh	Brookside Cemetery	parade rest soldier and two Parrott cannons
Three Rivers	Bowman Park	parade rest soldier
Three Rivers	Scidmore Park	smoothbore Napoleon cannon
Tipton	Franklin Cemetery	flag draped obelisk
Traverse City	Courthouse Lawn	zinc parade rest soldier and Parrott cannon
Traverse City	Oakwood Cemetery	parade rest soldier and GAR monument
Traverse City	U.S. 31 and North Cass Street	veterans memorial
Union City	Next to Congregational Church	parade rest soldier and two Parrot cannons
Vassar	Riverside Cemetery	parade rest soldier
Wacousta	Wacousta Village Cemetery	parade rest soldier
Wayne	Historical Museum	two Rodman cannons
Williamston	City Hall	parade rest soldier
Ypsilanti	Highland Cemetery	standard bearer soldier
Ypsilanti	Public Library Plaza	Harriet Tubman statue

CIVIL WAR MEDAL OF HONOR RECIPIENTS BURIED IN MICHIGAN (53)

Rank	Name	REGIMENT	CEMETERY	Town
Private	Frederick Alber	17 th MI Inf.	Oregon Twp.	Columbiaville
Private	John G.K. Ayers	8 th MO Inf.	Riverside	Three Rivers
Private	Frederick Ballen	47 th OH Inf.	Carleton	Carleton
Captain	Charles L. Barrell	102 nd Colored	Hooker	Wayland
Corporal	Francis A. Bishop	57 th PA Inf.	Blanchard	Blanchard
Chief Qtr Master	Thomas Bourne	US Navy	Poe	Jones
Sergeant	Joseph E. Brandle	17 th MI Inf.	Oak Grove	Coldwater
1st Sergeant	Ivers S. Calkin	2 nd NY Cav.	Oak Grove	Montague
Corporal	George W. Clute	14 th MI Inf.	Mount Morris	Mount Morris
Coxswain	Patrick Colbert	US Navy	Mount Elliott	Detroit
Corporal	Gabriel Cole	5 th MI Cav.	Sherman Twp.	Tustin
Brigadier General	Byron M. Cutcheon	20 th MI Inf.	Highland	Ypsilanti
1st Sergeant	Charles H. Depuy	1st MI SS	Evergreen	Kalkaska
2 nd Lieutenant	Henry M. Fox	5 th MI Cav.	Mottville	Mottville

APPENDIX III

Rank	Name	REGIMENT	Семетеку	Town
Private	Samuel S. French	7 th MI Inf.	Gilford	Gilford
Sergeant	Robert J. Gardner	34 th MA Inf.	Wright	Gregory
1st Lieutenant	Cornelius M. Hadley	9 th MI Cav.	Mount Hope	Litchfield
Corporal	Sidney Haight	1st MI SS	West Reading	Reading
Corporal	Addison J. Hodges	47 th OH Inf.	Ogden Zion	Blissfield
1st Sergeant	Charles M. Holton	7 th MI Cav.	Oak Hill	Battle Creek
Sergeant	Michael Hudson	US Marine Corps	Maple Hill	Charlotte
Assistant Gunner	John Hyland	US Navy	Oak Grove	Manistee
1 st Lieutenant	Patrick Irwin	14 th MI Inf.	Saint Thomas Catholic	Ann Arbor
Sergeant	Elisha J. Johns	113 th IL Inf.	Plum Grove	Union
Sergeant	Joseph S. Keen	13 th MI Inf.	Elmwood	Detroit
Sergeant	Daniel A Kelly	8 th NY Cav.	Old Maplewood	Reading
Captain	Joseph B. Kemp	5 th MI Inf.	Forest Hill	Ann Arbor
1st Sergeant	Henry Lewis	47 th OH Inf.	Soop- Pleasantview	Belleville
Sergeant	Frederick A. Lyon	1st VT Cav.	Mount Evergreen	Jackson
Sergeant	Daniel McFall	17 th MI Inf.	Rice	Cone (Milan)
Sergeant	John W. Menter	5 th MI Inf.	Franklin	Franklin
Corporal	Benjamin Morse	3 rd MI Inf.	Oakwood	Lowell
Corporal	Walter L. Mundell	5 th MI Inf.	Oak Ridge	St. Johns
Corporal	Henry E. Nash	45 th OH Inf.	Palmyra	Palmyra
Sergeant	Conrad Noll	20 th MI Inf.	Forest Hill	Ann Arbor
1st Lieutenant	Elliot M. Norton	6 th MI Cav.	Liberty	Alamo
2 nd Lieutenant	John R. Norton	1st NY Cav.	Forest Home	Greenville
1 st Sergeant	Stephen O'Neill	7 th US Inf.	Riverside	Sault Ste. Marie
Sergeant	Henry C. Peters	47 th OH Inf.	Riverside	South Rockwood

RANK	Name	REGIMENT	Семетеку	Town
Sergeant	Henry E. Plant	14 th MI Inf.	Nunica	Nunica
Assistant Surgeon	George E. Ranney	2 nd MI Cav.	Mount Hope	Lansing
Captain	Edwin F. Savacool	1st NY Cav.	Elmwood	Detroit
Private	Phillipp Schlachter	73 rd NY Inf.	Oak Lawn	Sturgis
Brigadier General	Frederick W. Swift	17 th MI Inf.	Elmwood	Detroit
Private	Peter Sype	47 th OH Inf.	Trinity Lutheran	Monroe
Private	Charles M. Thatcher	1 st MI SS	Evergreen	Kalkaska
2 nd Lieutenant	James W. Toban	9 th MI Cav.	Saint Patrick Calvary	Brighton
Captain	William G. Whitney	11 th MI Inf.	Allen	Allen
Ordinary Seaman	Franklin L. Wilcox	US Navy	Soldiers Home	Grand Rapids
Sergeant	William H. Wilcox	9 th NH Inf.	Lakeview	South Haven
Sergeant	Edward Van Winkle	145 th NY Inf.	Oak Hill	Battle Creek
Brigadier General	William H. Withington	lst MI Inf.	Mount Evergreen	Jackson
Sergeant	Alonzo Woodruff	1st US SS	Valley	Luther

Civil War Generals Buried in Michigan (73)

Rank	Name	Семетеку	Town
Brigadier General	George S. Acker	Riverside	Union City
Major General	Russell A. Alger	Elmwood	Detroit
Brigadier General	Charles Barnes	Leelanau Twp.	Northport
Major General	Henry Baxter	Sunset View	Jonesville
Brigadier General	William H. H. Beadle	Riverside	Albion
Brigadier General	Thorton F. Brodhead	Elmwood	Detroit
Brigadier General	Stephen Bronson	Highland View	Big Rapids
Brigadier General	Simeon B. Brown	Hillside	St. Clair
Brigadier General	Stephen G. Champlin	Fulton Street	Grand Rapids
Brigadier General	Henry L. Chipman	Elmwood	Detroit
Brigadier General	Henry B. Clitz	Elmwood (Memorial)	Detroit
Major General	Philip St. George Cooke	Elmwood	Detroit
Brigadier General	Joseph T. Copeland	Oak Hill	Pontiac
Brigadier General	Byron M. Cutcheon	Highland Park	Ypsilanti
Brigadier General	Charles V. DeLand	Mount Evergreen	Jackson
Major General	Gustavus A. De Russy	Elmwood	Detroit

Rank	Name	Семетеку	Town
Brigadier General	Christopher J. Dickerson	Oak Grove	Hillsdale
Brigadier General	William H. Dickey	Riverside	Hastings
Major General	Henry M. Duffield	Elmwood	Detroit
Brigadier General	Ralph Ely	Riverside	Alma
Major General	Clinton B. Fisk	Oak Grove	Coldwater
Brigadier General	Mark Flanigan	Elmwood	Detroit
Brigadier General	William S. Green	Elmwood	Detroit
Brigadier General	Albert Hartsuff	Elmwood	Detroit
Brigadier General	William Hartsuff	Lakeside	Port Huron
Brigadier General	William Hawley	Glenwood	Flint
Brigadier General	Moses B. Houghton	Burdell Twp.	Tustin
Brigadier General	Joseph O. Hudnutt	Highland View	Big Rapids
Brigadier General	William Humphrey	Oakwood	Adrian
Brigadier General	Frederick S. Hutchinson	Soldiers Home	Grand Rapids
Brigadier General	William P. Innes	Fulton Street	Grand Rapids
Brigadier General	James H. Kidd	Highland Park	Ionia
Brigadier General	Benjamin C. Lockwood	Elmwood	Detroit
Brigadier General	Cyrus O. Loomis	Elmwood	Detroit
Brigadier General	Salmon S. Matthews	Oak Hill	Pontiac
Brigadier General	Dwight May	Mountain Home	Kalamazoo
Brigadier General	Justus McKinstry	Highland Park	Ypsilanti
Brigadier General	Elisha Mix	Oakwood	Allegan
Brigadier General	Henry R. Mizner	Elmwood	Detroit
Major General	Henry A. Morrow	Silverbrook	Niles
Quartermaster Gen.	Friend Palmer	Elmwood	Detroit
Brigadier General	John G. Parkhurst	Oak Grove	Coldwater
Brigadier General	Benjamin F. Partridge	Elm Lawn	Bay City
Major General	Byron R. Pierce	Fulton Street	Grand Rapids
Brigadier General	James E. Pittman Jr.	Elmwood	Detroit
Brigadier General	Andrew Porter	Elmwood	Detroit
Brigadier General	Benjamin D. Pritchard	Oakwood	Allegan

RANK	Name	Семетеку	Town
Brigadier General	John Pulford	Elmwood	Detroit
Major General	Israel B. Richardson	Oak Hill	Pontiac
Brigadier General	John Robertson	Elmwood	Detroit
Brigadier General	Eugene Robinson	Elmwood	Detroit
Brigadier General	William Sanborn	Lakeside	Port Huron
Brigadier General	George T. Shaffer	Shaffer	Cassopolis
Brigadier General	Jacob Sharpe	Elmwood	Detroit
Brigadier General	Charles E. Smith	Mountain Home	Kalamazoo
Brigadier General	Israel C. Smith	Oakhill	Grand Rapids
Brigadier General	Joseph R. Smith	Woodland	Monroe
Brigadier General	George Spalding	Woodland	Monroe
Brigadier General	Oliver L. Spaulding	Mount Rest	St. Johns
Brigadier General	Ambrose A. Stevens	Saranac	Saranac
Major General	William L. Stoughton	Oak Lawn	Sturgis
Brigadier General	David Stuart	Elmwood	Detroit
Brigadier General	Frederick W. Swift	Elmwood	Detroit
Brigadier General	Henry D. Terry	Clinton Grove	Mt. Clemens
Brigadier General	William A. Throop	Elmwood	Detroit
Brigadier General	Charles S. Tripler	Elmwood	Detroit
Major General	Luther S. Trowbridge	Elmwood	Detroit
Brigadier General	Michael J. Vreeland	Woodmere	Detroit
Brigadier General	Lyman M. Ward	Crystal Springs	Benton Harbor
Major General	Alpheus S. Williams	Elmwood	Detroit
Brigadier General	Thomas R. Williams	Elmwood	Detroit
Brigadier General	William H. Withington	Mount Evergreen	Jackson
Brigadier General	Grover S. Wormer	Elmwood	Detroit

Sources/Suggested Reading

- Adjutant General of Michigan, Record of Service of Michigan Volunteers in the Civil War, 1861–1865. Kalamazoo, MI: Ihling Brothers and Everand, 1905.
- "African Americans in the Civil War." The Mitten, December 2002.
- Allen, Robert D., and Cheryl T. Allen. *Macomb County Civil War Footprints*. N.p.: privately printed, 2011.
- Anderson, Loraine. "Two Northern Michigan Men, Two Destinies." *Traverse City* (MI) Record-Eagle, February 22, 2009.
- Anderson, William M. They Died to Make Men Free: The History of the 19th Michigan Infantry in the Civil War. Dayton, OH: Morningside House, Inc., 1994.
- Bak, Richard. A Distant Thunder: Michigan in the Civil War. Ann Arbor, MI: Huron River Press, 2004.
- Baut, Donald V. "The Detroit Arsenal Story, 1833–1875." *Dearborn Historian* 17 (Winter 1977): 23–29.
- Bertera, Martin and Kim Crawford. *The 4th Michigan Infantry and the Civil War*. East Lansing: Michigan State Press, 2010.
- Bitter, Rand K. Minty and His Cavalry: A History of the Saber Brigade and Its Commander. N.p.: self-published, 2006.
- Bozich, Stanley J. Michigan's Own: The Medal of Honor Civil War to Vietnam War. Frankenmuth, MI: Polar Bear Publishing, 1987.
- Connell, Mike. "Hartsuff Brothers Became Generals." *Port Huron (MI) Times Herald*, April 11, 2010.
- Conway, James, and David Jamroz. *Detroit's Historic Fort Wayne*. Charleston, SC: Arcadia Publishing, 2007.
- Curtis, Orson. History of the 24th Michigan of the Iron Brigade, Known as the Detroit and Wayne County Regiment. Gaithersburg, MD: Old Soldier Books, Inc., 1988.

Sources/Suggested Reading

- Dempsey, Jack. Michigan and the Civil War: A Great and Bloody Sacrifice. Charleston: History Press, 2011.
- Dickinson, Julian D. The Capture of Jefferson Davis: President of the Confederate States of America. Detroit: Ostler Printing Company, 1888.
- Frank, Michael S. Elmwood Endures: History of a Detroit Cemetery. Detroit: Wayne State Press, 1996.
- Friggens, Thomas G., and Patrick E. Martin. Fort Wilkins: Yesterday and Today. Lansing: Michigan Historical Center, 2000.
- Garrett, Bob. "Flight to Freedom." Seeking Michigan, February 2, 2010.
- Genco, James. Into the Tornado of War: A History of the Twenty-First Michigan Infantry in the Civil War. Bloominton, IN: Abbott Press, 2012.
- Gray, John A. "The Fate of the Lincoln Conspirators." *McClure's Magazine* 37 (May–October 1911): 626–36.
- Herek, Raymond. These Men Have Seen Hard Service: The First Michigan Sharpshooters in the Civil War. Detroit: Great Lakes Books, 1998.
- Hershenzon, Gail D. *Images of America: Detroit's Woodmere Cemetery*. Charleston, SC: Arcadia Publishing, 2006.
- Hoffman, Mark. My Brave Mechanics: The First Michigan Engineers and Their Civil War. Detroit: Wayne State University Press, 2007.
- Hunt, Roger D. Colonels in Blue: Michigan, Ohio and West Virginia. Jefferson, NC: McFarland & Company, Inc., 2011.
- Hunt, Roger D., and Jack R. Brown. *Brevet Brigadier Generals in Blue*. Gaithersburg: Olde Soldiers Books, Inc., 1997.
- Kidd, James. Riding with Custer: Recollections of a Cavalryman in the Civil War. Lincoln: University of Nebraska Press, 1997.
- Kundinger, Matthew. "Racial Rhetoric: The Detroit Free Press and Its Part in the Detroit Race Riot of 1863." *Michigan Journal of History*, 2006.
- Longacre, Edward. Custer and His Wolverines: The Michigan Cavalry Brigade 1861–1865. Conshohocken, PA: Combined Publishing, 1997.
- Mason, Jack C. *Until Antietam: The Life and Letters of Major General Israel B. Richardson, U.S. Army*. Charbondale: Southern Illinois University Press, 2009.
- Mason, Philip, and Paul Pentecost. From Bull Run to Appomattox: Michigan's Role in the Civil War. Detroit: Wayne State University Press, 1961.
- May, George. Michigan and the Civil War Years, 1860–1866: A War Time Chronicle. Lansing: Michigan Civil War Centennial Observance Commission, 1964.
- ——. Michigan Civil War Monuments. Lansing: Michigan Civil War Centennial Observance Commission, 1965.
- McCarthy, Bernard, Chauncey P. Miller and Joseph R. Schroeder. *The Civil War Veterans*. Detroit: Elmwood Cemetery, 1993.
- Michigan and the Civil War: An Anthology. Lansing: Michigan Historical Center, Michigan Department of State, 1999.
- "Michigan Notables and Civil War Soldiers Buried at Woodmere Cemetery." Pamphlet distributed by Woodmere Cemetery.
- Millbrook, Minnie. A Study in Valor: Michigan Medal of Honor Winners in the Civil War. Lansing: Michigan Civil War Centennial Observance Commission, 1966.

Sources/Suggested Reading

- ———. Twice Told Tales of Michigan and Her Soldiers in the Civil War. Lansing: Michigan Civil War Centennial Observance Commission, 1966.
- Miller, Chauncey P. The Civil War Generals. Detroit: Elmwood Cemetery, 1991.
- Mull, Carol E. *The Underground Railroad in Michigan*. Jefferson, NC: McFarland and Company, 2010.
- Panhorst, Michael W. "Outdoor Sculpture in Jackson, Michigan." Ella Sharp Museum of Art and History, 2006. http://ellasharpmuseum.org (article no longer available).
- Person, Gustav J. "Captain George G. Meade and the United States Lake Survey." *Engineer*, September–December 2010.
- Petz, Weldon E., and Roger Rosentreter. "Seeking Lincoln in Michigan." *Michigan History Magazine*, 2009.
- Quaife, Milo M., ed. From the Cannon's Mouth: The Civil War Letters of General Alpheus S. Williams. Detroit: Wayne State University Press, 1959.
- Robertson, John. Michigan in the War. Lansing, MI: W.S. George & Co., 1882.
- Scott, Robert, Ed. Forgotten Valor: The Memoirs, Journals & Civil War Letters of Orlando B. Willcox. Kent, OH: Kent State University Press, 1999.
- Sheppard, Lawrence C. "A Tale of the 'Old Flag." *Dearborn Historian* 18 (Autumn 1978): 108–111.
- Smith, Leanne. "Jackson Resident Played Key Role in Execution of People Convicted in Plot to Assassinate Abraham Lincoln; His Role Was Excluded from The Conspirators," *Jackson (MI) Citizen Patriot*, April 15, 2011.
- Stoy, Roland. "Famous Horse Subject of Local Publication." *Coldwater (MI) Daily Reporter*, January 14, 2009.
- Taylor, Paul. "Old Slow Town": Detroit During the Civil War. Detroit: Wayne State University Press, 2013.
- Thank God for Michigan: Civil War Collector's Issue. Michigan History Magazine, 1998.
- Thornton, Leland W. When Gallantry Was Commonplace: The History of the Michigan Eleventh Volunteer Infantry, 1861–1864. American University Studies Series 9, vol. 90. New York: P. Lang, 1991.
- Townsend, David G. The Seventh Michigan Volunteer Infantry: The Gallant Men and Flag of the Civil War, 1861–1865. Fort Lauderdale, FL: Southeast Publications, 1993.
- Urwin, Gregory. Custer Victorious: The Civil War Battles of General George Armstrong Custer. Lincoln: University of Nebraska Press, 1983.
- Warren, Ezra J. Generals in Blue. Baton Rouge: Louisiana State University Press, 1992. Williams, Frederick. Michigan Soldiers in the Civil War. Lansing: Michigan Historical Commission, Reprint 2002.
- Woodford, Frank. Father Abraham's Children: Michigan Episodes in the Civil War. Detroit: Wayne State University Press, 1961.
- Woodford, Frank B., and Arthur M. Woodford. *All Our Yesterdays: A Brief History of Detroit*. Detroit: Wayne State University Press, 1969.
- Wunderlich, Kevin D. *Images of America: Vernor's Ginger Ale*. Charleston, SC: Arcadia Publishing, 2008.
- Younkman, Tim. "Bay City Civil War Profile: Captain James G. Birney IV Served Under General Custer in the 7th Michigan Cavalry, Received Sword on Display at Bay City Historical Museum." *Bay City Times*, April 9, 2011.

Sources/Suggested Reading

WEBSITES

www.allmichigancivilwar.com www.americanmemorial.weebly.com/Michigan.html www.bentley.umich.edu www.civilwar.org www.civilwararchive.com/unionmi.htm www.detroit1701.org www.findagrave.com www.4thmichigan.com www.generalsandbrevets.com www.historicfortwaynecoalition.com www.hmdb.org www.homeofheroes.com www.kalamazoomuseum.org www.michiganinthewar.org www.michiganmarkers.com www.michiganwomenshalloffame.org www.micwc.typepad.com www.mlive.com www.nps.org www.nps.gov/civilwar/soldiers-and-sailors-database.htm www.roadsandriders.com/memorials/MI/index.html www.seekingmichigan.org/civilwar www.7thmichigan.us www.suvcwmi.org www.thehenryford.com www.waymarking.com www.wikipedia.com

A

Abraham Lincoln Collection 103 Acker, George S. 148 Adrian 20, 21, 24, 25, 81 African American Cultural and Historical Museum 26 Alger, Russell A. 42, 43, 44, 64, 117, 133, 180 Allegan 117, 119, 120 Alma 154 Alumni Memorial Hall 25 Andersonville Prison 33, 107, 187, 188 Ann Arbor 14, 15, 25, 26, 27 Antietam 39, 98, 104, 105, 154, 189 Arlington National Cemetery 37, 48, 91, 103, 192 Armada 28

Ayers, John 148

В

Baker, Luther Byron 71, 81, 91 Barker, Kirkland C. 73, 74 Barns, Henry 47 Battle Creek 15, 47, 87, 118, 123, 124, 125, 126, 151 Battle of Hawes Shop 28 Battle of Yellow Tavern 20, 28, 98 Baxter, Henry 85, 86, 87 Bay City 154, 168 Beadle, William H. 119 Beall, John Yates 55 Beckley, Guy 25, 26 Bee, Andrew 144 Belle Isle 23, 33, 38, 39, 183 Bentley Historical Library 25 Benzonia 155, 156, 167 Berdan, Hiram 103 Berdan's Sharpshooters 103 Big Rapids 156 Birney, James 154, 155

Blair, Austin 38, 40, 42, 47, 50, 54, 79, 82, 84, 88, 132 Blissfield 28 Bloomfield Hills 29 Bogue, Stephen 149 Bonine Home and Carriage House 149 Bonine, James E. 149 Booth, John Wilkes 17, 31, 71, 81, 91 Borglum, Gutzon 55, 56 Bourne, Thomas 159 Boyd, William H. 100 Boyne City 156 Brainerd, James B. 132 Brandle, Joseph E. 127, 128, 191 Brodhead, Thornton F. 4, 5, 32, 33, 40, 72 Bronson Park 140, 141 Bronson, Stephen 156 Brooklyn 29 Brookside Cemetery 108, 109, 158 Brown, John 60, 61, 63, 98, 169 Buckabee, Edward J. 178

Buckskin 71 Burnside, Ambrose 50, 180	Church, Nathan 162 Church's Battery D 149, 188 Civil War regimental	Dearborn 17, 30, 158, 173 Dearborn Historical Museum 32 DeBaptiste, George 40,
Calumet 175 Camp Backus 46 Camp Banks 67 Camp Barker 145 Campbell's Station 191 Camp Blair 84 Camp Fremont 139 Camp Jackson 84 Camp Kellogg 137 Camp Lee 137 Camp Lyon 67	flags 88 Clinton Grove Cemetery 102 Clovese, Joseph 158 Cody, Buffalo Bill 97 Colbert, Patrick 35 Coldwater 15, 22, 127, 128, 130 Colonel Baker Post No. 84 163 Company C, Twenty-fourth Michigan	56, 62, 63, 143 DeGoyler, Samuel 78 Deland, Charles 80 Delaware Copper Mine 177 DePuy, Charles H. 163 Detroit 15, 17, 30, 33, 37, 38, 40, 41, 47, 49, 50, 51, 52, 56, 59, 61, 65, 66, 74, 179, 182, 183 Detroit Arsenal 32
Camp Owen 142 Camp Sigel 161, 162 Camp Stockton 102 Camp Tilden 149 Campus Martius 50, 51, 52, 151	Infantry 103 Cooke, Philip St. George 44, 46 Copeland, Joseph T. 102, 104 copper 74, 159, 175, 176, 177	Detroit Barracks 48 Detroit Historical Museum 54 Detroit Historical Society 38 Detroit Public Library 54, 65
Camp Ward 47 Camp Willcox 131 Camp Williams 23 Camp Woodbury 77 Cantonment Anderson 137 Cass, Lewis 44 Cassopolis 126	Copper Harbor 173, 176, 177 Copway, George 179 Corunna 157 Crapo, Henry H. 87, 158 Crogan Street Station 62	Dexter 67, 68, 69 Dias, George 158 Dickenson, Julian 46 Dickerson, Christopher J. 77 Dickey, William H. 138
Catton, Bruce 9, 153, 155, 156, 167 Centreville 127 Chandler, Elizabeth Margaret 23, 89 Chandler, Zachariah 40, 41, 42, 143 Chaplin, Stephen G. 134	Crosswhite, Adam 142 Custer equestrian statue 96 Custer, George A. 20, 24, 32, 50, 74, 88, 94, 95, 96, 97, 100, 101, 103, 104, 109, 128, 138, 154, 160, 183, 191 Custer, Libbie Bacon 74,	Don Juan 109 Doolittle, Charles C. 76 Dorsch, Eduard 100 Douglass, Frederick 31, 60, 61, 63 Dowagiac 130, 131 Dowagiac Area History Museum 130 Dundee 69, 70
Charles H. Wright Museum of African American History 58 Chattanooga 73, 84,	94, 95, 96, 109 Custer, Tom 93 Cutcheon, Byron M. 111	E Eastern Michigan University 49
188, 191 Chickamauga 42, 73, 84, 107, 117, 121, 127, 147, 161, 187 Christiancy, Isaac P. 100, 102	Dandy 97 Daniels, Jabez 78 Davis, Jefferson 34, 44, 46, 117, 120, 140, 144, 146, 163	East Lansing 14, 71 Eaton Rapids 131, 132 Edmonds, Sarah E. 89, 90, 153, 157, 158 Eighteenth Michigan Infantry 77, 99

Grosvenor, Ebenezer 87, 100 Hutchinson, Frederick Lansing 79, 87, 113, Grosvenor, Ira 100, 101 S. 134 151, 173 Hyland, John 164 Lee, Robert E. 17, 20, 37, H 44, 61, 158, 176 I Leutz, Emmanuel 57 Hackley Collection 54 LeValley, Orlando 158 Hackley Park 151, 165, 166 Innes, William P. 134, 135 Lincoln, Abraham 13, 17, Hall, Norman 98 Ionia 151, 160, 161, 162 18, 24, 29, 30, 32, Hancock 177 Ionia County Courthouse 42, 47, 54, 55, 57, Hanover 191 151, 161 65, 71, 76, 77, 79, Harper Hospital 66 Iron Brigade 30, 51, 52, 144 94, 97, 103, 104, Harrington, Henry 128 iron ore 175, 181 136, 140, 165, 181 Hart 160 Irwin, Patrick 28 Lincoln conspirators 24, Hart Plaza 55, 56 Ithaca 162 80,81 Hartranft, John F. 24, Lincoln's chair 30 J 80,81 Little Rock Missionary Hartsuff, William 107 **Baptist Church** Jackson 15, 78, 83, 84, Hartwick Pines State 57, 58 126, 132, 151, 173 Park 159 Jackson Mine 181 Little Traverse History Harwood, William Museum 167 James, Jesse 52 Webb 107 Jeffords, Harrison H. 67 Living Museum's Hastings 138 Jonesville 85, 86 Underground Haviland, Laura Smith Joseph R. Smith GAR Railroad Flight to 20, 21, 22, 23, 89 Post No. 76 100 Freedom 64 Hawley, William 158 Logan County Hayes, Rutherford B. 73 K Courthouse 32 Hazelbank 23 Lombard, George W. 76 Henry Ford, The 17, 30, 173 Kalamazoo 139, 140 Longstreet, James 157, Highland Cemetery 111 Kalamazoo Valley 158, 159 Highland Park Museum 140 Loomis Battery 46, 127, Cemetery 160 Kalkaska 163 128, 129 Hillsdale 75, 76 Kearny, Philip, Jr. 90, 165 Loomis, Cyrus O. 46 Hillsdale College 76, 77 Keen, Joseph S. 42 Lowell 137, 142 Hodges, Addison J. 29 Kemp, Joseph B. 27 Lyon, Frederick 80 Holland 139 Kentucky Raid of 1847 Holton, Charles M. 126 126, 149 M Houghton 177 Keweenaw National Howard, Jacob M. 40, 41 Mackinac Island 173, Historic Park 176 Hudnutt, Joseph O. 156 177, 178, 179 Kidd, James H. 153, Hudson 78 160, 161 Mackinac State Park Huff, John A. 20, 28 Post Military Kilpatrick, Judson 150 Cemetery 178 Humphrey, William 23 L Mackinaw City 163, 164 Hunterstown 191 Manistee 164 Hunt, Henry J. 182 Ladies' Soldiers Aid

Society 140

Lakeview Cemetery 175

Lambert, William 40, 63

Manistee County Historical

Maple Grove Cemetery

78, 92

Museum 164

Hussey, Erastus 118, 123,

124, 126

Hussey, Sarah 118, 123

March to the Sea 64, 113, 148, 158, 161, 182 Mariners' Church 57 Marquette 180 Marshall 142, 143	Mountain Home Cemetery 141 Mount Clemens 102 Mount Evergreen Cemetery 79, 80	Partridge, Benjamin F. 154 Pemberton, John 177 Perryville 188 Personal Freedom Act of 1855 124
Martin 144 Mason 91 Masonic Temple 57 May, Dwight 141 McFall, Daniel 92 McKinley, William 42, 166 Meade, George 66, 67 Merritt, Wesley 150 Michigan Cavalry Brigade 20, 87, 94, 103, 104, 135, 138, 153,	Mount Hope Cemetery 91 Mount Rest Cemetery 169 Mundell, Walter L. 137, 169, 170 Munger, George 140, 146 Munising 180 Muskegon 151, 165, 166 N Native Americans 23, 97,	Petoskey 155, 167, 168 Pickett, George 101 Pickett's Charge 78, 92, 98, 101, 142, 182 Pierce, Byron Root 117, 134 Pilgrim Home Cemetery 139 Pine Grove Historical Museum 104, 106 Pine Ridge Cemetery 154 Pingree, Hazen S. 64
161, 190, 191 Michigan Historical Museum 87, 88, 173 Michigan Iron Industry Museum 181 Michigan Soldiers Home 133, 135 Michigan Women's Historical Center and Hall of Fame 89 Midland 13, 165, 183	153, 178, 179, 180 Negaunee 181 New Buffalo 30, 144 Niles 15, 144 Nims, Frederick 101 Nineteenth Michigan Infantry 127, 131, 132 Ninth Michigan Cavalry 101, 130, 148, 188 Ninth Michigan Infantry 127, 130, 187	Pleasant View Cemetery 28 Pleasonton, Alfred A. 150 Plug Ugly 39, 183 Plymouth 103, 104 Poe, Orlando 39, 181 Post, George 24 Potter, Edward 88, 96 Pritchard, Benjamin D. 117, 119, 120, 121
Miegs, Montgomery 37 Milan 92 Minty, Robert H.G. 83, 84, 107	Noll, Conrad 27 Norris Block 112	Quincy Mine and Hoist 177 R
Minty's Sabre Brigade 34, 73, 83, 84 Monroe 15, 19, 88, 93, 94, 95, 97, 98, 99, 100, 101, 151, 183 Monroe County Historical Museum 93, 94, 95, 100 Monterey Pass 191 Montgomery, James 113 Moore, Orlando H. 117, 140 Morgan, John Hunt 117, 140, 148, 189 Morrow, Henry A. 144, 145 Morse, Benjamin 137, 142	Oak Grove Cemetery 77,	Raisin Institute 22 Raisin Valley Cemetery 22 Ranney, George E. 91 Rath, Christian 80, 81, 82 Raymond 189 Reinzi 139 Republican Party 40, 78, 79, 82, 83, 100, 126, 146 Richardson, Israel B. 104, 105, 189 Richmond 42, 189 Riverside Cemetery 104, 119, 138, 141, 148, 154, 182

Robinson, Frank 46 Rockland 181 S Saginaw 168 Samuel W. Grinnell Post No. 283 147 Sanborn, William 106 Saranac 146 Sault Ste. Marie 181 Savannah 39 Schlachter, Phillip 147 Schoolcraft 117, 140, 146 Second Baptist Church 60, 62, 63 Second Battle of Bull Run 72 Second Michigan Cavalry 43, 83, 91, 107, 137, 139, 188 Second South Carolina 113 Seventeenth Michigan Infantry 50, 80, 92, 127, 128, 189, 191, 192 Seventh Michigan Infantry 85, 92, 93, 98, 100, 101, 132, 190, 192	Smith, Charles E. 141 Smith, Henry W. 81, 99 Smith, Israel C. 136 Smith, Joseph R. 99 Sojourner Truth Institute 124 Soo Locks 181 South Mountain 49, 80, 189 Spalding, George 93, 96, 99 Spaulding, Oliver L. 169 Spotsylvania Court House 27, 92, 142, 147, 162, 178, 192 Spring Grove 159 Starr, Belle 52 Stevens, Ambrose A. 146 St. Ignace 182 St. Johns 137, 169 St. Louis 76, 111, 157, 170 St. Mark's Episcopal Church 136 Stockton, Thomas 159 Stones River 192 Stonewall Regiment 49, 80, 189 Stoughton, William L. 117, 147 St. Thomas Cemetery 28	Terry, Henry D. 102 Thatcher, Charles M. 163 Third Michigan Cavalry 54, 69 Third Michigan Infantry 117, 135, 136, 142, 190 Thirteenth Amendment 32, 40, 41, 65 Thomas, Nathan 146 Thompson, Franklin 89, 90, 153, 158 Three Rivers 147 Tinsdale, Jane 46 Tipton 110, 111 Toledo War 176 Traverse City 170 Truth, Sojourner 47, 50, 60, 89, 118, 124, 125, 126 Tubman, Harriet 112, 118, 123 Twelfth Michigan Infantry 141, 145 Twentieth Michigan Infantry 25, 27, 84, 111 Twenty-eighth Michigan Infantry 127
Infantry 85, 92,	117, 147	Twenty-eighth Michigan
132, 190, 192 Shaffer, George T. 127 Sheppard, Thomas H.	Stuart, James E.B. 20, 28, 33, 44, 98, 159	Twenty-fifth Michigan Infantry 139,
32, 33 Sheridan, Phillip 50, 56,	Sturgis 117, 147 Sultana 75, 76 Sunset View Cemetery 85	140, 189 Twenty-first Michigan Infantry 146, 161,
95, 107, 139 Sherman, William T. 42, 50, 64, 73, 74, 96, 107, 113, 135,	Surratt, Mary 24, 80, 81, 82, 99 Sype, Peter 99	162, 188 Twenty-first U.S. Infantry 145 Twenty-fourth Michigan
148, 157, 158, 161, 166, 182	T C 1 - 1 76 01 00	Infantry 51, 52, 65, 87, 103, 144, 190
Shiloh 145, 192 Signal of Liberty 25, 26 Silverbrook Cemetery 144	Taft, Lorado 76, 81, 82 Taft, William Howard 96 Tebbs Bend 140, 189	Twenty-ninth Michigan Infantry 169
Sixteenth Michigan Infantry	Tecumseh 23, 109 Tenth Michigan Cavalry	Twenty-second Michigan Infantry 104, 106, 188, 192
27, 159, 190 Sixth Michigan Infantry 132, 138, 139	136, 138 Tenth Michigan Infantry 77, 107, 157, 158, 191	Twenty-seventh Michigan Infantry 112

INDEX

Twenty-sixth Michigan Infantry 84, 162 Twenty-third Michigan Infantry 158, 168, 169

U

Underground Railroad
19, 22, 26, 37, 54,
56, 57, 60, 61, 62,
63, 64, 69, 107,
112, 118, 123, 124,
126, 130, 143, 144,
146, 148, 149
Under the Oaks 78, 83, 126
University of Michigan
25, 150
USS Hartford 163, 164, 168
USS Michigan 55, 73

V

Vandalia 118, 148, 149 Van Winkle, Edward 126 Vernor, James 34, 72 Vernors Ginger Ale 34, 72 Vicksburg 29, 76, 78, 99, 106, 148, 154, 177, 190 Vreeland, Michael 33

W

Walker, Jonathan 166, 167
Walker Tavern 29
Watts, Richard A. 24, 81
Webb, William 60, 61, 63
Weber, Peter 134, 135, 136
Webster, Daniel 29, 30
Welch, Norval W. 27
Weldon Petz collection 103
White Pigeon 149
Whitney, William G. 121
Wilcox, Franklin L. 134
Willcox, Orlando B. 48,
49, 131
William L. Clements
Library 25

Williams, Alpheus 23, 38, 183 Williams, Thomas R. 44, 177 Willow Grove Cemetery 28 Winchester 39, 104, 139 Wisner, Moses 104, 106 Withington, William H. 48, 80, 82, 159 Women's Relief Corps 89, 111, 112 Woodbury, Dwight A. 23, 24, 77 Woodland Cemetery 93, 98, 100 Woodmere Cemetery 33, 34, 62, 72 Woodruff, Alonzo 161 Woodruff, George A. 142 Wood, Thomas J. 50

Y

Ypsilanti 26, 49, 53, 111, 112 Ypsilanti Historical Museum 111

ABOUT THE AUTHORS

avid Ingall is the former assistant director of the Monroe County Historical Museum and was the chairman of the monument dedication ceremony for the Monroe County Civil War Fallen Soldier's Memorial. He is a sought-after Civil War speaker and tour guide and a member of the Civil War Trust, Monroe County Civil War Round Table, Little Big Horn Associates, Custer Battlefield Historical and Museum Association and Custer Battlefield Preservation Committee. David is a graduate of Western Michigan University. He resides in Temperance, Michigan, along with his wife and two children.

Courtesy of Bryan Bosch, Monroe Evening News.

A arin Risko is the founder of Hometown History Tours, a local tour company that shows off the rich history of Detroit and southeast Michigan, including its Civil War and Underground Railroad history. A member of the Detroit Metro Convention and Visitors Bureau, Karin is frequently called on by local professional and social organizations to speak on local history. Karin is a former history teacher and earned a bachelor's degree in secondary education and history from Central Michigan University. She lives on Grosse Ile, a historic island in southeast Michigan.